THE WORLD OF ESCOFFIER

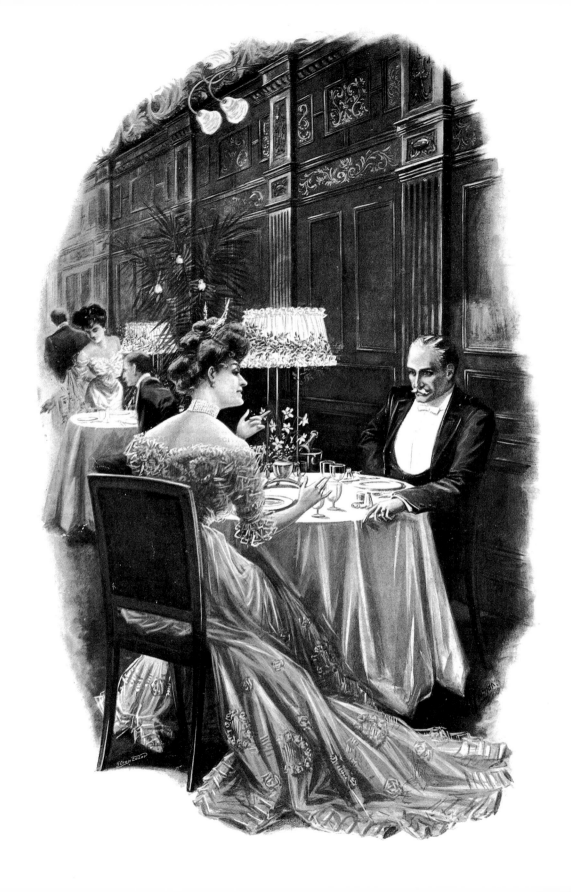

THE WORLD OF

Escoffier

TIMOTHY SHAW

The Vendome Press

Frontispiece: Dinner at the Savoy. The warm, flattering glow shed by electric lights and silk-shaded table lamps was a novelty which put clients into the right mood to enjoy Escoffier's unrivalled cuisine.

Designed by Mavis Henley

© Timothy Shaw 1994

First published in 1994 by Zwemmer
an imprint of Philip Wilson Publishers Ltd
26 Litchfield Street
London WC2H 9NJ

Published in the USA in 1995 by
The Vendome Press
1370 Avenue of the Americas
New York, NY 10019

Distributed in the USA and Canada by
Rizzoli International Publications
through St. Martin's Press
175 Fifth Avenue
New York, NY 10010

Library of Congress Cataloging-in-Publication Data
Shaw, Timothy,
 The world of Auguste Escoffier / by Timothy Shaw.
 p. cm.
 ISBN: 0–86565–956–7
 1. Escoffier, A. (Auguste), 1846–1935. 2. Cooks—
 France—Biography. I. Title.
 TX649.E8S43 1995
 641.5′092—dc20 94–22228
 [B] CIP

Printed and bound by Snoeck-Ducaju & Zoon,
NV, Ghent, Belgium

CONTENTS

Acknowledgements 7

1

THE MOST FAMOUS COOK
IN THE WORLD

9

2

AUGUSTE ESCOFFIER

15

3

OF COOKS AND KITCHENS

65

4

THE MASTER OF FRENCH
CUISINE

97

Recipes *149*

Bibliography *166*

Index *167*

ACKNOWLEDGEMENTS

My thanks are due to Prince Louis de Polignac for taking
an early interest in this project and to the Société
des Bains de Mer at Monaco for help over the book's
preparation and for permission to use illustrations;
the archivist Daniel Aubry introduced me to important
items concerning the Grand Hôtel. I am indebted to
Pierre Escoffier for personal memories of his grandfather
and for having indicated new facts and perspectives.
At Villeneuve-Loubet the Fondation Auguste Escoffier has
been an indispensable source of original information,
and I would particularly like to thank Madame Jeanne
Neyrat-Thalamas, Pierre Bresson and Pierrette Boissier
for allowing me unrestricted access to the Fondation's
library and archives, and for providing
illustrations. Jean Verdier of the Hôtel La Verniaz,
Evian-les-Bains, a member of the 'Escoffier Generation',
gave me an informed, comprehensive account of the
maître's professional achievement. At a vital moment
Jacques Rabouël entrusted me with his own immaculate copy,
complete with unchipped dust-wrapper, of the 1931 English
edition of Pierre Hamp's autobiography. I would also
like to express my appreciation of the help given me by
the librarians and staff of the Bibliothèque Louis Notari
at Monaco and the Bibliothèque de Cessole at Nice; and I
thank Francis and Angela Hoogewerf for providing me with
accommodation during the early stages of my work.

TIMOTHY SHAW

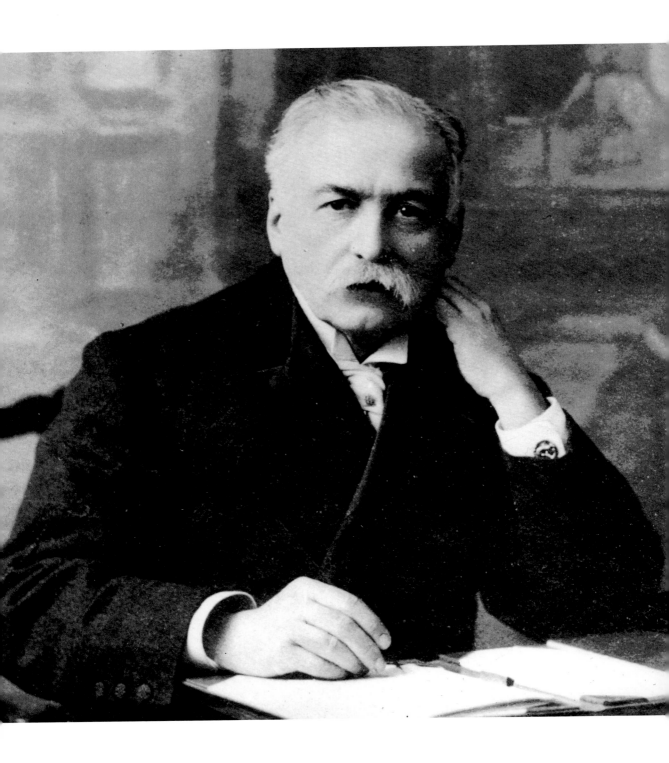

1

THE

Most Famous Cook IN THE WORLD

Escoffier often inscribed portrait photographs of himself with aphorisms such as 'La bonne cuisine est la base du véritable bonheur'.

On 12 February 1935 Georges Auguste Escoffier, 'the most famous cook in the world' as the obituarists called him, died aged eighty-eight at his villa in Monte Carlo. The epithet was no exaggeration. The great chef who for thirty years had ruled the prestigious hotel kitchens of the Savoy and the Carlton and who once, when asked if he would like to be a royal cook, said he doubted whether any king could afford his salary, was a renowned figure of whom everyone had heard. To the working cook he was a legend; to thousands who had never eaten a mouthful of any of his dishes, his face and signature were familiar from the bottles of Escoffier sauce which stood

on their larder shelves; but to those who had known him personally, or who had had the opportunity or been in the habit of enjoying his food, he was the presiding genius of a whole gastronomic epoch. With his death, both the genius and the epoch passed away for ever.

Even after his retirement in 1920, photographs of Escoffier still appeared in newspapers as he tirelessly travelled, wrote, advised, attended dinners and awarded prizes, wherever and whenever he could aid the cause of good food, especially the food and the produce of his native land. By the 1890s, such was the extent of his achievement and the degree of respect he had already won from clients and fellow cooks that he had been honoured with the title of *maître*, and had come to be regarded as the leading authority on *la grande cuisine*. A culinary demigod, he seemed to personify the extended, leisurely menus, the *relevés* and *entrées* and *rôtis* and *entremets*, the foie gras and the truffles, and the myriads of sauces and the good wine which were all so characteristic of the luncheons and dinners of the opulent, international society which flourished at the time of Napoleon III and disappeared on the outbreak of the First World War. The mere mention of Escoffier's name is still enough to evoke images of tables heaped with flowers; of elaborate, ornamentally presented dishes of meat, game and fish; of desserts cleverly concealed inside swans and grottoes carved out of ice; and, hidden away in the background, the tumultuous kitchens with their autocratic chefs and sanded floors and the colossal iron stoves which glowed red hot during the *coup de feu*.

Escoffier's career was one of the most illustrious in food history. After serving a traditional apprenticeship at Nice, on the Côte d'Azur, he cooked in Paris during the Second Empire; became *chef de cuisine* to the French General Staff at the time of the Franco-Prussian War; worked with the great hotelier, César Ritz, at Monte Carlo in the brilliant years of the Belle Epoque; at the Savoy Hotel in London in the 1890s; at the Grand Hotel in Rome and at the Paris Ritz. For eighteen years, as director and kitchen manager at the Carlton Hotel, Escoffier was the Edwardians' favourite chef,

and the personal friend of many of the grandest. He wrote books which became classics of food literature. In his active years he masterminded banquets for the royalty and aristocracy of Europe; he cooked for Russian princes and German grand dukes; for glittering *demi-mondaines*; for the Prince of Wales and Sarah Bernhardt and Adelina Patti; for diamond millionaires; for Gambetta, Lord Derby and Churchill; for Boni de Castellane and Oscar Wilde. He was the inventor of the *Pêche Melba*, the *Filets de Sole Walewska*, the *Poularde Edouard VII* and the *Bombe Néron*. At the Savoy he once prepared frogs' legs so deliciously and disguised them so cleverly that even the prejudiced English enjoyed them without knowing what they were. He organized hotel kitchens in Pittsburgh and New York as well as in Paris and London; and he was consulted several times by the Hamburg-American Line over the planning of kitchens on board their latest transatlantic liners. In 1919 he became the first cook in French history to be awarded the cross of the Legion of Honour; and in 1928 he received the rosette of the higher rank of officer. It meant national recognition on an unprecedented scale.

Despite his celebrity, however, Escoffier's manner was never anything other than quiet and unpretentious. He had nothing of Carême's grandiose theatricality, nor did he share Alexis Soyer's thirst for constant, topical publicity. Instead the small, dignified, grey-haired Frenchman, whose imperious moustache, fine forehead and dark, penetrating eyes were familiar to so many people, habitually felt that the best advertisement he could have was the good opinion of a satisfied client, and nothing more. Hardly ever seen in public without a starched white collar, a neat tie, gold cuff-links, and a dark, formal suit or a black frock coat, he was once justly said to look more like an eminent man of letters or an elder statesman than a chef. In fact, no one could have been a better-trained or more experienced practical cook than he was: whatever problems might arise in either kitchen or restaurant, Escoffier, calm, steady and dependable, was ready to deal with them. He made a perfect foil to the spectacular brilliance of César Ritz. He hated the shouting and swearing and drinking that went on in

large kitchens; and though he was himself, inevitably, a firm disciplinarian (at the Carlton during the London season, he might be in charge of as many as eighty cooks, from all of whom he demanded near-perfection), he tried never to lose his temper too violently with people who annoyed him. Whenever a cook did something wrong, Escoffier would walk out of the kitchen, rubbing his cheek and pinching his ear, only to return a few minutes later, when his rage had subsided, to tick the offender off in a calm and rational way.

Like many another good hotelier, Escoffier was often the recipient of clients' confidences, and sometimes knew almost as much about their private lives as he did about their likes and dislikes in matters of food. He could be relied upon to keep a secret, however, and even in old age retained all the best qualities of a wise, discreet and sympathetic listener. His grandson Pierre can remember him, after his retirement, sitting in the garden of his villa at Monte Carlo with his wife and a little group of children and grandchildren, listening with close, amused attention to everything everyone was telling him, but never saying a word about himself, and never, for a moment, mentioning the past. His memoirs, published after his death, characteristically contain quite a number of charming, old-fashioned concealments of high-born or princely identity. Without any doubt, the man whom Sarah Bernhardt addressed in her letters as '*mon cher, cher ami*'; of whom Lord Northcliffe said that he was 'such a restful man' to be with and to talk to; whom Edouard Herriot, when creating Escoffier an officer of the Legion of Honour in 1928, described as being not only a fine chef but also 'something I appreciate above everything else, *un homme de cœur*', was all his life a comfortingly patient and helpful friend to many people.

Significant as Escoffier's public image was, his work as a cook and as a cookery writer was even more important. Though by temperament and training the *maître* was a man of the *ancien régime*, Le *Guide Culinaire* of 1903 showed he could also be astonishingly modern in his ability to grasp and solve contemporary professional problems. Indeed the book established classic working paradigms

which were to hold good for an entire generation of chefs ('the Escoffier Generation'), and in this respect its influence has been worldwide. Escoffier also did a great deal to modify the general public's low opinion of the cook; and at the same time tried to upgrade the poor social image which the working cook had of himself and of the work he did. Escoffier had suffered keenly as an apprentice, and knew how hard it was to fight one's way up through the established kitchen hierarchy. His concern for the ordinary kitchen worker covered the hard early years when he was inexperienced and vulnerable, and also the later ones when he was often a destitute, alcoholic wreck. When the *Titanic* sank on 15 April 1912, it was typical of Escoffier that he should be the only person to remember the liner's cooks, all of whom died except one. He published their photographs, together with carefully researched obituaries, in his magazine *Le Carnet d'Epicure*.

To understand the origin and development of the two principal sides of Escoffier's career, symbolized respectively by the chef's white hat and the severe frock coat of the hotel Director, it is necessary to glance briefly at the main events of his life. It is a life which falls naturally into four main parts: the early years of childhood, apprenticeship and first experiences as a working cook; the period spent with César Ritz at Monte Carlo, Paris and London; the eighteen years alone at the Carlton after 1902; and finally the long, active retirement from 1920 to 1935.

2

Auguste Escoffier

Escoffier retained a lifelong affection for the Côte d'Azur. He was born near Nice, served his apprenticeship there, and later was chef de cuisine *at two of its hotels. The view of the town across the blue waters of the Baie des Anges was one he always enjoyed.*

When Auguste Escoffier was born at Villeneuve-sur-Loup on 28 October 1846, Louis Philippe was on the throne of France and Balzac was still writing novels. Villeneuve (now known as Villeneuve-Loubet) was in those days a village of some six hundred inhabitants, lying near the foot of the main road which wound down from the perfume-making town of Grasse towards the city of Nice and the blue sea of the Baie des Anges. The stone walls and red roofs of its houses jostled each other as they swarmed up the hill in a jumble of narrow streets, alleys and twisting stairways. At the bottom, near the river Loup, was the market place and the village inn; higher up came the church; and at the very top stood a medieval castle which had been held for centuries by the same family. Its fortified tower and crenellated walls were like a crown on the

15

summit of an ancient, feudal community, and suggested tradition, order and harmony, ideals which were to be respected and treasured by Escoffier all his life.

Half-way up one abrupt, precipitous lane stood, and still stands, the house of the Villeneuve blacksmith who was also the village locksmith, tool-maker, schoolmaster and mayor; and it was here that Escoffier was born. The family occupied only a part of the tall building, but that part included the stone-vaulted cellar full of bottles of the local wine and wood for the kitchen stove. Next to the house was a small yard with stables, a workshop and the blacksmith's forge. Jean-Baptiste, Auguste's father, was a strong and muscular man, the son of a grenadier in Napoleon's Imperial Guard, and, like many of the Escoffiers, long-lived, dying in his eightieth year in 1909. Beneath the curled-up brims of his modish hat, a family photograph shows that he had the sharp, intelligent eyes and fine moustache later to be characteristic of his son; while his gold watch chain, his flowing, loosely tied, black cravat and the jaunty angle of his pipe remind one incongruously of some romantic *fin de siècle* painter or poet. A firm, generous, likeable man, he was respected and popular in the village, and exerted an important, formative influence on the character of his son.

Another influence was the boy's early interest in food. Though the land round Villeneuve was poor, the area had a thriving tradition of regional cooking. The Romans introduced vines and olive trees, but the dearth of good grass meant that there were no cattle for the production of beef, its place being taken by pork, goat and lamb. The inn near the river served good local dishes; for Sunday lunch there was always a mutton *pot-au-feu* (Escoffier gives the recipe for it in his very last book, *Ma Cuisine*); and on Easter Monday every housewife in the village made her traditional omelette. Auguste's maternal grandmother was an outstanding cook, and it was she who initiated him into the delights and secrets of her art. At the age of ten the boy would spend hours in the kitchen, carefully watching her while she prepared her delicious *ragoûts* and *daubes*. He noted what she did, and many years later incorporated her techniques

The model for Manet's portrait was a young actress and demi-mondaine *called Henriette Hauser, but the picture was named Nana after the character in Zola's* L'Assommoir *of 1877. Though Escoffier does not mention Henriette in his* Souvenirs, *she may well have been one of the high class* cocottes *who brought their clients to the Petit Moulin Rouge at the time when he was* chef de cuisine.

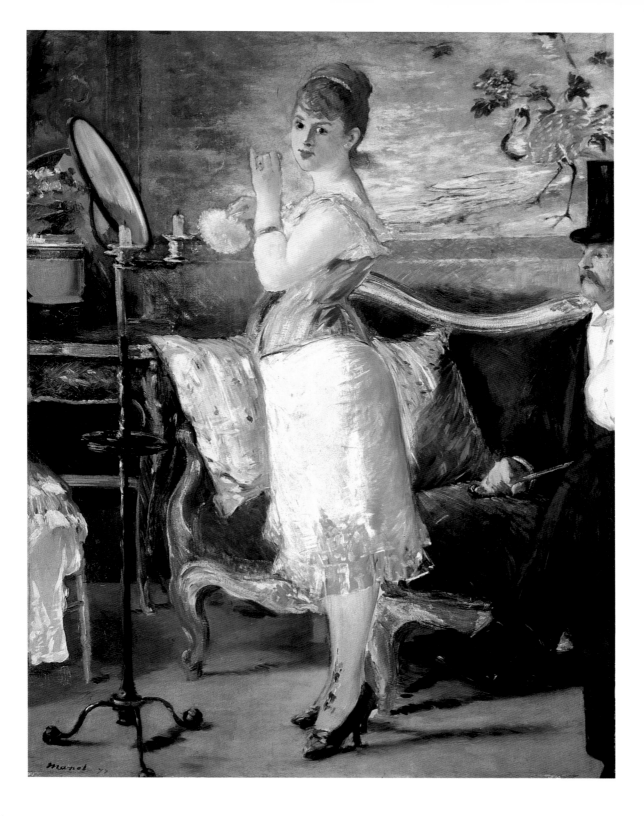

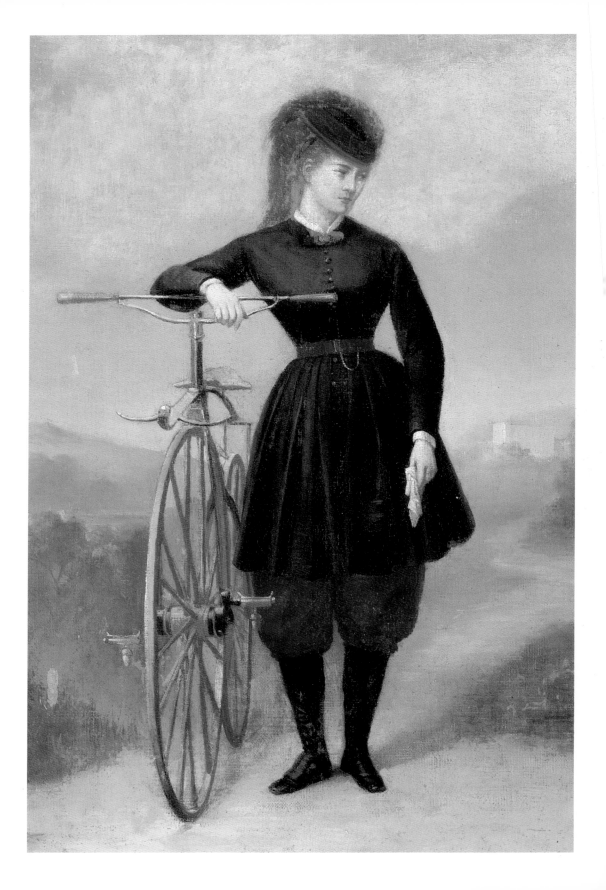

into recipes devised for the Savoy or the Carlton. On his own he experimented with different ways of making coffee; or toasted thick slices of country bread over the embers of a wood fire, spread them with *brousse*, the local goat cheese, and then ate them, accompanied by a glass of sweet white wine, just to see how they would taste. His grandmother, finding him at work, gave him a kiss and murmured prophetically, 'One day you'll make a very good cook.'

But however enjoyable cooking might be as a pastime, it had never once entered Escoffier's mind that he should make a career of it. It was not at all what he had in mind for himself. His heart was set on studying at the Ecole des Beaux-Arts in Paris and on being a sculptor (his first published book was to be about the modelling of wax flowers). In 1859, however, when he was thirteen and the time had come for him to start a job, his father told him that sculpture was out of the question. He must find a proper trade and earn his living. He was physically too small and frail to work at the forge; but luckily one of the blacksmith's brothers, François Escoffier, was the proprietor of a very successful restaurant in Nice, the Restaurant Français on the Quai Masséna, and he agreed to take Auguste into his kitchen as an apprentice. 'They just told me I was going to be a cook', Escoffier wrote later, 'and that was that!' Nobody asked him whether he liked the idea or not. His apprenticeship started in October 1859, and the ensuing six months proved to be the most miserable he would ever know. Even fifty years later he could hardly bring himself to talk of them. Until well into the present century, life in any professional kitchen was hard, rough and brutal; but for apprentices, who occupied the very lowest grade in the cooks' hierarchy, it was often well-nigh unbearable. Another feature in Escoffier's case was that his uncle (a restaurant proprietor in those days was never the chef but rather a formidable figure in side whiskers and a frock coat) was a hard and demanding master who made a particular point of never showing him any favouritism. The boy, who was so small that he had to wear special platform shoes so as not to get burned at the great iron cooker, was bullied and shouted at just like everyone else.

*In 1856 Escoffier
was already a famous
name in Nice's
gastronomic circles.
Auguste's uncle,
François, ran the best
restaurant in the town,
where he provided his
nephew with a hard
but rewarding
apprenticeship.*

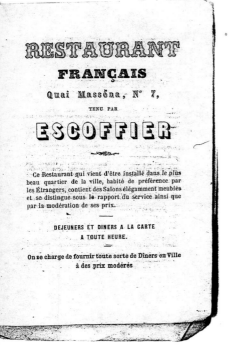

*The Restaurant Français
was fashionably situated
in the Quai Masséna,
now the Avenue de
Verdun.*

Once the six months were over, however, things got better. The unhappy apprentice started to enjoy the work he had so hated at first, and decided to make a determined effort to apply himself and to become a master of his trade. He turned out to be an excellent learner. After acquiring all the basic cooking techniques, he studied and recorded menus, meals and recipes; he kept notes on things like cutlery and tableware (his uncle once bought ten specially designed *entrée* dishes from the executors of an English nobleman who had died at Nice, and Escoffier, many years later, had improved versions of them produced by Christofle for the Paris Ritz); he learned all he could about buying and marketing; and he even began to ponder critically the low social status of the working cook. In his spare time he picked up extra knowledge by going to work for a neighbouring *pâtissier*. Above all, he made contact for the first time with members of the rich, foreign clientele who came to Nice every year in search of a warm winter and luxurious living. They were the sort of people who were to remain Auguste's principal customers all his life.

François Escoffier was an ambitious and enterprising restaurateur. The standard of cooking at the Français was high; indeed the Hôtel de Paris at Monte Carlo once stole its chef because he was the best in Nice; and the proprietor's flair for publicity is evident from his announcements in the local press and from the bold, full-page advertisement he inserted in the *Guide de l'Etranger* for 1857. Extravagant flourishes of decorated type were already making the name of Escoffier famous in the town's rapidly expanding gastronomic circles. In 1856, the year the restaurant opened, Nice was still part of the Kingdom of Savoy (it became French in 1860), but its economy was starting to depend more and more on the annual influx of English, French and Russian visitors – most of them rich, royal and titled tourists who filled the hotels, villas and restaurants from late September until early April.

English baronets and German dukes turned up their noses at a local *tourta* or *pissaladière*. The French insisted on the cuisine of Paris, and the Russians craved that of St Petersburg. François

Escoffier, well situated at 7 Quai Masséna, immediately below the Hôtel de France, whose impressive list of new arrivals appeared regularly in the newspapers, provided international *haute cuisine* with his *à la carte* lunches and dinners served at all hours of the day in 'elegantly furnished salons'. He even set up a special Russian section in his kitchen, headed by a Russian chef, to ensure the complete authenticity of the *shchi* or the *pirozhki* which were sent up to the wild, opera-loving naval officers with their dark blue uniforms and their huge gold epaulettes. The chef was, of course, a mine of information for the young Auguste whose Russian clients were to follow him all through his career, and whose future writings were never to lack Russian recipes.

In April 1863, at the end of the winter season, Escoffier finished his apprenticeship. After working at several local restaurants, he became *chef de cuisine* at the Hôtel Bellevue, where, at the age of eighteen, he was responsible not only for the cooking and the kitchen but also for all the food buying. The hotel (a delapidated section of which still exists) was then on the rural outskirts of Nice, standing amid fields and olive groves not far from the new railway station. Early in 1865 one of the guests, a certain Monsieur Bardoux, the recently retired owner of a Paris restaurant, was so impressed by the hotel's young chef that he agreed to recommend him to the new proprietor of his restaurant, a former notary called Lourdin who had given up the law and was now making a fortune in catering. To get work in a Paris restaurant was the dream of every ambitious young provincial cook. It was a step that could sometimes take years; to have achieved it so quickly was a triumph.

When Escoffier began working there, on Easter Monday 1865, the Petit Moulin Rouge (no relation to the Montmartre cabaret with a similar name) was considered to be one of the best and most select restaurants in Paris. The Goncourt brothers could remember it in its earlier days when Monsieur Bardoux, 'a napkin under his arm, and with the look of a Marseille convict', rushed round serving chicken stew or scribbling out notes to say which tables had been

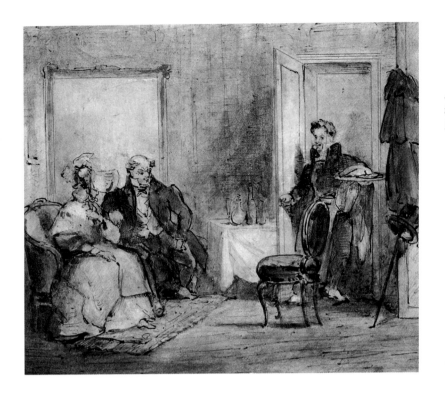

reserved, and when the girls in the *cabinets particuliers* joked and chattered uninhibitedly to each other from room to room. Later, under Lourdin, things changed and the restaurant improved rapidly. It was in a first-rate position, just off the Champs Elysées; it stood in its own garden like a small country house; and in the summer evenings you could eat outside as the sound of music drifted across from the nearby Concert Musard. On the ground floor there were large dining-rooms; and the two upper floors were given over to *cabinets particuliers*, private rooms useful for confidential working lunches among politicians or businessmen, but more often chosen for an intimate, undisturbed dinner with a mistress or a lover, or with some fashionable and expensive *cocotte*. In the garden there was an artists' table, reserved for a group of painters presided over by Arsène Houssaye, who ate there every day; and to one side of it, hidden by foliage, was the Russian table frequented by a colourful crowd of princes, nobles and army officers, familiar to Escoffier from his days at Nice. The Prince of Wales was a frequent customer; and the Duke of Brunswick, famous for his habit of leaving a *louis d'or* as a tip, was another.

Known only to a select few, the Petit Moulin Rouge possessed a secret entrance, situated in a side street and discreetly concealed from view by bushes and trees. Here carriages could deposit unobserved a minister of state, say, with an illicit mistress, or a well-known countess on the arm of a handsome young sculptor or student. The clandestine approach was also much favoured by the *demi-mondaines* who often came to the restaurant with their clients. Escoffier pitied these poor 'pigeons', as they were called, and often winced at the thought of the bill which some innocent young *milord* would eventually have to pay after eating his way through a long and carefully planned menu. 'Pigeon plucking' was an art at which Cora Pearl was particularly adept; and when, at a dinner for her and one of her victims, Escoffier produced *Noisettes d'Agneau Cora*, he wryly followed it with a dish of *Pigeonneaux Cocotte*. Blanche d'Antigny, one of Zola's models for Nana and the inspirer of the *Coupe d'Antigny*, was another rather special customer. In 1873, furious and disappointed, she stayed at the restaur-

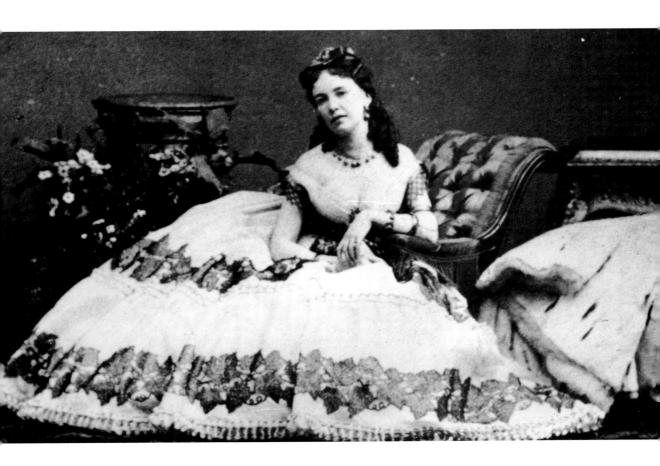

ant for two whole days on end, drinking champagne, because the Shah of Persia had visited Paris and never asked to see her. One January evening, Mademoiselle Rose of the Paris Opera, in the course of being entertained by a very rich banker, demanded a large bowl of out-of-season strawberries. They were duly brought to her, but the bill came to the then colossal sum of fifteen *louis*. Even the banker was seen to gasp.

Escoffier's first post was that of assistant *rôtisseur*. All day he stood in front of the great charcoal fire, watching the turning spits and waiting for the kitchen's mascot, an iron angel with outspread wings, to beat his drum when the clockwork had run down and another batch of chickens or pheasants was ready. Roasting was hot and highly skilled work, needing constant attention, but the new *commis* seems to have been a source of satisfaction even to the drunken bully of a chef, Ulysse Rochaud, since in 1867, after a five-month break for military service, Escoffier was made *chef garde-manger*; and in 1868 he was further promoted to the important position of *chef saucier*. He was now, at the age of twenty-two, virtually second in command of a large kitchen. His work included the planning of meals and the composition and writing of menus.

On 17 July 1870 Napoleon III declared war on Prussia. Almost immediately, despite the prevailing state of nationwide military chaos, hopeless panic and inefficient muddle, a senior staff officer called at the Petit Moulin Rouge and said he was desperately anxious to find a first-rate chef and a good cook for the mess of the General Staff. He was lucky to find Escoffier. On 25 July the latter was duly drafted to the garrison town of Metz, in the north of France, with the position of *chef de cuisine* to the second section of the General Staff. He was accompanied by another cook from the Petit Moulin Rouge, Jérémie Bouniol, as his assistant.

Over the next fortnight a series of quick Prussian victories divided the badly organized French army into two main groups, one under Marshal de Mac-Mahon, concentrated near Châlons-sur-Marne, and the other, under Marshal Bazaine, at Metz. On 14 August

The French army's long march into captivity took about three days. In his privileged position as chef de cuisine *to the General Staff, Escoffier was spared the most humiliating aspect of the defeat which was to have to walk unarmed past the rifles and bayonets of the triumphant Prussians.*

Bazaine decided to try to leave Metz and break through the Prussians to join Mac-Mahon; the very same day Escoffier took off his infantryman's uniform and donned in its place the white jacket of a *chef de cuisine*. As the troops moved forward, he was put in charge of a cumbrous, locked waggon drawn by two horses, containing the officers' mess-chests; a supply of eggs, potatoes, sausages, tinned sardines, brandy and coffee; and a large and very precious sirloin of beef. When they stopped for the night, the two cooks made a fire and roasted the beef on an improvised spit. Its delicious smell attracted a band of marauding fellow-soldiers who attacked the men in white, and tried to capture the meat. It was only when Escoffier counter-attacked vigorously with a drawn sabre that his officers' early breakfast was saved. Next day he and Bouniol managed to catch a rabbit which was successfully sautéed in pork fat with finely chopped onions, cognac and white wine.

On 16 August the battle of Gravelotte was fought. It was the bloodiest encounter of the whole war, and left some six thousand

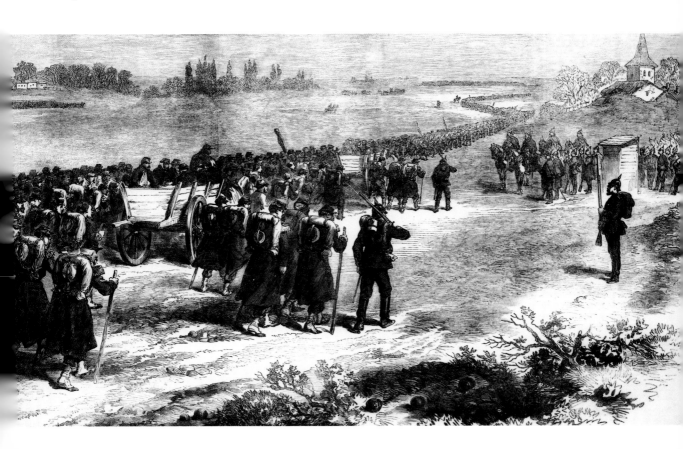

dead and nearly as many wounded. Throughout the conflict, a mile or two behind the lines, Escoffier was busy preparing a good meal in difficult circumstances. Tired, shocked or wounded officers rode out of the battle, ate, and then hurried back. Escoffier was ready for them with *hors d'œuvres*, fried eggs, potatoes, mutton chops and an excellent *blanquette de veau*.

After the battle, Bazaine's way forward was barred, and he made the fatal decision to take his army back into Metz, which was at once encircled by the Prussians. A siege followed which was a minor version of the great siege of Paris. By 28 August food was scarce: there was no butter; and the butchers were starting to sell horsemeat. On 8 September orders were given to slaughter even cavalry horses for food; a few days later the bread ration was cut, and there was no more salt. By the middle of October both the military and the civil populations were desperate with hunger. The Prussians' grip on the city was unbreakable; and when prisoners brought news of the defeat at Sedan, and that Mac-Mahon had been wounded and the Emperor captured, morale collapsed altogether. On 24 October, Bazaine, now commander-in-chief, surrendered unconditionally to the enemy, handing over not only the city of Metz but also all its arms, guns, ammunition and even the regimental colours. The troops were made prisoners of war.

Sieges are trying even for the best of cooks, but at Metz Escoffier's response was nothing less than masterly. Indeed the officers on Bazaine's staff found themselves blessed with a culinary Jeeves. At the start of the siege Escoffier, together with his fellow cooks and the batmen, were billeted in a large shed belonging to the local Latin teacher; and from here, realizing at once that there would be a shortage of food, the experienced *chef de cuisine* began hunting for a walled enclosure where he could build up a secret farm-yard. Having found a suitable place, he stocked it with chickens, geese, ducks, turkeys, rabbits, two young pigs, a sheep and a goat. He also assembled a supply of jam, dried vegetables, salt, tinned fish and Liebig meat extract, in addition to which he had the key to the officers' own personal reserves of wine and *eau de vie*. It is not

Escoffier and Bouniol stuck by each other all through the war. Their culinary inventiveness in difficult circumstances was astonishing.

surprising that the mess of the General Staff began to enjoy quite a reputation for *haute cusine* in the midst of an otherwise starving city; and even when, later on, the occasional *pot-au-feu de cheval* or *cheval aux lentilles* became inevitable, Escoffier was ready with new ways of making the unpleasant meat as interesting as possible, blanching it first to get rid of its bitterness. On 20 October he killed his last pig, which filled his larder with a welcome stock of sausages, terrines and ham; but the roast pork and grilled chops were to be his final pieces of decent meat. Only the goat remained whose watered-down milk was the basis for a butterless *sauce béchamel* and sorrel soup. By the time the ten-week siege was over, and all the ham and sausages had been consumed, even Escoffier was in a state of despair as to how he could go on feeding his officers.

On a cold, rainy day at the very end of October, Escoffier and Bouniol walked past the deserted camps and the piteous, abandoned horses dying of hunger in the streets of Metz, and boarded a train for Mainz where they were to be detained as prisoners of war. As cooks to the General Staff, they still enjoyed a relative amount of freedom, and on arrival at Mainz, wandered disconsolately about the streets of the old town, not knowing where to go, and even trying bravely to get jobs at a smart *pâtisserie* whose window display they had stopped to admire. Lacking any proper work permit, they were soon arrested by the town guard, and then followed a month of misery, first in the old citadel and afterwards in a prisoner-of-war camp. The terrible cold, the hard living conditions and the appalling food were things which Escoffier never forgot. Early in December, however, he was lucky enough to get permission to work in the kitchens of the elegant, colonnaded Kursaal restaurant at Wiesbaden, the fashionable spa just outside Mainz. Here Escoffier was firmly back in the world he knew; the chef and most of his brigade were French, and the two managers were from Alsace.

Ten days later, yet another stroke of luck befell him. The Prussians had transferred their star prisoner, Marshal de Mac-Mahon, to a villa in Wiesbaden; they had also transferred his staff officers to

another villa in the same street. Inevitably the latter needed a *chef de cuisine* and Escoffier was selected for the job. More than ever in his element, working comfortably and happily, he could now say with pride that he had been chef to both sections of the French General Staff, Bazaine's and Mac-Mahon's. It was typical of Escoffier's generous nature that he wished to share his good fortune with others; he not only sent for Bouniol as his assistant, but on Christmas Eve he visited his friends who were still suffering in the prison camp at Mainz, and brought them a specially prepared supper.

In March 1871, after the signing of peace preliminaries, Mac-Mahon and his staff returned to Paris, and Escoffier obtained permission to do the same. He had no sympathy whatsoever with the violent, revolutionary theories of the Commune, and managed to escape from Paris on the last free train to leave the Gare du Nord. He reached Versailles, which was now Mac-Mahon's headquarters, and entered his kitchen as assistant to the chef, Jules Servi.

On 14 August Escoffier left Mac-Mahon's service and became *chef de cuisine* to the commanding officer of the 17th infantry regiment, the Comte de Waldner. He stayed with the family for over a year, and it was a happy, important time in Escoffier's life, since it was at their country house, at Ville d'Avray near Paris, that the Waldners encouraged his interest in making wax models of flowers (then a very popular form of culinary decoration) and in writing a small book about the subject which was, as *Les Fleurs en Cire,* to be his first published work. In the autumn of 1872, Escoffier left the Waldners to go south for the first time since the war, and to spend the winter season as *chef de cuisine* at the Hôtel Luxembourg in Nice. Again Bouniol was with him as assistant chef. In April 1873 Escoffier returned to Paris, and once more joined the kitchen of the Petit Moulin Rouge, though this time, aged twenty-seven, he occupied the top post of chef.

Over the next five years, Escoffier's professional fame and standing grew considerably. Not only was he *chef de cuisine* at one of the best

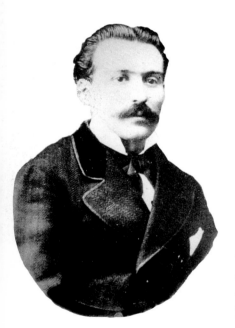

Escoffier in his late twenties, a few years before his marriage. After 1879 the young couple lived mostly in Paris and Monte Carlo where their three children, two sons and a daughter, were born.

restaurants in the capital, he was also attracting a greater number of distinguished and discerning clients than ever before. He was fully responsible for suggesting and creating dishes and making up menus for the meals served in private rooms. It was in one of them, a *salon* for six people decorated entirely with roses, that Prince Galitzin gave a dinner for Blanche d'Antigny; in another, Gambetta entertained the Prince of Wales; and it was through organizing a private supper early in 1874 that Escoffier first made contact with one of his most loyal and appreciative clients, the actress whose name was to become world-famous, and with whom, over the years, he was to build up an extraordinary friendship: Sarah Bernhardt.

The Petit Moulin Rouge was a summer restaurant. In the autumn, when it closed, Escoffier returned to the Riviera; and in 1876 he bought a food shop in the rue d'Antibes at Cannes which he turned into a restaurant, the Faisan Doré, for the winter clientèle he had known so well at Nice. In August 1878 he left the Petit Moulin Rouge to get married. He was now thirty-two; a photograph taken at the time shows that his hair and moustache were dark; his eyes wore an expression of intent, wistful concentration; but there was a strong hint of authority about his mouth and chin. His wife, Delphine Daffis, was the daughter of a Paris publisher; she was also a poetess who could never quite forget that subtle social differences separated the saucepan from the pen; and family tradition has it that Escoffier beat her father at a game of billiards and then asked for her hand as a prize. Almost immediately after the wedding, the couple left for Cannes to get the Faisan Doré ready and open for the start of the winter season.

Two months later, however, a triple tragedy struck the Daffis family. First, Delphine's father died suddenly; shortly after, his two other daughters, one of them only three years old, both died of diphtheria. The Escoffiers let the Cannes restaurant and returned to Paris, where Auguste managed to get a well-paid job as a director of Chevet's, the famous catering firm whose premises in the Palais Royal had been a landmark for gourmets ever since the First

Auguste Escoffier and Delphine Daffis were married in 1878.

She wrote verses which were printed in Le Carnet d'Epicure and tried to make money by letting out rooms in the family villa, though she is said to have been too easily taken in by charming but impecunious lodgers with impressive names for it to have been much of a success.

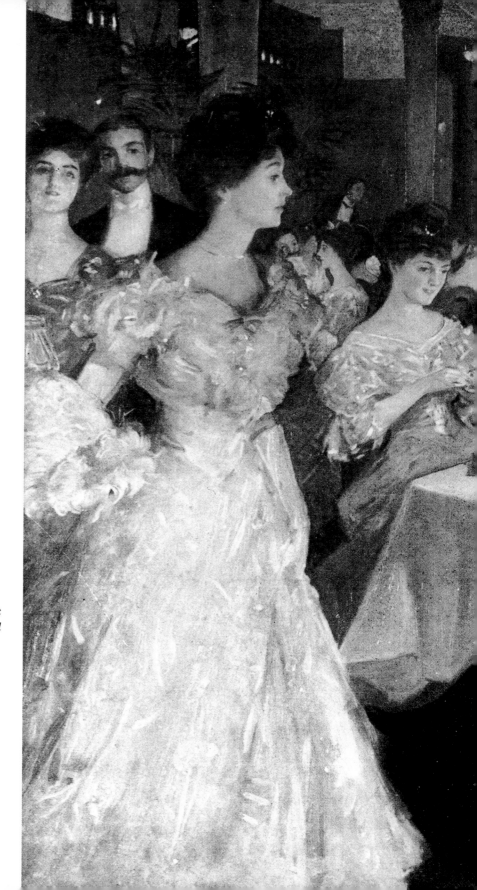

*Dining at
the Berkeley Hotel*

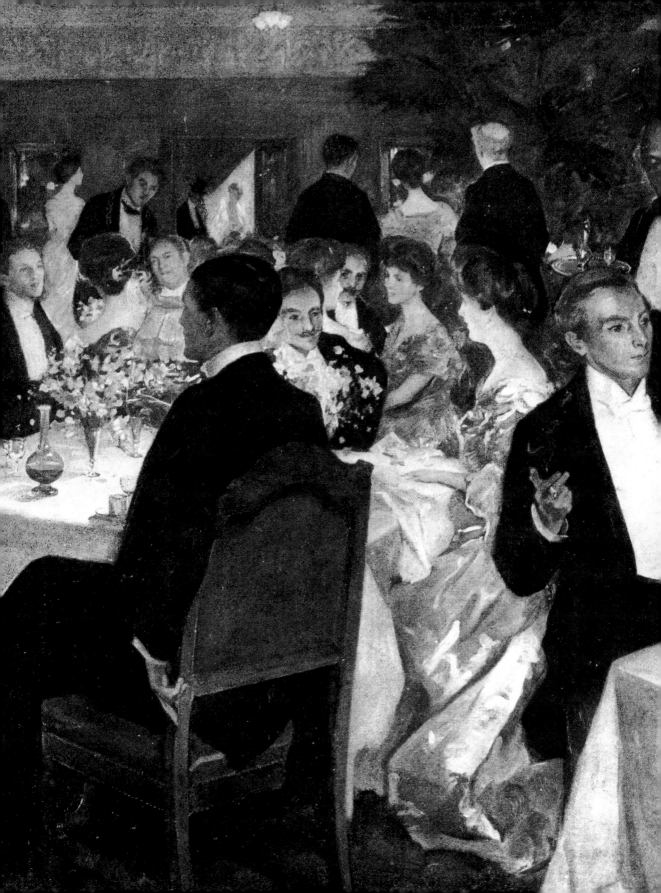

Empire. Chevet's catered for embassies, princely houses and government ministries; they even despatched dinners and banquets abroad, to clients in Germany or England, complete with all the right cutlery, tableware and waiters. Balzac's César Birotteau ordered a famous dinner for twenty guests which Chevet's duly delivered, accompanied by candelabra, magnificent silver, superb wines, and a magisterial *maître d'hôtel*. Escoffier was responsible for sending several banquets to England, always with some anxiety as to whether a rough crossing or a delay at Calais would be the cause of irreparable damage to the food. In 1883 he was in charge of the important lunch, dinner and garden fête given for two hundred people by the political writer, Juliette Lambert, aged forty-seven and dressed up as a shepherdess, at her country estate near Paris.

César Ritz

In the summer of 1884 Escoffier left Chevet's to set up a new restaurant attached to the casino at Boulogne-sur-Mer. The establishment opened in June amid great celebrations which lasted for three days and included a Folies Bergères cabaret at the theatre, gambling of all kinds at the *salles de jeu*, and a banquet in the restaurant. Escoffier sat at the food writers' table, and noticed with some approval that they were far more intent on what they ate and drank than on the tedious official speeches. The desserts were dominated by one of his own *pièces montées*, a great sailing ship made out of *pastillage*, tossing about on an ocean of enormous waves carved out of ice, and surrounded at the base by a profusion of wax-modelled flowers.

If Escoffier was now professionally somewhat unsettled (in addition to his work at Boulogne, he was also for a time *chef de cuisine* at the Restaurant Maire in Paris), and was looking round for the really ideal position, he was unknowingly just on the point of finding it. 1884 was to be the year in which he first met César Ritz; an encounter between two extraordinary men which was to be rich in consequences for both of them.

Ritz's country background was not altogether unlike that of

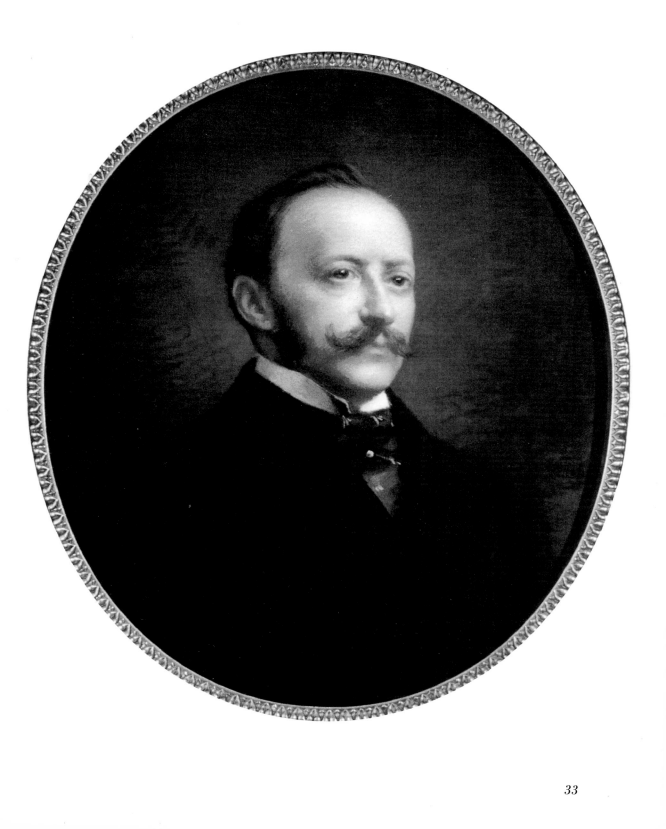

Escoffier. The son of a Swiss peasant farmer who was also mayor of his village, he was born in 1850 at Niederwald in the Valais. Apprenticed somewhat unwillingly as waiter in a local inn, he eventually made his way to Paris where he got a job at the Restaurant Voisin, serving *ragoût* of elephant trunk, *sauce chasseur*, during the siege of 1870 at about the same time that Escoffier was preparing his *pot-au-feu de cheval* during the siege of Metz. In 1873, at the age of twenty-three, Ritz's astonishing career as the meteoric genius of the great nineteenth-century hotels began when he became restaurant manager of the Grand Hôtel at Nice. In 1874 he went from the Rigi-Kulm Hotel in Switzerland to the Grand Hotel at Locarno. In 1875 he was manager of the Hotel Victoria at San Remo, and two years later, aged twenty-seven, of the prestigious Grand Hôtel National at Lucerne. He subsequently ran hotels at Menton (where he married the proprietor's niece) and at Trouville on the Normandy coast. In the 1880s he was proprietor-manager of the Hôtel de Provence at Cannes and of the Hotel Minerva at Baden-Baden in Germany. He was also connected with the Frankfurterhof at Frankfurt-am-Main and the Grand Hôtel des Thermes at Salsomaggiore.

Always elegant in appearance, with short side whiskers, a neatly trimmed moustache, stiff collar, red tie, a white carnation in his buttonhole and an impeccably cut morning coat, Ritz was a living power house of demonic, Paganini-like energy. Problems and difficulties which would have confounded anyone else never daunted him. He soared over them with the ease and speed of a thoroughbred, and was irritated by anyone who failed to think as fast as he did. Overnight he could transform a dingy cellar into a resplendent banqueting hall; in a moment he could devise ingenious ways of decorating and heating a vast, ice-cold dining-room in the Swiss mountains so as to make it attractive and cosy for unexpected, off-season tourists. He alone could cajole an earl's anorectic daughter into eating a delicious lunch; or knew how to deal with one of the Duke of Orléans' cast-off mistresses when she started to break up the Savoy furniture; or found the right words with which to tell the Prince of Wales that his favourite suite at the Paris Ritz was

Both at Monte Carlo and at the Savoy, Escoffier organized dinners to celebrate spectacular wins at the casino, but was never tempted to become a gambler himself.

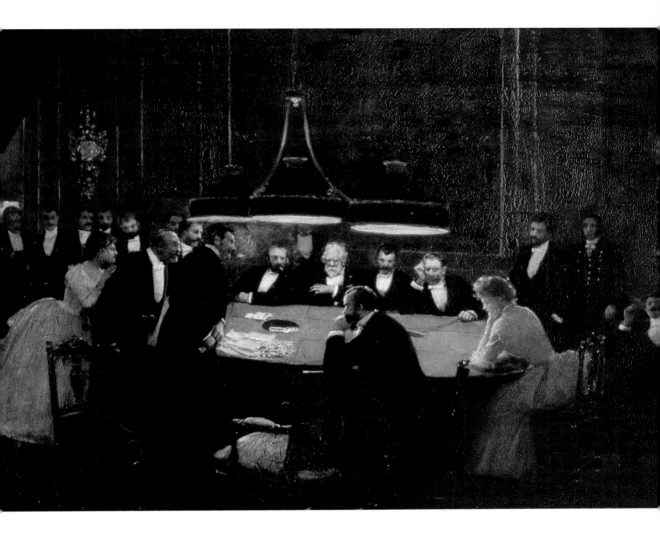

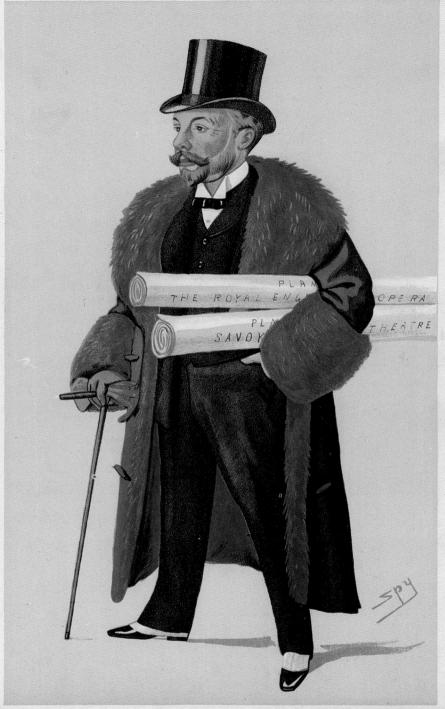

"Royal English Opera."

unavailable because it was already occupied by a republican-minded American millionairess who refused to give it up. No one was better than Ritz at making clients feel welcome and comfortable. A hotel should always be excellent, he maintained, but it was the first and last impressions of a stay which were the most vital. If both were good, then the client would almost certainly come back.

Ritz knew his railway timetables by heart, and could plan a continental journey by local trains which would bring him to his destination more quickly than if he had taken an express. At the London Savoy he kept a series of suitcases, each one permanently packed and labelled for a different address or a different country, so that he could rush away anywhere at a moment's notice without having to worry about preparations. Fashionable lakes and spas, the Swiss Alps, the Mediterranean coast, luxury travel, and the alternating modes of winter, spring and summer seasons formed the natural background to Ritz's existence. He understood instinctively the needs of a new, rich, international cientèle; and he was prepared to offer it nothing less than perfection. He was the first hotelier to grasp the importance of things like electric light, private bathrooms, telephones, fine linen, good furniture and cupboard space. Above all he was a pioneer in realizing that one of the most essential adjuncts to any first-class hotel was a first-class restaurant.

Spy's cartoon shows a confident and successful Richard D'Oyly Carte in his early years as a developer. Had it not been for his desperate appeal to Ritz when the Savoy Hotel was failing, Escoffier might never have come to London.

In January 1882 Ritz was appointed manager of the newly opened Grand Hôtel at Monte Carlo. His *chef de cuisine*, Jean Giroix, whom he had discovered at Trouville, was excellent, and for the first two winter seasons everything had run smoothly in both kitchen and restaurant. In 1884, however, Giroix was enticed away from the Grand by the offer of a much higher salary from the manager of the Grand's main rival, the Hôtel de Paris, whose turnover had been falling on account of their disappointing cuisine. For Ritz it was a disastrous blow, but before leaving Giroix told him that he had once worked at the Petit Moulin Rouge in Paris where the young chef had been exceptional. He suggested him as a possible replacement.

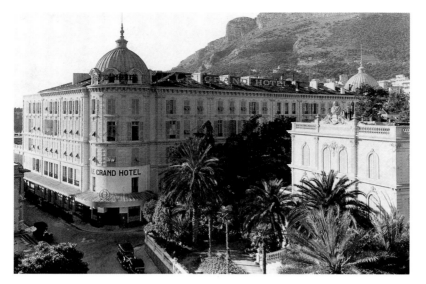

The Grand Hôtel at
Monte Carlo opened in
1882 In those days it
enjoyed fine views over the
harbour and the palace,
and was only a short walk
away from the casino.
Xavier Jungbluth was its
first proprietor and César
Ritz its first general
manager. It was here in
1884 that Escoffier joined
him as chef de cuisine.

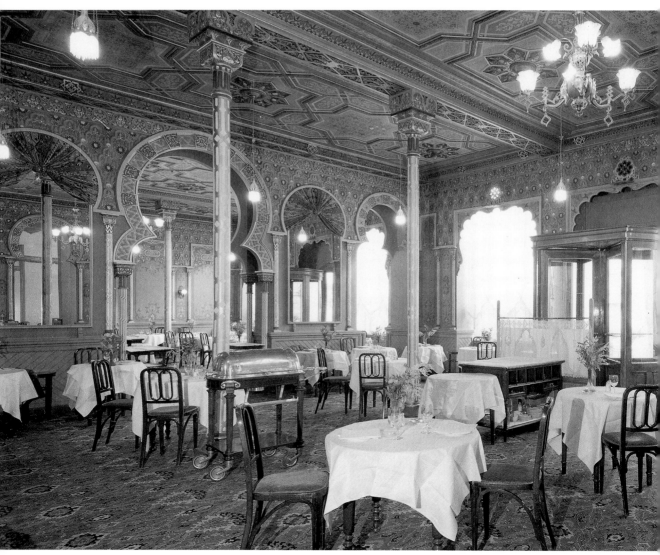

The restaurant at the Grand Hôtel was in the latest 'moorish' style made fashionable by the French military expedition to Tunis in 1881. Clients discussed the menu with César Ritz and their coffee was prepared by a turbaned African.

Ritz acted on the advice, and in October 1884 Escoffier took over the management of the Grand Hôtel kitchens. The two men liked each other immediately. They worked well together, and the partnership between them was to last until Ritz's breakdown and retirement in 1902, a period of eighteen years. They differed greatly in temperament and character, but formed a perfect complement. They both, the dapper, dynamic Ritz as much as the small, steady, disciplined Escoffier, shared the same passion for their trade, the same inventiveness, and the same quest for perfection in everything they did for their clients.

Monaco in the 1880s had all the features of a rapidly expanding boom town based on the gambling habits and the holiday pleasures of the cosmopolitan rich. The ancient, rocky peninsula still jutted out to sea, with the narrow streets of the old town at one end and the palace of the reigning prince, Charles III, at the other; but opposite it, on the other side of the harbour, where the sleek hulls of smart steam yachts lay neatly at anchor, rose the newly named hill of Monte Carlo and the domed silhouette of Charles Garnier's recent casino and opera house. Here and there one could make out the balconies and gardens of the latest villas; but the newest building of all was the Grand Hôtel which had opened in January 1882. Put up by a Nice property company in the surprisingly short space of nine months (bits of it were always falling off, Ritz never stopped complaining about the cost of repairs, and its internal walls collapsed during the earthquake of 1887), it was private enterprise's challenge to the state-owned Hôtel de Paris. Today the large, mutilated, rather shabby building houses the main Monaco post office; but when it was new, it gloried in its two hundred and fifty rooms and *salons*, its fine staircase, its hydraulic lifts and electric light (a steam engine in the basement drove the dynamo), its central, open-air garden, and its exclusive shopping arcade which was embellished by marble columns copied from the Palais Royal in Paris. At one end of the garden a low building, joining up the two side wings, contained the restaurant, a suite of *cabinets particuliers*, the Café Anglais, an electrically lit smoking room, and the kitchens.

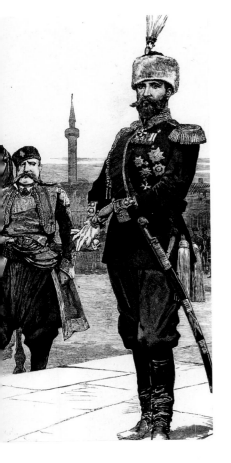

In 1887 he spent the first winter of his exile on the Côte d'Azur, forgetting his troubles at Monte Carlo and enjoying dinners by Escoffier at the Grand Hôtel.

The restaurant was designed and decorated in the 'Moorish' style. Rich carpets and fantastic horseshoe arches had been made fashionable by the French military expedition to Tunis in 1881, the year the hotel was built, and which had been accompanied (a source of considerable local interest and pride) by the heir to the throne of Monaco, Prince Albert. The client arriving at the *Salle Mauresque* was greeted by a black doorman in a splendid livery; César Ritz came in person to discuss the menu; and after a delicious dinner prepared by Escoffier and his cooks, excellent Turkish coffee was specially made at the table by a turbaned African in exotic robes of blue and gold. The hotel's cuisine was soon reputed to be the best in Monte Carlo, and it is a measure of Escoffier's success that in February 1885, half-way through his first winter season, the Prince of Wales came to stay at the Grand. He had certainly not forgotten the good meals he had eaten at the Petit Moulin Rouge.

Over the next few winters the restaurant was to attract a number of important Russian and German aristocrats. Prince Kochubey, whom its arabesques may have reminded of the divan-strewn Oriental Room at his family's country house at Dikanka, stayed at the hotel in 1885, accompanied by his mistress Katinka, a pretty Hungarian dancer who was also a keen amateur cook. Adelina Patti ate in the restaurant when she was singing at Nice in 1886. In 1887 the Grand Duke of Mecklenburg-Strelitz, accompanied by members of his suite, came over once a week from Cannes to have lunch at his favourite table. That same winter, Alexander of Battenberg, the ex-Prince of Bulgaria, was another frequent guest. English clients included Joseph Chamberlain and Lord Derby.

The splendours and miseries of the roulette table also played their part in the life of the Grand Hôtel. From time to time, the crack of a revolver might be heard from a room on the third floor as some desperate loser put an end to his days, an incident which Ritz would immediately attend to in his usual adroit, urbane way, glossing it all over as though the client has just gone down with a mild attack of 'flu. Even his wife was amazed by him on these

Suicides which took place in the Grand Hôtel were swiftly and efficiently dealt with by César Ritz. Ruined gamblers who could not wait to get back to the hotel sometimes shot themselves at dawn in the casino gardens.

occasions. Handled by the perfect hotelier, the whole tragedy seemed to disappear before it had even happened. To Escoffier fell the more cheerful task of devising dinners and banquets for the triumphant winners who celebrated their successes with the best champagne, the most expensive wines, and extravagant menus eaten at tables heaped with flowers. Further festivities were accorded to the victors in the Monte Carlo pigeon-shooting events, when hundreds of unfortunate pigeons were released from cages on a terrace near the casino so that competing marksmen could, without too much difficulty, blow them to bits as they fluttered out into the blue Mediterranean sky. The English purported to despise such an unsportsmanlike activity, but they often turned out to be better at it than anybody else. The Grand Hôtel organized its own competition. In 1886 there were forty-seven competitors, and the winner was Mr Seymour who received an *objet d'art*, 820 francs and an Escoffier dinner as his prize. Next year the winner was Mr Davenport-Handley who, in addition to his dinner, was awarded 525 francs and a canteen of silver.

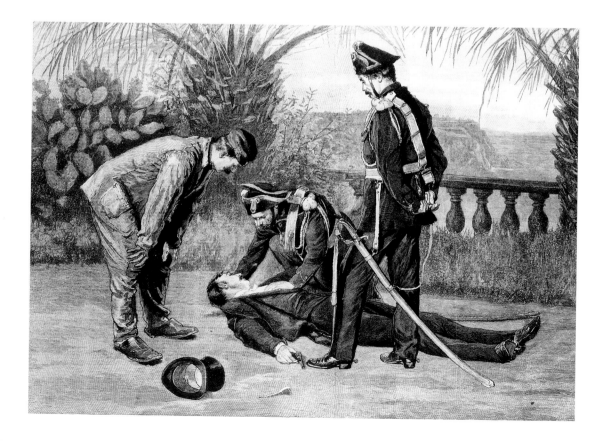

At the end of every April, when the winter season was over, the Grand Hôtel closed its doors, and the great migration of clients and staff towards cooler stations took place. Ritz and Escoffier moved as manager and *chef de cuisine* to the luxurious Grand Hôtel National at Lucerne on the shores of the romantically beautiful Vierwaldstättersee. Ritz, who for several years now had run the establishment for its proprietor, Colonel Pfyffer d'Altishofen, formerly an officer of the Bourbon court at Naples before its overthrow in 1860, had turned it into one of the best-known and most comfortable hotels in Europe. The same style and perfection of service pertained at Lucerne as at Monte Carlo, and often even the clients were the same. In the autumn of 1887, however, the continuity was broken. Both Colonel Pfyffer at Lucerne and Xavier Jungbluth, proprietor of the Grand at Monte Carlo (and an uncle of Ritz's wife Marie) decided to retire from the hotel business; Escoffier continued as before, but Ritz, who did not want to work under new proprietors, resigned and devoted himself to his own hotel at Cannes and to managing the Hotel Minerva and the Konversationshaus restaurant at Baden-Baden. It was at Cannes in the winter of 1889, at the Hôtel de Provence, that Ritz was approached by Richard D'Oyly Carte to take over the management of the Savoy Hotel in London.

Already known internationally as impresario, theatrical manager, composer and, since 1875, producer of the highly successful Gilbert and Sullivan operas, D'Oyly Carte had further ambitions in the field of property development. In 1881 (the year of the construction of the Grand Hôtel at Monte Carlo) he had built the Savoy Theatre, the first public building in England to be lit by electric light – a feature that was to endear him to Ritz. In 1884 its success led him to plan a large luxury hotel adjacent to the theatre which would rival even the very best American hotels (which had so impressed him) in comfort and efficiency. He pushed ahead with the project, and in 1889 the Savoy Hotel was completed. Designed by Thomas Collcutt, it was equipped with seventy bathrooms, a large number for that period, and sufficient to prompt a builder to ask D'Oyly Carte if he was expecting amphibious clients. (The

The Savoy Hotel of 1889 was one of the first of London's terracotta Renaissance palaces. Coffered ceilings and elaborate chimney-pieces were offset by Turkey carpets and comfortable armchairs. By using the latest designs in wallpapers and ceramic tiles, D'Oyly Carte aimed at capturing the mood of contemporary aestheticism.
In 1893 the greatest aesthete of all, Oscar Wilde, took rooms at the hotel and was frequently seen dining there with Lord Alfred Douglas.

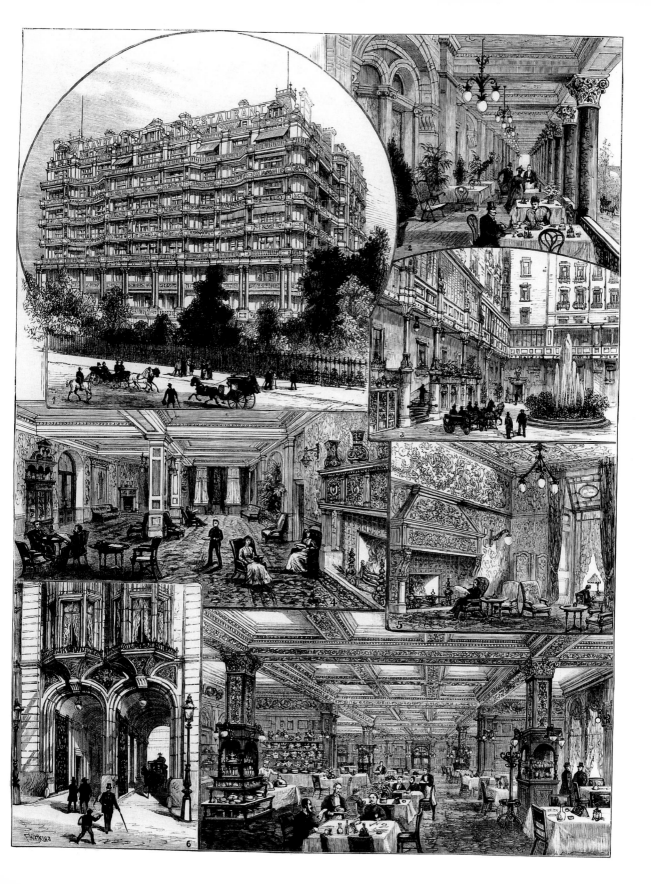

Victoria Hotel, in Northumberland Avenue, opened in 1887 with only four bathrooms for five hundred guests!) There were six hydraulic lifts, electric lighting everywhere, William Morris wallpapers and De Morgan tiles. Surrounded by palm tress and satsuma pottery, diners waited for their guests in comfortable, terracotta-coloured armchairs before making their way into the panelled Renaissance restaurant with its coffered ceiling picked out in scarlet and gold, and a view over the Thames which was to become legendary. The hotel was built on sloping ground between the Strand and the Embankment; its main entrance opened originally onto a forecourt which contained a Della Robbia-style fountain, and was approached via a steep incline. This could sometimes be perilous. The food writer Colonel Newnham-Davis, going to arrange details of a dinner, told his cabman not to drive down the hill, but the man insisted, with the result that horse, hansom, driver and passenger all got out of control and slithered down the last ten yards like some large, unwieldy toboggan, stopping just in time at the Savoy with an abrupt, undignified jerk. The more convenient carriage entrance from the Strand was not built until 1904.

D'Oyly Carte brought together a reasonably efficient staff and what he considered to be an excellent team of managers. The hotel opened in June 1889 amid a blaze of ostentatious publicity. Everything seemed to promise well, but to the practised eye of Ritz, who was a guest at the celebrations but not yet in D'Oyly Carte's employ, it was clear that grave errors had been committed. London had the right sort of clientèle, that was certain, but D'Oyly Carte's senior management had previously worked only in large private houses; they had no commercial experience, and were incapable of running a large hotel successfully for financial profit. And though the kitchens were light and airy, the food served in the restaurant was uninteresting. The clients would surely drift away, and before long the venture would be running at a loss. Within a few months, all these forebodings were borne out: the public began to lose interest, the turnover fell, the shares slumped, and D'Oyly Carte set off anxiously for Cannes to beg Ritz, the only man in the

world he thought capable of doing it, to save his hotel from catastrophe.

After some consideration Ritz agreed to come to London on condition that he could bring with him his own specially picked brigade of managers, which of course included Escoffier. D'Oyly Carte consented to this and proceeded to sack his original managerial staff, a step which not only left a longstanding legacy of bitterness at the Savoy, but also involved its directors in a costly legal action for wrongful dismissal. Contracts were signed in January 1890, and at the end of the winter season, on the first Sunday in April, Ritz and Escoffier took up their new posts in London. In the kitchens, the departing chef and his cooks had done all they could to make life impossible for their successors. Such was their resentment that they had virtually sabotaged all the cooking equipment and destroyed everything in the storerooms; there was not even a packet of salt left undamaged. On a Victorian Sunday no food shop was open; it was impossible to procure fresh supplies at short notice; and the situation could have been disastrous, had not the chef of the nearby Charing Cross Hotel been a good friend of Escoffier and sent him all he needed to start work. Even the directors, it seems, were slightly suspicious of their new *chef de cuisine*; they made Escoffier cook them a trial meal just to see if he really was good enough for the Savoy.

The switch from the warm sun of the Riviera and the mountains of Lucerne to the hansom cabs and pea-soupers of the London of Sherlock Holmes was dramatic, and at first Escoffier had no intention of staying for very long. Unlike his wife, however, who hated living abroad and preferred to remain at home at Monte Carlo with their three children, he soon got accustomed to his new surroundings and decided to stay. He visited his family frequently during his years in England but did not go back to live continuously at the Villa Fernand until he retired in 1920. It must be remembered, too, that in London at that time the workforce of the main hotels and restaurants was almost entirely French or French-speaking; he would never have felt too cut off from his cultural roots.

Right from the start, the improvements which Ritz and Escoffier effected at the Savoy were a success. Neither their invention nor their energy ever seemed to flag. They built up a large clientèle which was more colourful and more flamboyant than that of any other London hotel. The Prince of Wales and Lily Langtry came from Marlborough House; exiled foreign royalty was represented by the Duke of Orléans, a handsome playboy prince who became Orleanist claimant to the throne of France on the death of his father, the Comte de Paris, in 1894; international finance by gold and diamond millionaires from Kimberley and the Transvaal; wit

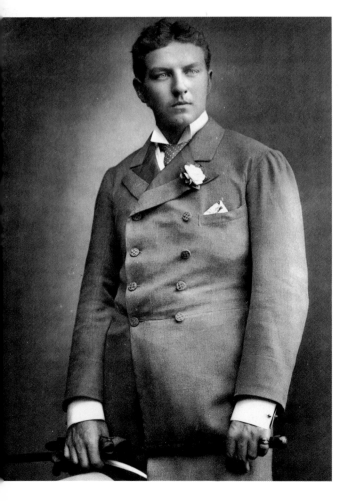

Lily Langtry was the reigning 'professional beauty' at Marlborough House when Ritz and Escoffier were at the Savoy. The 'Jersey Lily' employed her own French chef at home, but with the Prince of Wales she enjoyed many meals cooked by Escoffier.

Philippe, Duke of Orléans, became the Orleanist pretender to the French throne after the death of his father, the Comte de Paris, in 1894. A handsome playboy prince of considerable charm, he dabbled variously in cloak-and-dagger politics, military adventure, tiger shooting and Arctic exploration, His love of good living led him to keep a permanent suite at the Savoy.

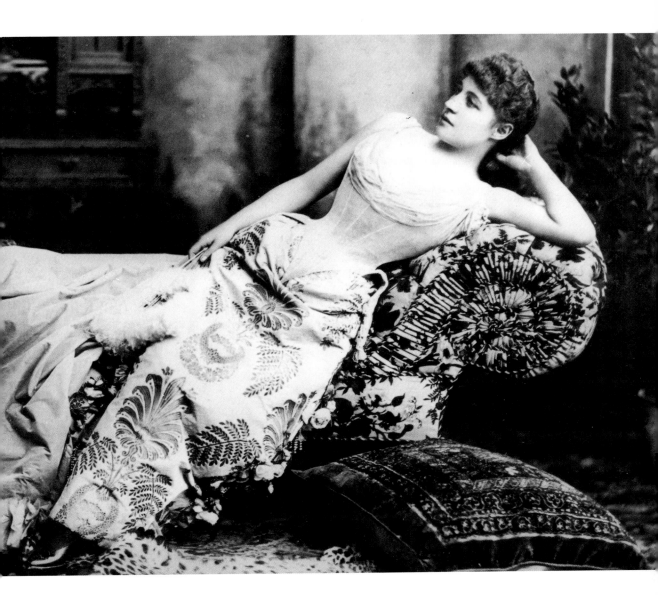

and politics by Wilde and Labouchère; and the theatrical and oper-
atic world by Henry Irving, Ellen Terry, Sarah Bernhardt, Nellie
Melba and many others. The shaded electric lights of the restaur-
ant cast a soft and flattering glow. Late suppers after the theatre
were officially allowed for the first time; Sunday dinners at the
Savoy became the rage; its Christmas menu offered thirty different

47

dishes; and at midnight on New Year's Eve 'Auld Lang Syne' was sung around the tables by men with monocles and women wearing long gloves and diamond tiaras, while the sight of the same smart women smoking cigarettes in the public rooms was a source of shocked excitement. A Viennese bakery was added to the kitchen to provide the best bread that Londoners had ever eaten; and an orchestra, conducted by Johann Strauss, played in the restaurant during dinner. The idea of background music was revolutionary, and it was quickly copied by almost every other eating-place in the capital.

Ritz's and Escoffier's contracts with the Savoy directors stipulated that the two senior managers could be loaned out (like Hollywood film stars) to work on any other hotel project in which D'Oyly Carte or the Savoy had an interest. One instance of this, after their acquisition by the larger company, was the refurbishing of Claridge's and the Berkeley Hotel, but by far the most splendid was that of the Grand Hotel in Rome. The Savoy had bought the building uncompleted and it was Ritz's task to convert it into one of Europe's top luxury hotels. This he did at his usual lightning speed. Work started in October 1892 and the hotel opened early the following year. There were two hundred rooms, each, for the first time in hotel history, with a private bathroom; there were electric lights everywhere; and there was a *jardin d'hiver* resplendent with exotic plants. Marie Ritz was in charge of curtains, carpets and furniture (most of which she chose from the pages of a Maples catalogue); and Escoffier was responsible for the kitchens and for selecting a first-rate brigade of cooks; a delicate matter, as it turned out, since the Roman backers insisted he should mix a quota of unknown Italians with his familiar, trusted Frenchmen.

Another important clause in the Ritz and Escoffier contracts allowed them to freelance on independent projects or businesses of their own during six months of the year. This was probably just a reflection of the traditionally seasonal structure of the catering trade at that time, but it was eventually to lead to trouble. At first Ritz concentrated on the establishments he already owned at

The table is laid for a Savoy banquet. The system of sevice à la russe *left enough room down the middle for elaborate Edwardian floral decoration and even, it seems, for heavily festooned palm trees to be fitted in as well!*

Cannes and Baden-Baden, but in 1896 he embarked on something far bigger and far more ambitious, nothing less than the creation of a hotel in the Place Vendôme. Having found a small group of backers, he formed a company of his own (Escoffier and other members of his managerial team were all directors) to purchase and develop the site of the Paris Ritz, thus starting one of the most exciting stories in the annals of nineteenth-century *hôtellerie*. Ritz worked wonders of energy and determination at every stage. Though not very large, the new hotel was to be more luxurious and more expensive than any other. It was the second hotel to have a private bathroom for every bedroom; and it was furnished with

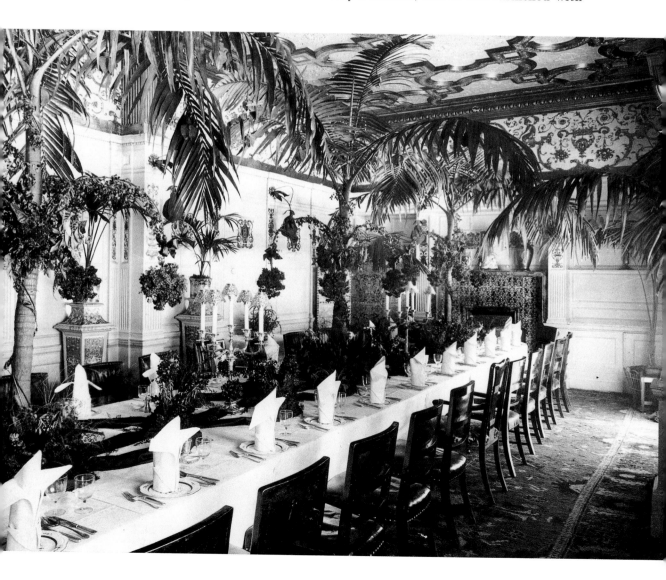

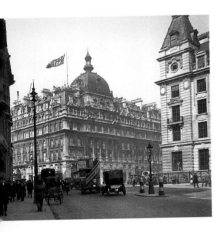

The Carlton Hotel, at the corner of Pal Mall and the Haymarket, was completed and opened in 1899.

Bombed during the Second World War, the building was demolished in 1957. The site is now occupied by New Zealand House.

fine, genuine, French seventeenth- and eighteenth-century furniture, paintings and china. The architect, Charles Mewès, had finally succeeded in weaning the Ritzes away from Maples catalogues, and was thereby the unwitting founder of the craze for Louis Quinze interiors which was to be such a pronounced feature of the new Edwardian hotels. Escoffier was once again in charge of planning the kitchens. The cooks included his old *chef saucier* from Monte Carlo and several *chefs de partie* from the Savoy; the *chef de cuisine*, whose name was Gimon, was specially trained by Escoffier for the post, and went on to become one of the great chefs of the 1930s. The Paris Ritz opened on 5 June 1898, and Ritz and Escoffier stayed there until they returned to London in March 1899.

Here too there were important changes. In 1897, the year of Queen Victoria's Diamond Jubilee, a bitter financial quarrel had broken out between Ritz and D'Oyly Carte which had had the effect of severing forever the relationship between the former and the Savoy board of directors. The whole matter was kept secret at the time and remains mysterious, though the source of the trouble seems to have been the flamboyant, highly ambitious personality of Ritz and his use of the amenities of the Savoy to acquire and entice financial backers for his own new, independent hotel in Paris. Things soured to an impossible degree, until the only way out was through the dismissal of Ritz and the other members of his team. According to the directors, 'They forgot they were servants and assumed the attitude of masters and proprietors.' Dismissal, however, could involve the board in heavy damages (as it already had done in 1890), and they therefore protected themselves by building up a potential legal case against their difficult employees which could be activated if they decided to make trouble. Inevitably Escoffier was involved, as a member of the Ritz group. Allegations of fraud, malpractice and wrongful conversion of Savoy property were made against Ritz, while Escoffier was accused of taking unauthorized commissions from suppliers. Affidavits, writs, confessions and boardroom minutes were issued and then hidden away by the Savoy in their secret archives; they have only quite recently been brought to light by the researches of the food writer

The design of the Carlton's Palm Court owes much to Ritz. At great expense, he made the architect lower the floor level to that of the street outside. Well-dressed women, Ritz said, would now be able to make theatrical entrances and exits as they mounted or descended the steps in full view of everyone else, and this would attract them to the hotel. It did.

Paul Levy. The taking of a 5 per cent commission on large orders placed with wholesalers by an important *chef de cuisine* was an accepted and recognized custom all over the continent, but it was strictly speaking illegal in England, which gave the Savoy its advantage. Escoffier had certainly been in the habit of taking regular commissions; but any imputation of dishonesty (he was locked out of his office while it was searched for evidence) was deeply painful to him and, he felt, quite unjustified. As it was, however, the unpleasantness made no difference to the future careers of either Ritz or Escoffier. On their return from Paris, both men went straight to the new Carlton Hotel, a large, uncompleted building which Ritz's company had recently acquired, and was about to turn into yet another international luxury establishment. One job had replaced another without any difficulty.

The Carlton occupied an extensive site at the corner of the Haymarket and Pall Mall. Demolished in 1957 to make way for New Zealand House, it was originally designed by C. J. Phipps as a symmetrical

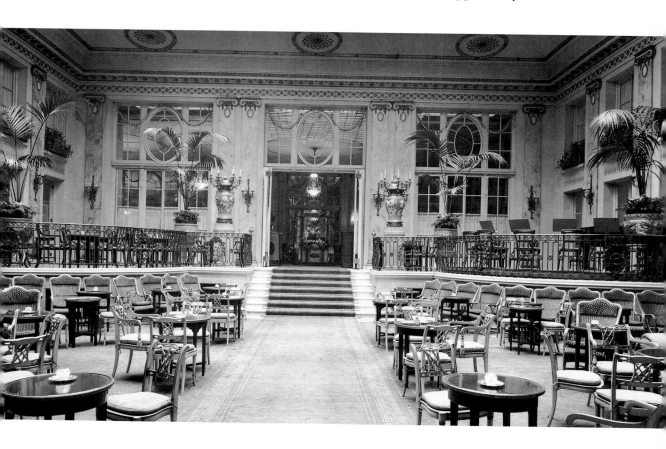

*London's Waldorf Hotel
was opened in 1908.*

*Its Palm Court,
embellished with
raised galleries,
was one of the early
imitations of that
at the Carlton.*

part of the block which contained Her Majesty's Theatre, and was finished by the architects Lewis Isaacs and Henry Florence. The exterior was a seven-storey mass of classical, Italianate detail with a turreted cupola and a Corinthian colonnade. It was a monument to late Victorian grandiosity. The interior architecture and decoration by Charles Mewès were once again in French eighteenth-century style. The centre of the hotel was graced by a glazed and much admired Palm Court, which achieved fame when it was filled with water for one of Sir Alfred Beit's Venetian parties, and his guests were punted about it in gondolas while Caruso sang to them. Escoffier's kitchens, staffed by a brigade of sixty and capable of producing five hundred *couverts* at a single dinner, were in the basement, as was the grill room which was lit by panels of diffused lighting, another of Ritz's brilliant innovations. The main restaurant was on the ground floor. Each bedroom had a private bathroom, the Carlton being the first hotel in London to be so equipped; wardrobe and storage space were increased; and Ritz even envisaged the possibility of providing each room with its own telephone.

The new hotel opened on 1 July 1899, and was another immediate success. Clients who had got to know Ritz and Escoffier at the Savoy had no difficulty in finding their way down the Strand and across Trafalgar Square to the new address; 'Where Ritz goes, we go!' declared the Prince of Wales. But the hotel was not immune from national and international developments: four months after the opening, the Boer War broke out and the Carlton restaurant saw many farewell dinners for officers leaving next day for South Africa, their red jackets standing out sharply amidst the black evening clothes of the other male diners.

In January 1901 the Queen died and the Prince of Wales succeeded her as Edward VII; sad news for the Carlton since his accession to the throne meant the loss of the Prince and his friends as customers. For Ritz personally even worse consequences were to follow. The new king's coronation was fixed for June 1902; the procession was due to pass along Pall Mall, right under the windows of the Carlton, and the hotel was ready for the great day with a whole

series of celebrations, including a special, formal dinner for those who would still be wearing court dress. Ritz had worked frantically at the arrangements for weeks on end, and he was already suffering from moments of total exhaustion. Every room was let; every place at every table was reserved by guests coming from all over Europe. Then, just two days before the event, the country learned that the new king was to undergo an emergency operation for appendicitis, that his life might be in danger, and that the coronation was to be postponed indefinitely. For Ritz it was an appalling shock (the bursting of a bombshell, in his own words) and it led to his complete mental and physical breakdown. Pale and shaken, Ritz walked into the middle of the crowded lunchtime restaurant, waited for silence, and announced the news; then, after dealing with the first of literally hundreds of cancellations, he collapsed, became delirious and was put to bed. He never fully recovered. The coronation and the Carlton celebrations took place two months later; but sadly the London Ritz was built and opened in 1906 in the absence of the brilliant man who had conceived it. In 1918 Ritz died alone at a Swiss clinic at Küssnacht, not far from Lucerne, the scene of so many of his early successes.

From 1902 to 1920 Escoffier continued to manage the Carlton kitchens and to keep his seat on the board of directors. These eighteen years were the culmination of his working career; since 1884 he had been a member of a great partnership, but now he was to become famous on his own, not only as a recognized expert on French food and cooking, but also as an international celebrity. At the Carlton, where he had a small flat on the fifth floor, his regular working day was a demanding one for a man in his sixties. He was up every morning at half past six, and it was sometimes well after midnight before he went to bed. The small, agile figure in a black frock coat (he only wore his white jacket and *toque* on Sundays) was down in the kitchen at seven to direct the cooking of breakfast; by eight he was in his little office on the first floor where he would organize the day's marketing, arrange the menus, and have his own breakfast. Back in the kitchen, he watched and supervised the preparations for lunch until eleven o'clock when he had a meeting with the

restaurant manager and the *maître d'hôtel*. After a light early meal
(if he was not invited to eat later in the restaurant with a friend or a
client) Escoffier would return to the kitchen to be present at the
coup de feu, every now and then going upstairs to check that all was
going well in the restaurant and to have a word with any client who
wanted to see him. In the afternoon he would spend several hours
in his office, attending to his correspondence, reading and writing;
then, after taking a short walk (the small upright figure in a black
coat and hat was so well known to the policemen on duty in Pall
Mall and the Haymarket that they would stop the traffic to let him
cross, whereupon the *maître* would invariably take a silver six-
pence from his pocket and tip the obliging constable), he would be
in the kitchen once more to preside over the cooking of dinner and
the preparing of after-theatre suppers, work which would last until
nearly one o'clock in the morning. Escoffier's calm, tenacious dedi-
cation and devotion to his trade may have differed from Ritz's
pyrotechnics, but it was largely due to its *directeur des cuisines* that
the Carlton was so soon considered to be the best and smartest
hotel in Edwardian London.

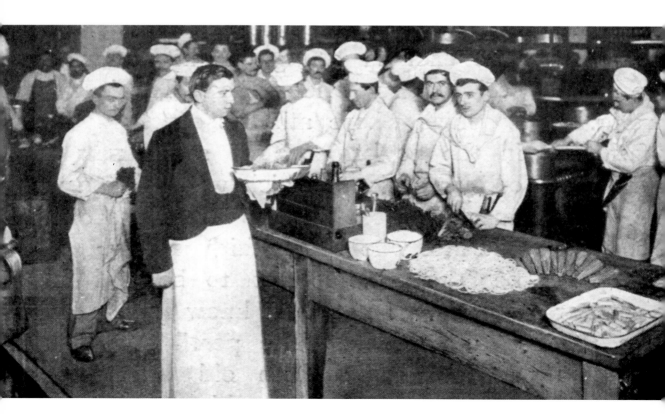

Escoffier's meals and menus for special occasions were highlights of the social season. The Derby and Ascot, Goodwood and Henley, garden parties by the Thames, presentations at Court, fancy dress balls and suppers — all were catered for. In 1900, at the Carlton lunch given to launch Elinor Glyn's first book, the principal course was centred round *Poularde Céleste*, an imaginary dish invented by the author but so well described in the novel that Escoffier had little trouble in producing it in reality. Even if there was no Prince of Wales, there was still no dearth of royal clients. When in November 1904, the Duke of Orléans entertained Léon Daudet to a sumptuous lunch in the restaurant, the burly, vituperative editor of *Action Française* was as impressed with the meal as he was with the brilliance and good looks of the 26-year-old pretender. A little later Leopold II of Belgium, travelling incognito, stopped at the hotel to enjoy a special ten-course Escoffier meal; while a somewhat simpler supper with *Sole Tosca, Selle d'Agneau de Galles* and *Poularde de Bresse à la Broche* was served to Alfonso XIII of Spain in August 1912. *Pêche Melba* appeared regularly on the menu, though without the original swan; Sarah Bernhardt was fêted with a sumptuous banquet after the first London performance of *L'Aiglon*; and on the night of the German invasion of France in August 1914, Lloyd George and Winston Churchill both dined at the Carlton. The very same evening Ho Chi Minh, the future Communist leader, was working in Escoffier's kitchen as a *commis entremettier*, preparing vegetables.

In October 1909 Escoffier's professional jubilee (fifty years from the day he started his apprenticeship at his uncle's restaurant in Nice) was celebrated with speeches and toasts and a banquet for 180 people at the Monico Restaurant in Shaftesbury Avenue. The occasion was a memorable tribute to the '*maître*', as everyone now called him, by representatives of the French cooking profession who came to London from all over the world. In 1912, the year of the sinking of the *Titanic*, a serious fire broke out in the upper floors of the Carlton, and for a time it was thought that Escoffier's life was in danger. An anxious crowd collected in the streets below, and when finally the familiar figure appeared, safe and sound,

The kitchens at the Carlton were in the basement. The cooks, working under sparse electric light, all wore their own sets of knives hanging at their waists in scabbards, a traditional part of their equipment since the eighteenth century.

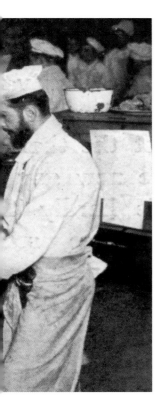

descending a fire escape, they greeted him with a long round of clapping and cheering. Even in the popular mind he was becoming a legendary figure.

Escoffier's renown was not due solely to his skills in the kitchen, however, nor even to his friendship with prominent customers; it owed a lot to his growing celebrity as an author. At Monte Carlo in 1884 he had started to contribute articles and recipes to *La Revue de l'Art Culinaire*, a new, pioneering professional journal, and in 1885 he published the first edition of *Les Fleurs en Cire*. It was at the Grand Hôtel that he also began to plan a textbook of recipes and culinary procedures which would serve as an elementary grammar for young cooks and waiters. During the Savoy years, the project was abandoned; but at the Carlton, after the retirement of Ritz, Escoffier took it up again, and in 1903 published the first edition of *Le Guide Culinaire*. Its clear style, its comprehensive vision, and its large repertory of some five thousand recipes at once marked it out as a classic both for professional cooks and for non-professionals seriously interested in cooking. Other editions followed in 1907, 1912 and 1921. In 1912 he supplemented it with *Le Livre des Menus*, a study of how kitchens should be organized in all classes of hotel or restaurant, and how meals should be served and menus composed and written. In 1911 he took on the daunting task of editing and publishing his own magazine, *Le Carnet d'Epicure*, which contained articles in French and English on *haute cuisine*, family cooking, French regional cooking, and all sorts of topics currently of interest to cooks and hoteliers. Published monthly in London, it continued to appear until after the outbreak of war in 1914.

In 1912 Escoffier inaugurated the famous series of *Dîners d'Epicure*, superb examples of French *grande cuisine*, which were devised by him but were to be cooked and served simultaneously in different towns and cities all over Europe. In London the first was eaten by three hundred people at the Hotel Cecil; applause thundered when one of the guests stood on his chair to read out a telegram of congratulation from Sarah Bernhardt, and it became even louder

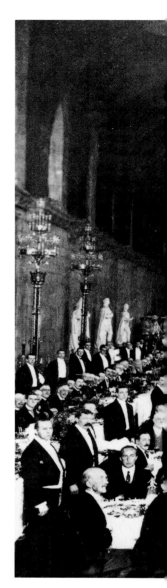

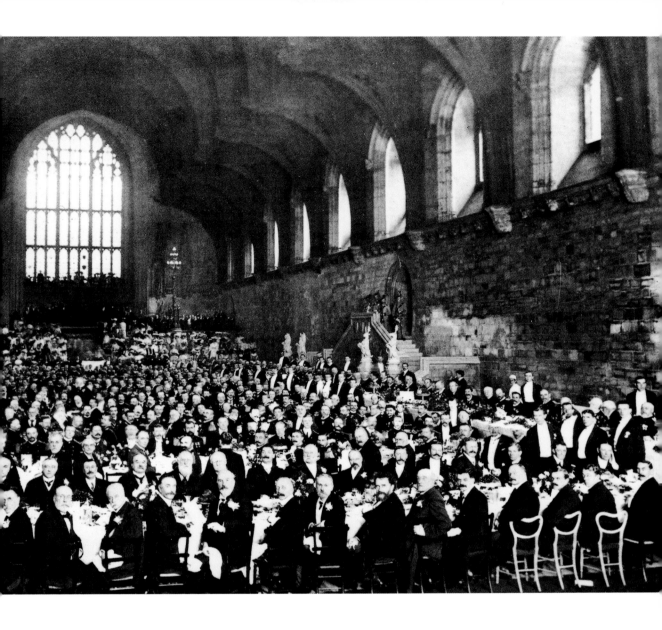

The impressive Anglo-French naval banquet given in Westminster Hall in 1905 marked the French fleet's visit to Portsmouth which followed up the Entente of the previous year. Escoffier's menu included *Truite froide Amiral Caillard, Chaud-froide de Caille à la Loubet and Poularde Edouard VII.*

when he climbed onto the table to read out another from the French poet Jean Richepin. The menu, which was being eaten in thirty-seven other places at the same time, included *Dodine de Canard au Chambertin, Agneau de Pauillac à la Bordelaise, Poularde de France à la Gelée à la d'Orléans,* asparagus with *sauce divine,* and *Fraises Sarah Bernhardt.* Regular dinners were also eaten by the members of Escoffier's gastronomic club, *La Ligue des Gourmands.* At one of these, where a highlight of the menu was a softly

57

poached fillet of sole, carefully folded so as to enclose a delicate filling of mushrooms and spinach and garnished with shrimps and truffles, one sensitive French chef actually burst into tears when he saw a German confrère stubbornly adding salt to the dish before he had even tasted it.

Escoffier's international repute spread even wider when the Ritz-Carlton Company loaned him out to work on other projects, much as he had been loaned out during his years at the Savoy. On 26 February 1903, in Paris, he was in charge of the first of the famous literary dinners eaten by the ten members of the Académie Goncourt. In June 1906 he received the first of several commissions to design and organize the kitchens on board German transatlantic liners owned by the Hamburg-American Line. Their two most recent and most luxuriously appointed ships were the Belfast-built *Amerika* and the *Kaiserin Auguste Victoria*, built at Stettin; the Kaiser, usually touchily chauvinistic in matters of meals and menus, insisted that both should have first-class French restaurants and that the cooking should be done by French chefs. Escoffier was called in as an expert; the Ritz-Carlton Restaurant on board the *Amerika* was decorated by the Paris firm of Sormani; and Escoffier assembled a brigade of ten cooks who would work in a kitchen directly and conveniently attached to the dining-room where, as in London, an orchestra played during meals. The Kaiser came on board at Cuxhaven for the first stage of the liner's maiden trip, and had time to enjoy a specially prepared dinner.

Earlier in the day there had been some discussion over whether the menu should be written in German or in French, but when a translator made a mistake over the word *mousse*, thinking it meant a cabin boy, it was decided to keep it in French. The dinner included sole cooked in Rhine wine, lamb, chicken and quails, but Escoffier tactfully changed the embarrassing *Mousse d'écrevisses* into *Ecrevisses à la moscovite!* After dinner, the Kaiser paid an official visit to the kitchen, thanked the chef charmingly for the excellent food, and then asked about his experiences as a prisoner of war at Mainz. 'I trust you were well treated,' remarked the Kaiser genially. 'Well

treated is not quite the phrase I would use,' replied Escoffier, 'though others suffered far more than I did'; and he spoke of his hatred of war and of the miseries it brought. 'I am only sorry I could not have been there,' continued the Kaiser magnanimously, 'I would have liberated you!' At this point, he probably intended the conversation to stop; but Escoffier, with a twinkle in his eye, went on: 'I am most grateful for Your Majesty's concern on my behalf; but even had Your Majesty had been there, recognizing me might have been difficult!' There were fewer undertones when the Kaiser firmly changed the subject, and began to talk about his eating habits. At breakfast, he said, he copied the English, and had coffee, cream, eggs and bacon, kidneys, chops, steaks, grilled fish, and fruit. Lunch was a substantial meal, but dinner was always very light, a custom which the German Emperor found to be a relief to his stomach and an improver of his guests' conversation.

In March 1907 Escoffier crossed the Atlantic for the first time on board another of the company's liners, the *Deutschland*, in order to advise on the best position for a grill-room in relation to the ship's movement in a rough sea. In New York he stayed at the Knicker-bocker Hotel, a visit which eventually led to his providing the recently opened establishment with a brigade of French cooks and a *chef de cuisine*, all carefully selected from his kitchen staff at the Carlton. In 1910 Escoffier was again in New York, this time to set up and choose staff for the kitchens of the new Ritz-Carlton Hotel. After six weeks, during which he lunched with Sarah Bernhardt several times, he moved on to Pittsburgh where he modernized the kitchens of the Grand Hotel. In 1911 he presided over a catering exhibition at Frankfurt-am-Main. In 1913 the Carlton was again commissioned by the Hamburg-American Line to establish kit-chens on board their latest and largest liner, the 53,000-ton *Imperator*; and Escoffier was again sent to Germany together with Charles Scotto, one of the chefs he had trained, who was to be *chef de cuisine* to the new restaurant kitchen. As before, the Kaiser came on board, this time for a two-day trial voyage from Cuxhaven to Heligoland and back, and presided over a formal lunch in the morning and an imperial banquet in the evening (both

of them for over 100 people). Afterwards he watched a startling cinema show at which one film featured a pretty young actress suggestively engaged in lobster-catching, while another, somewhat out-of-place in the circumstances, showed the latest French submarine manoeuvres off Tunis; and next morning, in the Palm Court, he had a long after-breakfast conversation with Escoffier. It was their second talk, and where the first had touched precariously on the Franco-Prussian War and the chef's experiences in the

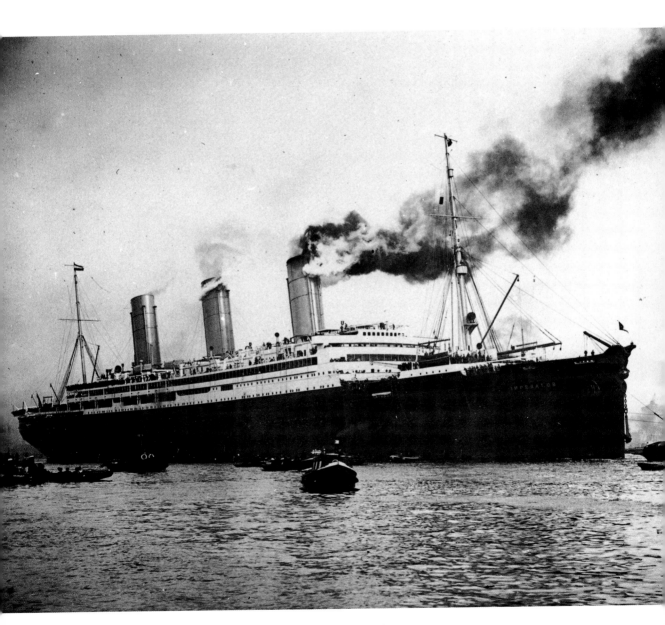

camp at Mainz, during the second Escoffier boldly discussed the possibility of a change in international attitudes, and of a new relationship between Germany and France which would lead to a lasting European peace.

The *Imperator* was the last Hamburg-American liner to be built before the start of hostilities; it was later taken by Britain, probably unjustly, in reparation for the sinking of the *Lusitania*, and

The 52,000-ton Imperator *(later the* Berengaria*) was the last of the big Hamburg-American liners to have its kitchens organized by Escoffier. At the start of the ship's maiden voyage in 1913, he was responsible for the lunch and dinner served to the Kaiser and over a hundred other guests. It was on board the* Imperator *that Escoffier had the second of his two private conversations with the German emperor.*

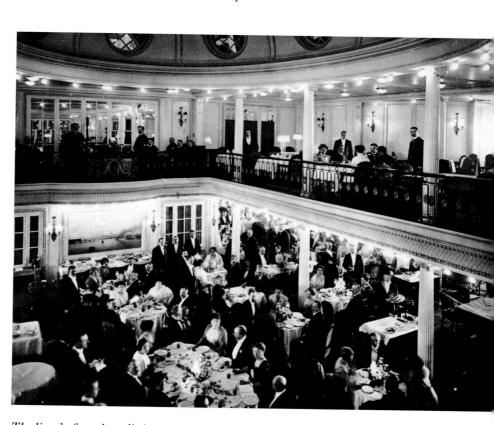

The liner's first class dining-room was designed by Charles Mewès who had already worked at the Ritz and the Carlton. The gallery, the mirrors and the fluted Ionic columns are all typical of his classical French style.

renamed *Berengaria*. Both ships were destined to play a part in Escoffier's life. In December 1910 he made the return voyage to Liverpool on board the *Lusitania*; and in 1926 he went again to America, now as an official guest of the Cunard Line, on board the *Berengaria*, which, of course, was full of memories for him as the old *Imperator*.

War broke out in August 1914, and on 1 November Escoffier's second son was killed in action. With a much-reduced brigade in the Carlton kitchens and restricted by food rationing, his skill in keeping the restaurant going during the war years often recalled the ways in which he had kept his staff officers fed during the siege of Metz. He sampled the Christmas puddings which were sent out to troops during their first winter at the front; he organized charities to help the widows and children of French cooks killed in action; and at the same time he tried to keep his Carlton clients happy with tough, unrationed venison, finely minced and served with eggs, or prepared as a *daube provençale* with noodles and chestnut purée. In October 1919 President Poincaré, on an official visit to London, awarded Escoffier the cross of the Legion of Honour in recognition of a lifetime's service to the cause of French food. The following year, aged seventy-four, Escoffier left the Carlton, and went to join his wife at their villa in Monte Carlo.

Retirement was overshadowed by ill-health and financial worry. Despite the fact that his salary at the Carlton (the equivalent of around £60,000 today) was twice that of a leading Fleet Street newspaper editor and almost as high as that of a High Court judge (and he had his own flat at the hotel), Escoffier died a poor man, partly no doubt because of his great generosity towards his children and grandchildren, but also through unwise and unlucky investments. At heart he had always been more of an artist than a moneymaker; his last fifteen years, nevertheless, were years filled with activity. He visited New York two more times in 1926 and 1930, on the latter occasion crossing the Atlantic on board the French liner *Paris* (he visited the ship's kitchen and was photographed surrounded by its brigade of cooks) to preside over a grand inaugural dinner at the Hôtel Pierre, and to celebrate his eighty-

In the winter of 1914 Escoffier helped to finalize and test the recipes for the Christmas puddings to be sent out to the troops at the front.

It is good to know that the Christmas fare was appreciated!

fifth birthday. He presided over catering exhbitions in Zurich, Paris and Grenoble; attended banquets; made speeches; received national honours, as at Copenhagen in 1923, when he was decorated by the King of Denmark and produced the *Soufflé Princesse Renée* in the Danish national colours; and had streets and boulevards named after him. Articles, memoirs, and books continued to flow from his pen; his last important work, *Ma Cuisine*, was published only the year before his death.

No request, if it was in the name of French food, was too small to be listened to. On 25 November 1927, when asked to do so by some Paris *midinettes*, Escoffier composed a delightful menu for the feast of Sainte Catherine, the patron saint of seamstresses and dressmakers. He also found time (between journeys) to act as part-time assistant manager at two local Monte Carlo hotels, one of them run by Madame Giroix, the widow of the chef who had originally recommended him to César Ritz. At the age of eighty-eight, surviving his wife by only a few days, Escoffier died at Monte Carlo on 12 February 1935. He was buried in the family tomb at Villeneuve-Loubet.

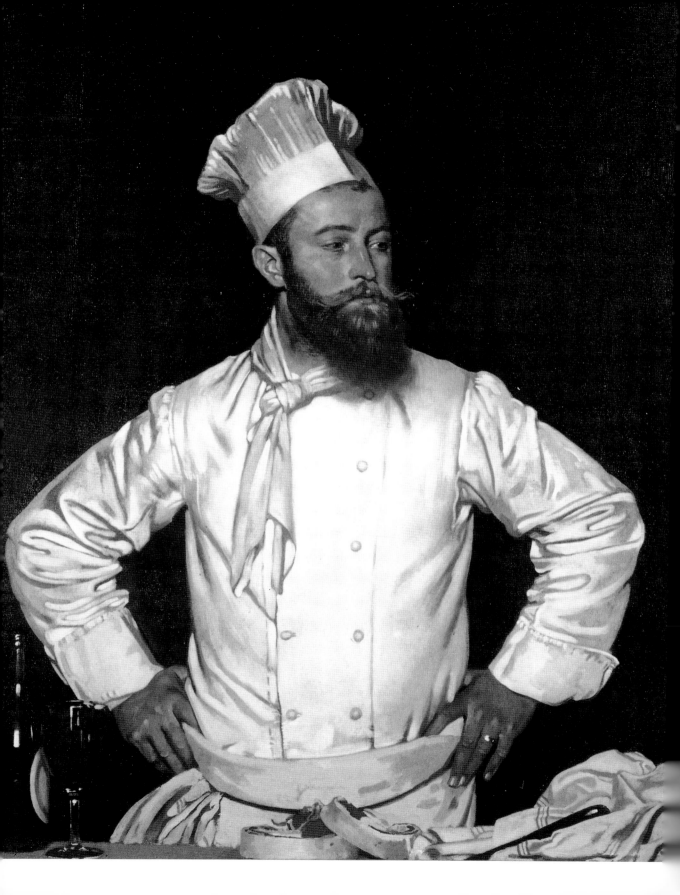

3

OF

Cooks AND *Kitchens*

'The Escoffier
Generation'.
Sir William Orpen's
portrait of a Paris chef
in 1921 conveys vividly
the professional pride,
authority and self-
assurance that marked
cooks who had been
trained by Escoffier in
the years before the
First World War or who
had worked in kitchens
he had organized
or influenced.

On a November day in 1908, Escoffier led his brigade of white-hatted and white-jacketed cooks up to the flat, leaded roof of the Carlton Hotel to have their photograph taken. It was an important occasion which, for a few moments at least, would turn even the humblest and most overworked of them into something like a star. The picture shows five rows of *ouvriers*, a mass of fifty-two faces huddled together against a humdrum, urban background composed of grey London sky, sagging telephone wires and, in the distance, the upper part of the cupola of Her Majesty's Theatre; but, if one looks closer, can can detect in the features of each man the personal, individual traces of the labour and hardship, the triumphs and the failures which dominated his working life and were the ruthless rulers of the old professional kitchen. In the

middle of the row of honour, like a black crow surrounded by white doves, sits Escoffier himself, frock-coated and with a firm but benign expression on his face. On either side of him are his *chefs de partie*, jovial, confident, jaunty and ambitious; the successful, authoritarian sergeant majors of the culinary army. At the very back stand the *plongeurs*, the dishwashers.

The taking of an annual or seasonal photograph of the entire brigade was a common custom in many hotels and restaurants.
The pictures are unique in that they are often the only surviving portraits of the men and boys who spent their lives in the hot underground kitchens of the time.

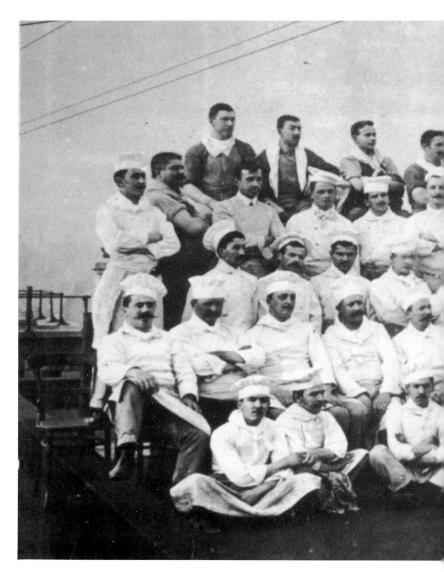

Thick leather aprons are strapped round their bodies like armour; cloths hang from their necks; and their bare, brawny arms and square shoulders proclaim them triumphant prizefighters in the battle against filth and scraps and greasy water. Elsewhere in the picture, standing or sitting in whatever places were allotted to them, are the *aides* and the *commis*, the ordinary cooks, thirty-five

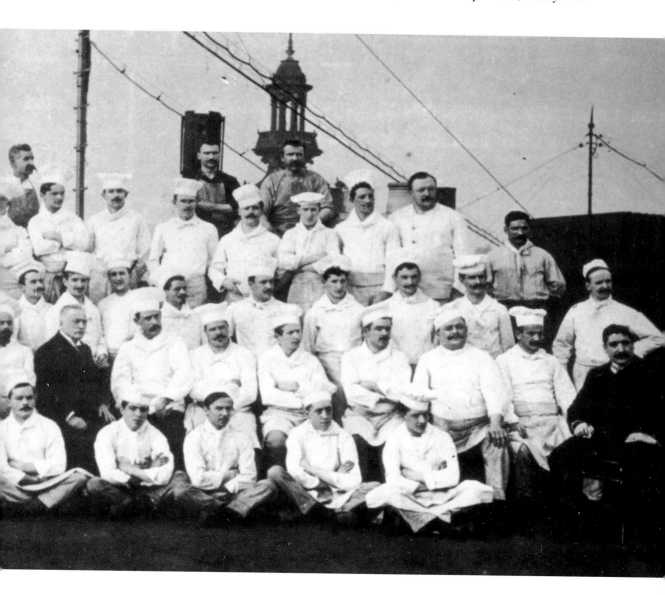

of them, all aged between about sixteen and twenty. On the faces of some one can read intelligence, determination and good humour, whereas others, it is clear, are already sickly, overwhelmed and broken, destined to a lifetime of drudgery in the unhealthy surroundings of dubious or second-rate establishments.

From the celebrated Monsieur Auguste Escoffier down to the palest and most anonymous *aide de cuisine*, the roof-top photograph presents in microcosm the rigid hierarchy of what the cooks themselves called *le métier*. The fiery underworld to which the brigade returned, once the photographer had folded up his tripod and put away his black cloth, was another of its unquestioned elements. The kitchens, however, were a region almost totally unknown to the vast majority of the Carlton's clients. Few ever expressed any desire to see them, and there were long-standing historical reasons for this. For centuries kitchens had been shunned as places of blood, dirt, grease and undesirable smells, animated by the shouting and swearing of uncouth, uneducated and obscene cooks. They were also well-recognized sources of flooding and fire. Even in the 1850s, French domestic handbooks advised the mistress of the house never to set foot in her own kitchen lest she be tainted, physically and morally, by its polluted atmosphere; whenever it became necessary to communicate directly with the cook, the interview should take place in the more salubrious atmosphere of the drawing-room. In 1600 the French agriculturalist, Olivier de Serres, was treated as a mild but amusing eccentric and entirely ignored when he insisted that kitchens should be installed on the first floor, so as to be light and airy and conveniently next door to the dining-room. By immemorial custom, they were much more likely to be situated as far away from it as possible; in the side wings of French *châteaux*, for example, or even as in certain medieval monasteries or English country houses, hived off into a completely separate building.

Rational, scientific collaboration between cook and architect developed slowly. Jules Hardouin-Mansart designed magnificent kitchen buildings for Versailles and the Grand Trianon; John

Nash's kitchen at the Brighton Pavilion was praised by Croker as one of the wonders of the age; but in 1867, Jules Gouffé, director of the kitchens of the Paris Jockey Club during the Second Empire and brother of Queen Victoria's head chef, was still complaining that architects were simply not taking enough interest in the problems of the working cook, and that kitchen design left much to be desired. It is true that in the 1830s Alexis Soyer had collaborated with Charles Barry over the construction of the famous kitchens at the Reform Club, but such a case was exceptional.

In most towns and large cities, sheer lack of space relegated the despised but essential kitchen to the status of a dark, underground cellar without any proper ventilation, light or sanitation. London terraced houses benefited in varying degrees from the amenity of their areas, but Paris kitchens knew no such relief. Air was supposed to enter through small openings cut in the wall at pavement level, but these holes were usually blocked up, either accidentally or intentionally because they were a source of dirt or because neighbours complained about the obnoxious smells which blew out of them. As a result, most urban kitchens, large or small, were devoid of fresh air; a particular cause of suffering in summer when the cook might be working with a coal-burning stove in front of him and an open charcoal grill behind, and in a temperature above 45° centigrade. Gas jets, flaring all day in an attempt to provide some sort of light to work by, only made the heat more infernal. Poisonous gases and fumes seeped into the atmosphere from faulty flue pipes. The smell arising from unwashed saucepans, left for several days in a corner, mingled with that of bones and scraps and buckets of greasy washing-up water (perks of the *plongeurs* who sold them as pigs' swill) and the stink of the primitive drains of lavatories opening directly off the main kitchen. The sawdust on the floor was sometimes so saturated with fat that a burning ember falling from the *rôtissoire* was enough to set it alight.

In 1903 *La Presse* cheered its Christmas readers with the news that the cooks at several of the very best Paris restaurants were so disgusted by the filthy conditions of the kitchens in which they

worked that they refused to eat the food cooked in them. A few years earlier, a *commis* cook, arriving for his first day's work at the Restaurant Marguery, a well-known and much respected establishment in the Boulevard de Bonne Nouvelle, had felt physically sick as soon as he set eyes on the kitchen; that night he felt no happier when he discovered he was expected to sleep in his dirty clothes on one of the banquettes of the *salle*, and could not go to bed until the very last customer had finally left to go home. In 1929, well within Escoffier's lifetime, George Orwell worked in the kitchens of the prestigious Hôtel Lotti in Paris, and in *Down and Out in Paris and London* left his famous account of the lives led by its cooks and waiters, and of his own experiences there as a *plongeur*. Big London kitchens, both private and professional, with

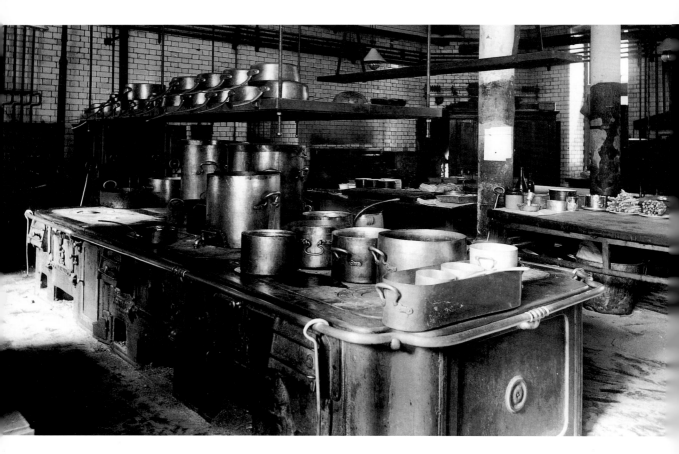

their tendency to have sash windows opening out on to areas, had the reputation with French *ouvriers* of being more hygienic than those in their own capital. D'Oyly Carte's kitchens at the Savoy, in particular, were noted for their new and modern equipment. When in 1913 the kitchens of the Plaza Athénée Hôtel in the avenue Montaigne were built on the ground floor and were five and a half metres high, the fact was immediate front-page news in the trade press.

Bad working conditions and exhausting fourteen-hour days took their inevitable toll on the cook's health. Only the very top chefs managed to escape into the more normal surroundings of private service, restaurant proprietorship, hotel administration or comfortable retirement; the rest, the ordinary *commis*, toiled on until they died either of alcoholism or of the destructive effects of their own drudgery. Their life expectancy was low, and few lived to be more than forty-five. This was the average age limit given by Antonin Carême in 1822 (he himself died at the age of fifty) in the days when all kitchen ventilation was kept tightly closed during the *coup de feu* so that the elaborately arranged *relevés* and *entrées* should not get cold before being served, a custom which also meant that for an hour each day cooks breathed in the undiluted gas thrown off by the open charcoal *potagers*. But even the general introduction of closed cast-iron cookers did little to lengthen the cook's life span. In 1883 an article in *La Revue de l'Art Culinaire* stated that most cooks still died in their early forties, and in 1912 the fact was repeated in *Le Carnet d'Epicure*, the magazine edited by Escoffier. According to a medical report published around the turn of the century, there were more occupational diseases to be found among cooks than among miners. In addition to slow asphyxiation by poisonous fumes, these included tuberculosis, digestive troubles and symptoms of undernourishment brought on by poor food, varicose veins caused by long hours of standing, and deformations of the ankle from being made to carry excessively heavy loads on the head as an apprentice. The biggest scourge of all, however, was chronic alcoholism. Pale, dessicated and sweating profusely in the stultifying atmosphere of the basement

In 1893 the Savoy kitchens were remarkable for the amount of daylight which entered them. We see the sawdust on the floor; the pokers for stirring up the coal fires of the stoves; the bain-marie *of the* sauciers *with its simmering containers of* espagnole *and* fonds de cuisine; *and the racks containing every kind and size of copper cooking utensil, all of which had to be scrubbed and scoured by the* plongeurs *after use.*

kitchen, it is hardly surprising that cooks, and *sauciers* in particular, drank steadily whatever wine, spirits or beer they could get hold of. The crippled, calloused hands of the *plongeurs*, their fingernails worn to nothing by the continual rubbing and scratching of plates and saucepans, were but another example of the physical degradation brought on by work in the old kitchens.

Apprenticeship, the process of initiation into the brutalities of the culinary underworld, was in itself brutalizing; and this was especially the case in France. There are French cooks even now who shudder at the memory of apprenticeships served only forty years ago, and describe experiences very similar to those of their nineteenth-century counterparts. A boy was usually apprenticed at the age of thirteen for a period of three years, his parents paying the master a premium and a further penalty sum should the apprentice fail to stay his full time and thus deprive the master of his useful services during the last year. The boy brought with him his own *trousseau*, which included aprons, toques, white jackets, shirts, shoes, and sometimes even bedding; the master undertook to feed him and house him and to teach him his trade. In theory, the apprentice was allowed to keep for himself the tips he received when making deliveries, but in practice this money was mostly absorbed by the cost of laundry and shoe leather, and in paying his share of the upkeep and cleaning of the dormitory. Some masters also levied arbitrary fines against which there was no appeal. The boys were frankly regarded by most *patrons* as an easy source of cheap labour, as slaves to be exploited at will and without any fear of outside interference. Their traditional lot included kicks, blows and general rough treatment. They scrubbed the floors, and cleaned and lit the stove. A fifteenth-century account of the kitchens of the Duke of Burgundy describes the chef sitting on a wooden throne and brandishing a long wooden spoon with which he tastes the sauce, and then chastises the *enfants de cuisine* if it is not to his liking. In December 1904 an apprentice cook ran into a Paris police station, his face covered in blood from a blow he had received from his chef; but, though the matter was investigated, no action was taken, and he was turned out of the kitchen with no

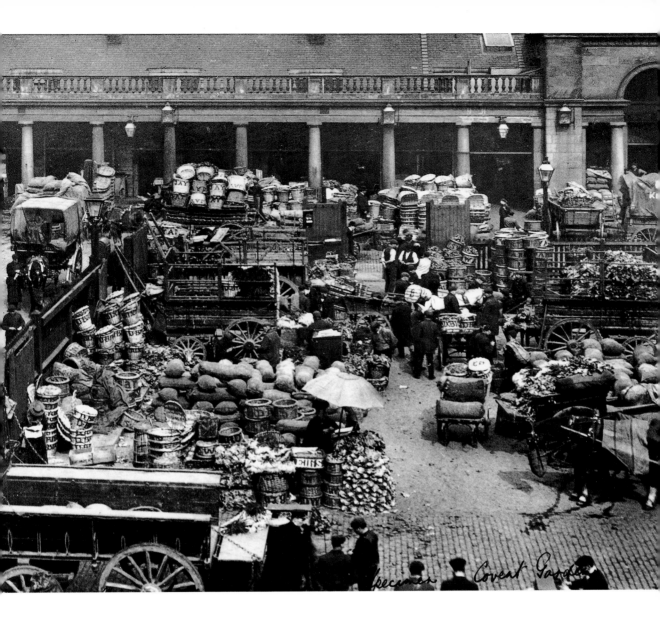

compensation. The boys were often housed in unhealthy and verminous conditions; one Paris *pâtissier* in 1905 made his apprentices sleep in stables where three horses were kept, while others were accommodated in small, unlit cells or had to make do with a mattress in a corner of the kitchen.

An apprentice's day often started at five in the morning, when he accompanied his master to the market and carried the day's pur-

chases back to the restaurant, sometimes as much as a mile or so away. The goods were either piled up in a basket which the boy balanced on the top of his head, or packed into a wooden barrow to be slowly manoeuvred along the crowded pavements. In either case the weight was always far in excess of the legally appointed limit. During the day, the apprentice had to get used to being kicked and cursed by the *chef de cuisine* and the various *chefs de partie*, and if he was unable to stand up for himself he was bullied mercilessly by any *commis* who happened to be his senior, even if only by a single week. Contrary to fond parental illusions, it was only very rarely that a chef or a proprietor bothered to give his apprentice any proper professional instruction. It was up to the boy himself to learn if he wanted to, and in order to do so he had to have intelligence, vision and, above all, an unusual amount of determination.

Escoffier, we have seen, was an outstanding example of an apprentice who could overcome hardship and difficulty, and really manage to benefit from his years of apprenticeship. His uncle's advertisements announced that the Restaurant Français would deliver meals to any address in Nice at any hour of the day; and we can well imagine Auguste's tiny, white-coated figure, a heavy *manne* perched on the top of his head, hastening along the rue de France to deliver a carefully prepared dinner or supper to the residence of some English *milord* or Russian count, and noticing and remembering everything: clothes, dishes, styles of service, manners, expressions, menus, and anything else it might one day be useful to know about. From François Escoffier he learned all he could about buying. Nice market in the early hours of the morning provided an abundance of local produce, fruit and vegetables; and in those days, the fishermen, their boats drawn right up on to the beach, offered not only all the usual Mediterranean fish, but also soles, skates, lobsters, crabs, eels, whiting and mackerel. From farms in Piedmont, François bought beef, veal, game, truffles and poultry; and during the winter, fresh pork was always available from peasants in remote villages high up in the mountains above Nice.

In a few years, all this knowledge would prove invaluable to the young chef at the Hôtel Bellevue; just as the lessons he learned from his uncle's Russian chef would not be forgotton during the great years in London. When Colonel Newnham-Davis, taking Mrs Charlie Sphinx in blue and white and wearing turquoises and a new diamond crescent out to dinner at the Savoy in April 1896, poured some thick, white cream into his plate of *borsch* (it was to be followed by a *Timbale de Filets de Sole*, a *Poulet de Grain à la Polonaise*, English asparagus and a *Parfait de Foie Gras*), he remarked that 'of all the restaurants where they made this excellent Russian dish the Savoy takes the palm', and added that, made by the *maître*, it was the best soup in the world. Nor probably did Nellie Melba and many others who enjoyed Escoffier's delicious, ingenious desserts know that his interest in ices and *entremets sucrés* and crystallized fruits had been awakened in him as an apprentice, when he worked extra hours in the *laboratoire* of Monsieur Autheman, one of the best *pâtissiers* in Nice, whose shop was only two doors away from the Restaurant Français.

Once the apprentice had completed his time, his master gave him a written certificate which was the equivalent of a professional passport. Without it no one would employ him. Every newly qualified *ouvrier* hoped to get a job in one of the big Paris kitchens, but it was more usual to start in a smaller restaurant, probably one in the provinces. Brigades varied in size from five or six men in a minor establishment to nearly a hundred in a really large one. When Escoffier was chef at the Grand Hôtel at Monte Carlo in the 1880s the kitchen staff would have numbered about forty-five; at the Carlton, during the peak period of the Edwardian season, he was sometimes in charge of as many as eighty, though at normal times the total would have been nearer sixty. Under the overall command of a *chef de cuisine*, a brigade was divided up into a number of separate *parties*, each responsible for a particular type of work or culinary process, and each with its own *chef de partie*. One can get a good idea of what one of the really big Paris kitchens of the Second Empire looked like from the famous engraving of that of the Café Riche after its enlargement by its proprietor Louis

Bignon in 1865. The *table chaude*, where the waiters collect the plates of food, is in the foreground; the *garde-manger* is in a separate room to the left. The middle of the kitchen is filled by a colossal cast-iron stove; and in the far corner stands the fine *rôtissoire* with its formidable array of spits and, next to it, its traditional companion, the charcoal-burning grill whose classical mouldings and elaborately embellished chimneypiece were always an impressive feature.

It was as a *commis rôtisseur* that Escoffier began working at the Petit Moulin Rouge in 1865. All day he stood in front of the wide, open wood fire, wiping the sweat from his face, and carefully watched the spits loaded with poultry, game and joints of meat as they turned slowly round, regulating their speed, adjusting their proximity to the heat, and basting the roasts. A good *rôtisseur*, such as Auguste clearly was, had to possess an artist's instinct for subtle combinations of different degrees of heat, different qualities of wood, and the different thicknesses and textures of the pieces to

Manufacturers' catalogues showed a more schematic version of the professional kitchen. Briffault provided a plumbing system which carried hot water from the boiler in the stove to the plongeurs' sink.

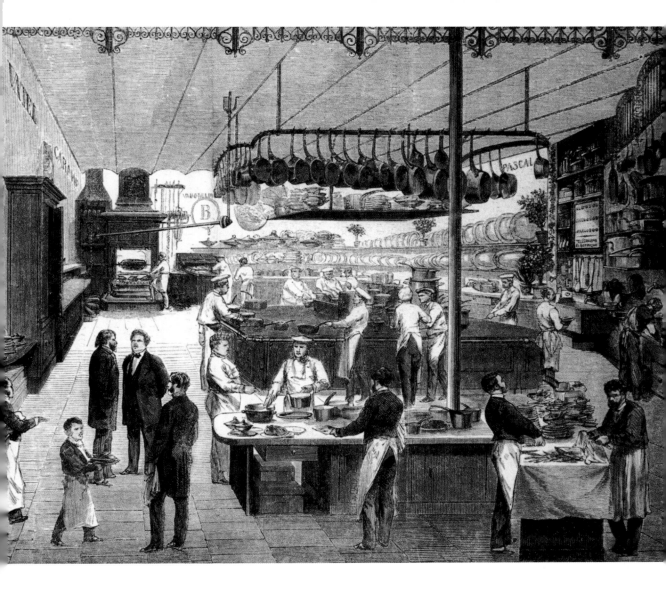

The Paris kitchens of the Café Riche, after their enlargement by Louis Bignon in 1865, were considered to be a model of progressive modernity. We see the garde-manger *on the left; the great stove in the centre; the* rôtissoire *and the grill in the background; and the* plonge *on the far right.*

be roasted. It was by no means every cook who was capable of all this, especially when harassed by strings of orders shouted out by the *aboyeur* during the *coup de feu*. You can learn how to be a cook, so ran Brillat-Savarin's famous aphorism, but you have to be born a *rôtisseur*. Beside the *rôtissoire* stood the charcoal grill, for the *rôtisseurs* were the *partie* responsible for everything that had to be grilled, no matter whether it was meat or fish (this was something which changed later on, at the Carlton, when Escoffier instituted a special *partie* of *poissonniers*). On part of the grill stood the recep-

tacle of hot fat for deep frying (the *négresse*, as it used to be called in kitchen slang), which meant that the *rôtisseurs* were also in charge of all the *fritures* such as *pommes soufflées* or the preparation of *blanchailles* or whitebait — a sign of Escoffier's affection for England was the praise he always accorded these little fish which, in those days, could still be caught in the Thames and eaten fresh at Greenwich. *Le Guide Culinaire* (especially the first edition of 1903) gives a full and interesting description of the work of the *rôtisseur* which recalls much of what must have been Escoffier's daily experience at the Petit Moulin Rouge and also puts a strong case against the oven-roasting of meat, a view that was virtually inevitable in the nineteenth century when ovens were deficient in both temperature control and ventilation, and is not altogether without adherents even today.

In 1867, the year of the Paris Exhibition, Escoffier was made *chef garde-manger*. The *garde-manger*, or larder, was the name of the *partie* which received produce and raw ingredients from the suppliers, prepared them for cooking, and then distributed them to the chefs of the other *parties*. It was the kitchen's vital link with the outer world; and it was its chef's responsibility to check all deliveries for freshness and quality. The *garde-manger* was housed separately from the main kitchen, usually in a high, white room which was as cool as the eternal fire of the *rôtissoire* was hot. Down one side hung sides of beef, lamb and pork and, during the season, venison and game. It was the *partie*'s job to produce the right cuts of meat, quickly and impeccably prepared, whenever the *rôtisseur* or *chef saucier* called out for them. The *garde-manger* was also in charge of whatever primitive refrigeration methods were in vogue at the time. At the Petit Moulin Rouge in the 1860s these would still have consisted of a number of *timbres*, or ice-drums: round wooden buckets with a layer of crushed ice at the bottom and a loose, moveable top, used principally for conserving fresh fish. Keeping them clean and fully stocked with unmelted ice was something of a nightmare. By the mid-1880s, when Escoffier was at Monte Carlo and the Savoy, the *timbres* were being replaced in the more important kitchens by *armoires à glace*, massive wardrobe-

As a means of keeping food cool, the armoire à glace *was a vast improvement on the earlier* timbres *or ice-drums. Its hollow sides and centre section were packed with ice which melted more slowly than it did in the* timbres *because it was not in direct contact with the air. The* armoire's *adjustable shelves anticipated those of a modern refrigerator.*

like cupboards, their mahogany doors often encrusted with heavy, decorative mouldings and surmounted by broken pediments, festoons, elaborate carvings and inserted clockfaces. The sides and doors were doubled for insulation; and inner compartments, hermetically sealed, were filled with crushed ice which melted much more slowly than in the old *timbres*, and created a comparatively cool area of shelving and drawers, a crude forerunner of the modern refrigerator. Some of these early ice cupboards were famous enough to become objects of professional pilgrimage. Much visited and admired was that at the Russian embassy in Paris, which had been built for the gourmet ambassador, Prince Orlov. Another well-known example, described by Urbain Dubois as being of 'irreproachable perfection', was installed at the Restaurant des Quatre Saisons, owned by an ex-chef of Alfonso XII of Spain.

If the *rôtisseurs* might be compared to the artillery of the kitchen army, and the *garde-manger* to its commissariat, its infantry, beyond any doubt, were the *sauciers*. Their pitch extended over most of the central iron stove, and they were the chief users of its ovens and hot plates. They were of essential importance in the scheme of the old *grande cuisine*. They made all the *fonds* (basic stocks) and all the sauces; they were in charge of the *bain marie* which simmered away around saucepans of *espagnole* and *velouté* and various *fumets*, the basic elements from which all other sauces were derived; they prepared the *garnitures* which formed the decorative adornment without which any principal dish would have been inconceivable; above all, they made the intricate *relevés* and *entrées* which formed the back-bone of the restaurant menus of the Belle Epoque in France and the Edwardian era in England, the great 'creations' with the splendid names and aristocratic dedications which immortalized not only princes, actresses and celebrated *demi-mondaines*, but also the chefs who had invented them. In view of his importance it is not surprising that the *chef saucier* was automatically regarded as the kitchen's second-in-command who, in the absence of the chef, stepped at once into his shoes. Escoffier became *chef saucier* at the Petit Moulin Rouge in 1868, and this was his last position before returning there as *chef de cuisine* in 1873.

FOURNEAUX BRIFFAULT
PARIS, 72 & 74, AVENUE PARMENTIER, 72 & 74, PARIS

EXPOSITION DE BRUXELLES 1897. — MÉDAILLE D'OR

The great stoves had underground flues which bore away the smoke and fumes after they had circulated round the ovens and had heated the hotplates.

Sharing the stove with the *sauciers* were the *entremettiers* responsible for soups (later, at the Carlton, Escoffier created a special *partie* of *potagers*), egg dishes, omelettes, and the preparation of vegetables, though not, of course, for *pommes soufflées*, which were fried by the *rôtisseur*. By ancient tradition, the *entremettiers* made some of the desserts and sweets; they also made the numerous hot

hors d'œuvres which were so popular at the time (the cold ones were prepared by the *garde-manger*), and, at the Savoy and the Carlton, the indispensable English savouries. Other *parties* included the *pâtissiers*; the *glaciers*, who specialized in ices and iced sweets and drinks; and the *plongeurs*, who washed the dishes and scoured and polished the copper utensils which abounded in the old kitchens. Known to everyone by his powerful and penetrating voice was the *aboyeur*, the 'barker', who called out the orders brought down to the kitchen by the waiters so that each *chef de partie* knew exactly what his particular team had to produce. At the very bottom of the hierarchy were the *garçons de cuisine* who swept the floors and lit the fires, and heaved and pushed the bins of kitchen rubbish in and out of the service entrance. At the back of the Savoy, the *garçons* became a regular, familiar element of local street life. They secreted unspeakable scraps and leavings which, to the annoyance of the *plongeurs*, they bestowed magnanimously on grateful down-and-outs. They knew the names of all the Italian organ grinders who could be heard from the kitchen windows, churning out tunes from *Cavalleria Rusticana* or the latest hit from the Empire or the Alhambra, while little girls in rags and clogs danced and sang to the music with Eliza Doolittle accents. They helped the Sisters of Charity, when they came with a small cart and a very old horse (when it died, Escoffier presented the convent with a replacement), to load their vehicle with surplus eatables for their old people's home. Sometimes, when the guests at a large dinner had eaten a certain delicious *entrée* which consisted of fillets of quails' breasts cooked with small oranges and flavoured with port, there might be two hundred plump little legs left over, unused, and these were always given to the Sisters of Charity. Doubtless the diners at the Savoy fully appreciated their *Filets de Cailles aux Pommes d'Or*, but it was often thought that the old people's version, which Escoffier named *Pilaw de Cailles à la Mode des Petites Soeurs des Pauvres*, was the one which was enjoyed the most.

Day-to-day life in the kitchens of the Savoy Hotel, at the time when Escoffier was *chef de cuisine*, has been brilliantly described by the French writer, Pierre Hamp. After a particularly tough

Pierre Hamp was the pseudonym of Pierre Bourillon. His autobiographical account of what it was like to work as a cook in Escoffier's kitchens in the 1890s is the best we have. Mes Métiers was published in 1931, and a slightly bowdlerized version appeared in English as Kitchen Prelude in 1932.

apprenticeship to a Paris *pâtissier* followed by two unsatisfactory jobs, he applied successfully to Escoffier for a post in London. In November 1894, aged seventeen and speaking no English, he landed at Newhaven after a rough crossing, and found himself in a strange, cold land, inhabited, it seemed, almost entirely by large men in imposing uniforms. At Victoria Station he attracted the attention of two Frenchmen, cooks who had been working in

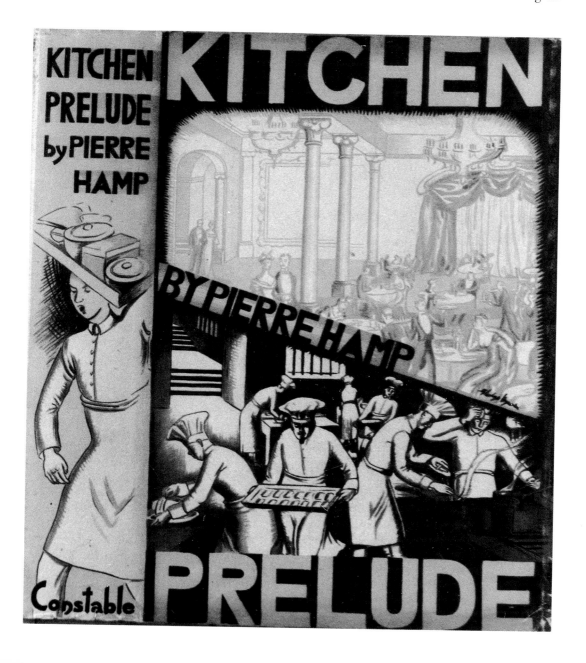

England, and who were now returning to their own country. They were full of grumbles and bitterness. They hated everything English, and even inveighed against Escoffier as an unscrupulous exploiter of youth and a payer of miserable salaries; their advice to Hamp was to get back to Paris as quickly as possible. He ignored them and boldly hailed his first hansom, showing the cabbie a written card which read: Savoy Hotel, Victoria Embankment.

When he was inadvertently put out at the hotel's main entrance, more large men in uniform immediately surrounded him and bustled him unceremoniously round to the back door. Inside the labyrinthine lower regions, Hamp was immediately struck by their extensive layout, so unlike that of any premises he had seen before. Shown to the staff quarters, his surprise increased. His room was so large and clean, compared to the bug-infested attics he had taken for granted in Paris, that for a moment he thought that another mistake had been made, and that he had been taken to a guest's bedroom. There was even the untold luxury of a bathroom. He was, however, quite correctly on the floor reserved for French cooks, Swiss *pâtissiers*, and Austrian bakers; below it was that of the German and Italian waiters; lower still was the floor of the English house-maids. Order was kept by yet another giant in uniform, a burly commissionaire bedecked with so many medals, thought Hamp, that he might have been the conqueror of India.

The kitchens were clean and light; glazed tiles covered the walls; the staff ate good food; and the cooks were allowed to choose their own chops and steaks. By Paris standards, conditions were almost luxurious. Escoffier, a diminutive martinet whose white hat was taller than that of anyone else, governed his brigade from a private office, and let there be no doubt about the nature and extent of his authority. The kitchens of the Savoy were an independent realm of which he was sole and absolute ruler. Even a visit from César Ritz was a rare event; and when one did take place, it was more like a formal, diplomatic meeting between two sovereigns than a routine encounter of a general manager with his chef.

The Carlton menu for the gala dinner celebrating the coronation of Edward VII. Its postponement, due to the king's illness, and the cancellation of the great procession brought on Ritz's physical and mental breakdown. The Carlton management nevertheless did what they could, by retaining the specially printed menu, to create an atmosphere of prolonged royal festivity.

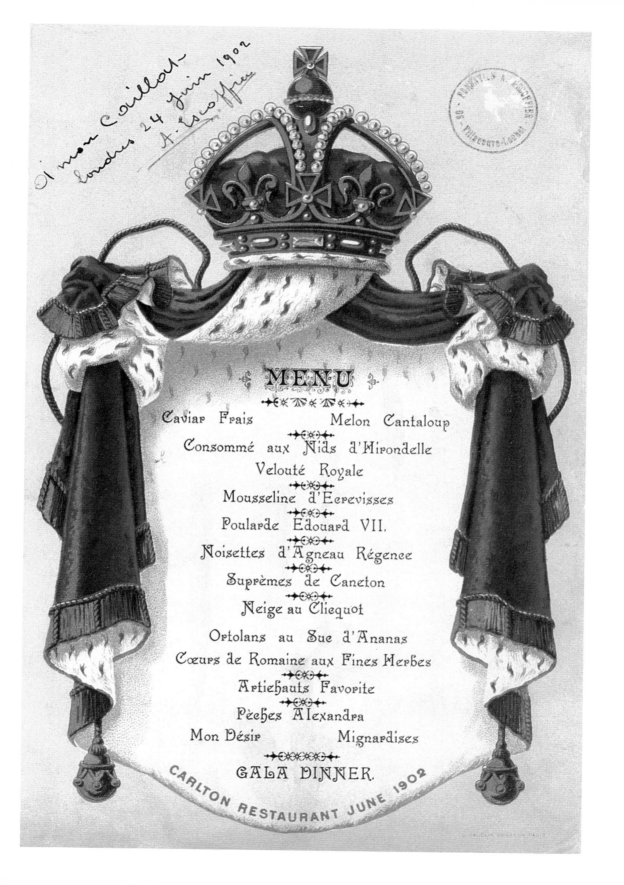

À mon Coillot
Londres 24 Juin 1902
A. Escoffier

MENU

Caviar Frais Melon Cantaloup

Consommé aux Nids d'Hirondelle

Velouté Royale

Mousseline d'Ecrevisses

Poularde Édouard VII.

Noisettes d'Agneau Régence

Suprèmes de Caneton

Neige au Cliequot

Ortolans au Sue d'Ananas

Cœurs de Romaine aux Fines Herbes

Artiehauts Favorite

Pèches Alexandra

Mon Désir Mignardises

GALA DINNER.

CARLTON RESTAURANT JUNE 1902

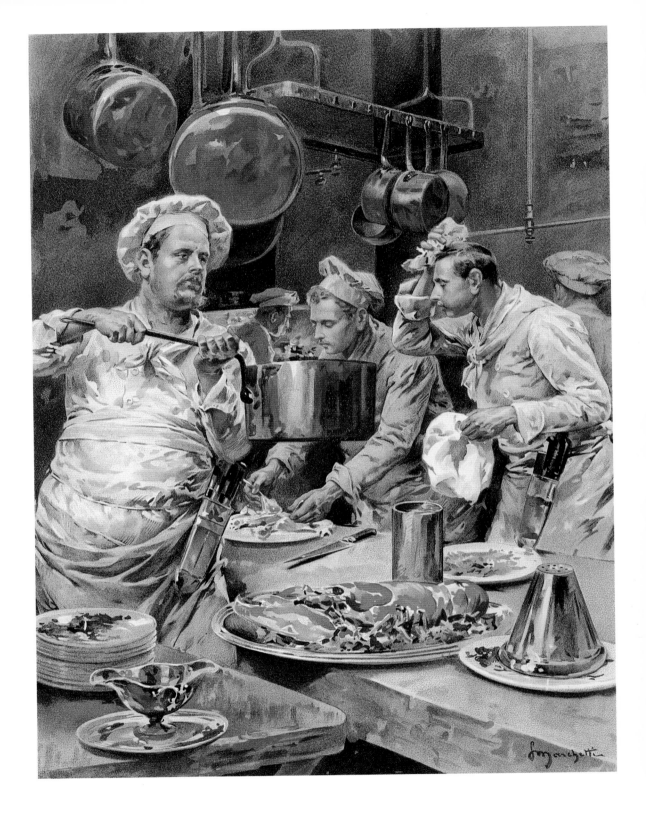

Hamp was allotted to the smaller of the two *garde-mangers*. Here the *chef de partie* was the gentle, poetic and charmingly ineffectual Victor Morin; an old friend and contemporary of Escoffier's who had fallen on hard times after a comfortable, respected career as *chef de cuisine* in a large private house. Escoffier saved him by finding him a place at the Savoy, but the work was never quite to Morin's liking. His dignity was bruised each time one of the busy chefs in the main kitchen called to him to prepare some special cut of meat or a chicken ready for the spit or a dish of *hors d'œuvres*. The traditional shout of '*Garde-manger!*' followed by a brisk order was a recurrent insult to Morin, who would murmur sadly to himself: 'I'm not used to being treated like that! I'm just not used to it!'

His amateur verses were published in *La Revue de l'Art Culinaire*, and were a source of merriment to the other French cooks and of incomprehension to the Swiss *pâtissiers*. His nostalgic articles on the great displays and the flamboyant *garnitures* of the Second Empire cuisine he had known as a young man were ignored by everyone. Another of Morin's complaints against Escoffier was that his old friend only came to see him when he wanted to tell him off; but since the pace of work in the smaller *garde-manger* was often so slow that the efficiency of the entire kitchen was adversely affected, this was not altogether surprising. Then there was the problem of the deep antipathy which grew up between Hamp and the other *commis* who worked with him. It was an enmity which the quiet, courteous *chef de partie* was incapable of controlling. One day it exploded into violence. A half-gutted trout was flung backwards and forwards between the two boys, until it fell to the floor as they set about each other with their fists. Without a murmur Morin picked up the trout, finished cleaning it, and handed it over to be cooked and served to a hungry client.

The two daily coups de feu, *for lunch and dinner, meant periods of hectic, exhausting activity for cooks working in big kitchens. The tension could be terrible, but at the end of it the brigade often took a triumphant pride in the work achieved.*

It was Escoffier's aim to import as many food products as possible from France. These included peaches from the Rhone valley; truffles from Périgord and the Dauphiné; frogs' legs and Rouen ducks from the Halles in Paris; Brétel butter from Normandy and Brittany; and green-tipped asparagus from Lauris in the Vaucluse.

Otherwise the *garde-manger* was mostly stocked with produce bought from suppliers in London. English beef was the best for roasting on the spit, though French meat could be used for making a *bouillon* or a *fond brun*. Poultry and game were delivered to the Savoy by a man wearing a dark suit, a stiff collar, a neat tie, and a bowler hat. To the French cooks he seemed the very embodiment of England, a walking version of Big Ben or the white cliffs of Dover; if anyone dared to make a joke about the Queen, the Constitution or any British custom, he would turn and silence the offender with an expression of withering contempt. As he emptied his baskets, and carefully laid out pheasants and grouse and turkeys on the *garde-manger* table, he would glance at the little group of foreigners and declare with triumph: 'You've nothing like this in France, you know! Nothing! Nothing!'

Next to the smaller *garde-manger* was the *légumier*, where the daily deliveries of fresh vegetables were stored and prepared. Here English cabbages, cucumbers and cauliflowers mingled with Channel Island tomatoes or artichokes and aubergines from southern France and the Italian Riviera. Amid the profusion of crisp, fresh greenery, the domed shells of live turtles moved cumbrously about, waiting to be transformed into the Victorians' favourite soup. From the coasts of Japan they had crossed the Indian Ocean and the Red Sea, nailed by their flippers to the wooden deck of a sailing ship to prevent them escaping or falling overboard. In the *légumier* of the Savoy, the creatures still bore the stigmata of their two-month crucifixion, as Hamp called it; and indeed even the manner of their death was that of an execution. In 1867 Jules Gouffé described how, in the big Second Empire kitchens, the turtle, suspended in the air by its two hind flippers, its head and neck dangling downwards, was decapitated by a swinging blow from a large cleaver. Escoffier, in *Le Guide Culinaire* of 1903, mentions a slightly more gruesome method of slaughter which was certainly the one followed at the Savoy. The turtle was placed on its back near the edge of a table; a weighted butcher's hook was inserted into its jaw to extract its head from the shell; and then its throat was cut, and the blood collected in a bowl placed on the

floor. The flippers were removed (Escoffier cooked them with a *sauce à l'américaine*); the two halves of the shell were prised apart and sawn up for stewing; and the edible meat in the interior was sorted out to make the soup, which was usually accompanied by a glass of chilled milk punch, made with rum and kirsch, and flavoured with orange and lemon. In *Ma Cuisine* of 1934, Escoffier brushed aside the whole complicated business of turtle slaughter, and suggested that it was much easier to buy the soup ready made, and, if possible, hot!

From the cool privacy of the *garde-manger* Hamp was moved to the heat, sweat and turmoil of the great stove in the centre of the main kitchen. Here he worked with the *sauciers* and the *entremettiers*, and got to know new kitchen characters. There was little Macchia, the Provençal *commis rôtisseur*, who toiled for hours, sick, exhausted and on the verge of collapse, in front of the naked fire and the slowly turning capons; and then there was the *chef entremettier*, Monsieur Michel, who had a fine tenor voice, and sang arias from Verdi or Meyerbeer as he scraped away at bundle after bundle of asparagus. Some of the brigade, like the sad Morin or the obscure helper who in his heyday had been a bullying, drunken *chef de cuisine* at the Petit Moulin Rouge in Paris, owed their jobs at the Savoy to Escoffier's charitable concern for the less fortunate members of his profession. Others had mysterious pasts which were hardly ever talked about. One of the *plongeurs*, wanted by the French police, knew he could never return to his native village, or be buried there when he died. Monsieur Louis, the *aboyeur*, had been a croupier in Paris, but had suddenly left on an unexplained journey round the world which involved a long stay in New Caledonia, an island famous for its penal colony.

To escape from the strain of the kitchen, Hamp would sometimes go down to one of the quieter lower floors, inhabited by Viennese bakers and Swiss *pâtissiers*; here he would find Monsieur Eberlé, the *chef glacier* and a born artist, chipping away with hammer and chisel at huge blocks of Norwegian ice and turning them into castles and mountains and storm-tossed ships, to be decorated

later on, upstairs, by bears made of sugar and shepherds in meringue cloaks. Eberlé worked rapidly with frozen fingers, his body protected by a thick apron on which fell a continuous shower of melting ice splinters; he seemed completely happy in his meticulous, ephemeral labour, only pausing from time to time to turn aside from his ice to cough and spit, for he was, in fact, dying slowly of tuberculosis. It seemed only too appropriate that as soon as his masterpieces were completed they were borne away on a kind of stretcher by two waiters in black suits, looking for all the world like a couple of undertakers.

The elderly, grey-haired revolutionary, Monsieur Victor, was another of Escoffier's protégés. A violent and bloodthirsty Communard, he had fled to New York in 1871 to escape execution or imprisonment, and then somehow found his way back across the Atlantic to London and the Savoy where he worked as an assistant in the large *garde-manger*. One evening, when he and Hamp were on night duty together, Victor told him his story. He had been *chef de cuisine* to a rich family in the Faubourg Saint Germain during the Second Empire, hiding for years the sullen hatred he felt for his employers. In 1871 he joined the Fédérés, and helped to burn his employers' furniture and to set fire to the streets of Paris. His birthday was on 23 December and he would celebrate it by wildly plunging his head into the great vat of rum in which currants and dried fruit were macerating before being used for the Savoy's Christmas puddings. One night Hamp found him there, almost unconscious with alcoholic stupor, and pulled the old man out just in time to save him from drowning. Other more circumspect cooks would imbibe the mixture by the handful, swallow the rum, and then spit the chewed currants back into the tub.

If incidents such as these took place without Escoffier's knowledge, there were others in which he could not fail to be involved. In 1895, when the Savoy gave him the title of Directeur des Cuisines, he promoted an Alsatian *chef de partie* to the rank of *chef de cuisine* with the special duty of standing at the *table chaude* and checking each plate of food as it passed out from the kitchen to the waiters

and the *maîtres d'hôtel*. The *chef saucier* at the time was a violent, black-eyed Italian with a furious temper called Bozzone, and there was no love lost between him and the new chef, Monsieur Charles. One lunchtime, at the most hectic moment of the *coup de feu*, the latter twice sent back the *saucier's* dishes to be done again, saying loudly that they were '*mal foutus*', which was just about the most humiliating insult a *chef de cuisine* could throw at a *chef de partie*. The enraged Italian flew at the chef with a metal ladle, and a vicious fight developed as Monsieur Charles defended himself with his fists, knocking off Bozzone's white hat and eventually driving him right out of the kitchen. In the middle of the uproar, Escoffier rushed from his office to restore calm, but found it difficult to do so. For a few moments it was as though an energetic pygmy was trying vainly to separate two battling giants; and it was not until the *chef saucier* had decided to make good his escape that discipline and normal service were finally re-established. The fight left a bad atmosphere among the *ouvriers*; the authority of the *maître* had been flouted and, for a moment, shown to be ineffective; and two senior cooks had allowed themselves to behave in a way which was both undignified and unprofessional. Indeed it was in the wake of this incident that Hamp decided to leave the Savoy, his notice being received with ill grace by an unhappy Escoffier who could hardly bring himself to look his departing cook in the face.

Many years later, at the Carlton, another dispute was to show Escoffier in a far better light. One day Jacques Kramer, Ritz's successor as managing director and therefore a figure of importance in the hotel, came down to the kitchen in the middle of the *coup de feu* and commanded one of the overwrought cooks to prepare him a dish of sphaghetti immediately. When he saw that the pasta was not given first priority, the hungry manager began to shout at the cook until the boy, unable to stand any more abuse, hurled the spaghetti in Kramer's face. A furious row ensued, but Escoffier took the cook's side, defended him vigorously, told the manager off for his lack of consideration, and dismissed him from the kitchen. Morale was strengthened and Escoffier's standing enhanced.

It is from Pierre Hamp's memoir that we get an idea of the appal-
lingly long hours worked by the Savoy cooks in the mid-1890s, and
of the tension which lay behind their fights and outbursts. During
the London season, which lasted from May to July, the kitchens
were expected to be open continuously from seven in the morning,
when the first breakfast might be wanted, until one o'clock the
following morning, when the waiters came down with the final
orders for supper. This meant an eighteen-hour day, which was
only assured when the younger cooks agreed to work shifts of six-
teen hours each on a rota system, and to give up their free time in
the afternoon. In the unremitting heat thrown out by the coal-
burning stove and the *rôtissoire*, and rewarded with only the most
meagre of wages, it was virtually slave labour. When the manage-
ment tried to make the cooks work the full eighteen hours without
a break, most of them refused; it was a question not so much of
illegality but of simple self-preservation.

Sometimes work started at half past six in the morning with the
preparation of the bacon and eggs, the sausages, the kippers and
haddock which constituted the repugnant and incomprehensible
English breakfast. The two periods of *coup de feu*, at lunch and at
dinner, were times of demonic, frenzied activity when up to five
hundred people might have to be served a complete meal in the
space of about an hour and a half. Fifty or sixty men, their lives
suddenly dominated by unseen, unknown taskmasters whose
imperious orders were called out incessantly by Monsieur Louis,
the *aboyeur*, ensconced in his wooden pulpit, struggled, rushed,
pushed, sliced, skinned and poured with the rapid, fantastic
accuracy of skilled fencers or acrobats at a circus. Emotional and
physical tensions rose dangerously. Speed and perfection were
everything; the cooks, perspiration pouring down their faces from
the glare of red-hot metal, struggled and shouted and strove with
the nightmarish determination of men fleeing for their lives from a
burning building. It was only late in the evening, after the last
dinner had been passed over the *table chaude*, that calm descended
on the kitchen and on the cooks waiting for supper orders. These
were intermittent; there was no *coup de feu*; the fires were merely

kept smouldering, to be stirred up with a poker if and when they were needed. Suppers were part of the season's late night jollifications, eaten after the theatre or after leaving somebody's party or ball. If the demand was not intense, the cooks had a chance to rest or chat, but never to close their eyes. When at last they were told to make their way up to bed, they were half dead with fatigue.

Many cooks reacted to the tension by drinking or gambling, but generally the French *ouvriers* responded to the daily challenge with an amazing degree of courage and endurance. '*En sortir*' was the kitchen's equivalent of 'The show must go on' just as the polite, alert '*Bonjour, messieurs*', with which chefs and cooks greeted each other every morning, was a symbol of their professional pride. However great the number of clients, however overwhelming the work, it had always to be carried out satisfactorily; and none but a French brigade, it was felt, had the tradition and the stamina to do this. Other nationalities might produce *maîtres d'hôtel* and waiters and hotel managers, but only the French could provide the sheer staying power it took in those days to work in a professional kitchen. From one of the windows at the Savoy the cooks could see men working on a nearby building site, and it was a source of amusement to them, when the siren blew at mid-day, to watch the Englishmen stop work instantly, no matter what it was they were doing, put on their bowler hats, and scamper away for their lunch hour. The brigade had only contempt for any French cook who failed to keep up with the rest of his *partie*. On one occasion Escoffier gave one of his protégés a temporary job with the *sauciers*; he had been chef in a quiet *maison bourgeoise*, and at his first *coup de feu* he collapsed under the pressure, and had to sit down on a chair. The poor man was so teased that he was never seen again at the Savoy!

It would be wrong to think that Escoffier was blind to the troubles and problems of the ordinary working cook, however much of an insensitive autocrat he might have appeared at times to the junior members of his brigade. Concern over the low level of the cooks' social status had been growing steadily among leading members of

the profession ever since about 1870, and in 1883 Philéas Gilbert raised the matter in some of the early issues of *La Revue de l'Art Culinaire*. Neither he nor Escoffier had ever forgotten their own misery as apprentices in the 1860s, nor their early reflections about a cooking career. Pale, dirty, malodorous, and usually without much formal education, cooks felt themselves ostracized and despised. In London they formed a small clique of their own, haunting the streets and cafés of Soho, speaking little English, and with hardly any spare time in which to explore other parts of the city. Escoffier tried to make them dress better when they were out of the kitchen; to think more highly of themselves and of their craft; and, above all, to give up their habitual drinking, gambling and bad language. He encouraged some to write about their work; others, like Victor Morin or Achille Ozanne, to write poems or, like Sylvain Bologna, a member of Escoffier's brigades at both the Savoy and the Carlton, to draw and paint. In 1910 he published a pamphlet outlining his own proposal for a universal Friendly Society to provide financial assistance to the poor, including cooks. He also took an active part in the running of several charities for the benefit of aged or destitute members of the profession.

It is interesting that Escoffier should have been expressing these concerns just at the time when Lloyd George was devising the legislation which would lead eventually to the Welfare State. This included the Old Age Pensions Act of 1908; the controversial 1909 Budget; the 1911 National Insurance Act against illness and unemployment; and the Shop Hours Act of 1911, legalizing weekly half-day closing and annual holidays. This latter Act would have been of special relevance to cooks; but, unfortunately, since kitchens were classed neither as factories nor as shops, culinary workers were put into an ambiguous position as regards any legal benefits. Such was the tension this caused that in 1913 cooks' and waiters' strikes broke out at a number of important London hotels and restaurants (including Claridge's and the Savoy, but not the Carlton where an acceptable agreement had already been reached with the staff) over the whole matter of holidays, long hours, bad food, and impossible working conditions, which included in one

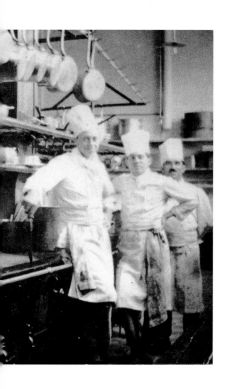

Chefs de partie
*in the kitchen of a
large hotel.*

case the odious behaviour of a particularly tyrannical *maître d'hôtel*. Noticed perhaps by Saki, the cooks' downing of tools may have inspired the serious industrial action which, in *The Byzantine Omelette*, devastated Sophie Chattel-Monkheim's dinner for the Duke of Syria; and the incidents were certainly a reflection of the major national strikes in the docks, railways and mines which had already shaken Asquith's Liberal government in 1911 and 1912.

That there were no strikes at the Carlton is hardly surprising, for it seems that Escoffier had always been aware of the importance of creating a good relationship between management and staff. At Monte Carlo in the 1880s he was a leading figure at the local cooks' club and vice-president of their annual dance. In 1912 he attended the cooks' ball in London; and in 1911 he presided over the Christmas dinner and concert given for the cooks at the Carlton. The kitchen on this occasion was hung with decorations, a long, festive table was laid, and sixty-five cooks sat down to eat their fill of oysters, grilled *andouillettes*, stuffed turkey, plum pudding and *bombes glacées*. The champagne was Moët et Chandon 1904, and after coffee and brandy and a speech by Escoffier the concert began. There were comic turns, dramatic recitations, several favourite songs and even a cello solo. When Escoffier raised his glass and drank to the health of everyone present, to their families, and to their successful careers, it may well have been the happiest and most harmonious moment of the year for the whole brigade.

To some cooks it may also have been the most hopeful. The patriarchal figure in the neat, dark suit had once been a bullied apprentice and a sweating *aide-rôtisseur*; now he was not only an admired leader, he was living evidence that somewhere, beyond the confines of the kitchen inferno, there existed a world of dignity and respect which even a *commis saucier*, if he worked hard and was lucky, might one day be able to share.

THE *Master* OF *French Cuisine*

*Edwardian Rococo.
A sternly personalized
aristocratic menu
of 1909.*

Avoided by the rest of the hotel staff, the Savoy kitchens were like some remote autonomous state, an impenetrable country which only the bravest of foreigners ever visited. Its frontier was the *table chaude*, the long, heated table on which the food was placed when it was ready for the dining-room. On one side, the harassed cooks sweated and toiled; on the other, the well-groomed, smartly dressed waiters and *maîtres d'hôtel* queued obediently at the special sections marked with the names of the various *parties de cuisine*. In their black suits and white aprons, they clustered round like predatory bluebottles, picking up the fruit of the cooks' labour

and bearing it away, out of sight, down the long, ill-lit passage which led to the restaurant.

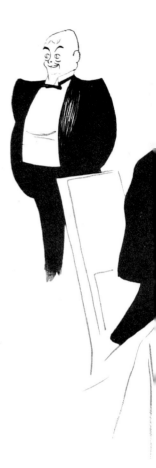

Many of the cooks, who were French, hated the waiters, who were usually Italian, Swiss, or German, and who lived apart from them on a different floor of the staff quarters. The waiters had all the glory, it was felt, and the cooks had all the work. In the restaurant the waiters never ran or shouted or swore; they got better pay than the cooks; and in addition they could earn magnificent tips. If a guest enjoyed his dinner, it was the waiter who received all the compliments, not the cook; for it was the man in black who came into direct contact with the client, who talked to him, advised him, and in time, with tact and skill, could build up some sort of regular acquaintance with him, though not perhaps quite as deviously as did Felix Krull.

But things were not always as good for waiters as cooks liked to imagine; compliments could be followed by angry or petulant complaints; the hierarchy in the *salle* was as complex and as autocratic as that of the kitchen; and on at least one occasion, when a waiter spilt a plate of soup right down the front of a woman diner's elegant Paris dress and then, in a panic, tried to mend matters by frantically dabbing at her with a cloth, the man she was with sprang promptly to his feet, and in true Edwardian style knocked the unfortunate offender to the ground. But even an event such as this, happening in the middle of a crowded restaurant, failed to deter kitchen workers from supposing that any waiter's lot was far easier than their own. No *commis* cook who ventured down the long, stone passage ever forgot the impression the first, distant glimpse of the restaurant made on him. The order, the tranquillity, the white tablecloths, the cutlery, the glasses, the women's clothes and jewellery, their magnificent hats, the smart shoes resting on the scarlet carpet over which the waiters moved grandly and almost confidentially from customer to customer beneath a gilded ceiling; all were a revelation of life lived on another planet which, as far as most cooks were concerned, would for ever remain unattainable.

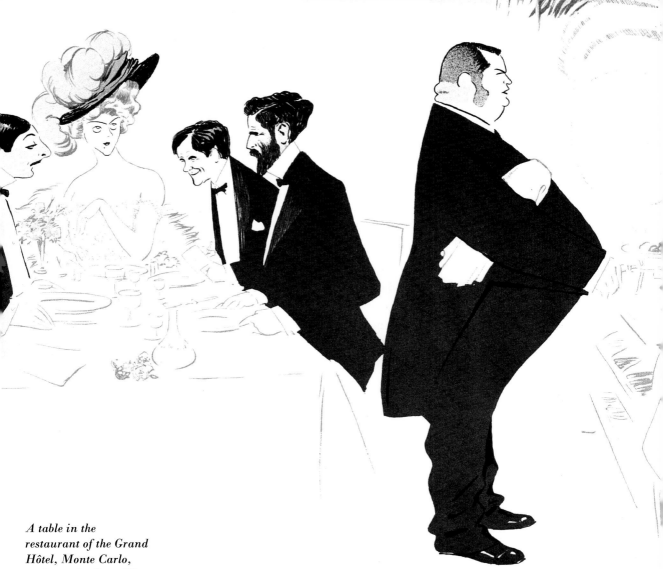

A table in the restaurant of the Grand Hôtel, Monte Carlo, as drawn by Sem. The man standing on the left is Monsieur Patard who succeeded Xavier Jungbluth as proprietor in 1887. Ritz left the hotel when he took over, but Escoffier continued to work under him until 1890.

One incident typifies this feeling of infinite distance and unattainability. Late one night in 1893, during the great Italian actress's first London visit, one of the *maîtres d'hôtel* at the Savoy came down to the kitchens with a supper order from Eleonora Duse. She had returned to the hotel, worn out after a particularly demanding evening performance, and then rang to order a *consommé* and a poached wing of chicken, specially asking the waiter to say to the chef how sorry she was to make him work so late, and to explain the reason. Downstairs the message was passed on. Duse's gentle

words, her weakness and exhaustion, her simplicity, her under-standing, overwhelmed both the waiter and the duty chef with emotion. It was something that had never happened before. A star, as it were, shining in the firmament, had actually apologized to them, the denizens of an underworld, because an order had been given late. A great client had treated them almost as though they were her equals, and that, in 1893, was rare.

The chasm which lay between the world of the kitchen and the world beyond was immense, but nevertheless it was the dream of every *ouvrier* to cross it. He faced a time limit, however. Few cooks could stand the intense physical pressure of the daily *coups de feu* much after the age of thirty. A successful cook, on the way up, had to have been a good *chef de partie* in his twenties, and then *chef de cuisine* before his thirtieth birthday.

Thereafter there were two ways ahead. Either the cook could stay within the hotel system, and become the privileged, black-coated, Escoffier-like manager of a prestigious restaurant or of the kitchen in some important establishment; or he could take a comfortable job as chef in a large private house, where he could start to build up capital through commissions paid to him by suppliers, indulging in some discreet falsification of accounts, and making a profit on purchases. If, at the same time, he was lucky enough to acquire even more money by marrying the well-endowed daughter of a wealthy wholesale grocer or butcher, so much the better. Adolphe Dugléré, *chef de cuisine* at the Café Anglais and the inventor of a famous sauce, earned far more money on the side as an amateur picture dealer than he ever did from his commissions and investments. Eventually our cook could look forward to a comfortable retire-ment; or, if he wanted, he could decide to set up his own restaurant, perhaps in Paris, and become a proprietor, perhaps even an impor-tant and well-known personality, giving the establishment its tone and entering, at last, into direct and honourable contact with his clients.

The media have made us so aware of the much-publicized chef-

proprietor of the 1960s and after that we easily forget the *maître d'hôtel*-proprietors who dominated the great restaurants of the nineteenth century. The chef was an important character, naturally, but he was someone the diners hardly ever saw. At the Grand Hôtel, Monte Carlo, a client arriving at the Oriental Restaurant would be shown to his place under the arabesques by a *maître d'hôtel*, and then be offered the menu by César Ritz, as he moved about the room bestowing polite words of welcome on each table,

Elennora Duse, the great Italian actress, was one of the first of the Savoy's famous theatrical clients. The naturalness of her style was in direct contrast to Bernhardt's French theatricality. They sometimes both played the same role. Marie Ritz admired her performance in La Dame aux Camélias, *for example, but Ritz and Escoffier preferred that of Sarah Bernhardt.*

always suiting his phrases to the rank or status of its occupants, his hands clasped tightly behind his back, a sign, people said, of the strain and worry of his job. Escoffier was present in the food, but never in person. Had he appeared, most clients would probably not have recognized him, but they were flattered if Ritz remembered their names, and even more pleased if Monsieur Xavier Jungbluth, the proprietor, greeted them in the hall and stopped for a short chat.

The chef's inferior rank was completely in line with a system of domestic hierarchy inherited from the French eighteenth century. In princely or noble houses of the *ancien régime*, the catering arrangements were in the hands of a professional *maître d'hôtel* who purchased supplies, arranged the menus, kept the accounts, and who had under him two important subordinates: the *écuyer de cuisine* (the modern chef) and the *officier de l'office* (the modern wine waiter). The *maître d'hôtel* would have been in charge of a kitchen at some stage of his career as part of his training; but his ultimate position was vastly superior to that of the *écuyer*, though socially he long remained very much the inferior of his employer. In 1829, after a splendid banquet given by James de Rothschild at his estate near Paris, Lady Morgan, the Irish novelist, asked to be introduced to the man who had organized it all, Antonin Carême. It is interesting that her meeting with the most famous *maître d'hôtel* of the age of Napoleon and George IV was only permitted to take place in the vestibule near the front door while a carriage waited outside to take him home. The position of certain restaurant owners of the Second Empire was rather more solid. Edmond de Goncourt gave Bardoux of the Petit Moulin Rouge a place in his Journal, but other proprietors were inclined to be more haughty. At the Café Riche, the most expensive restaurant in Paris and estimated in 1867 to be worth a million francs, Louis Bignon refused to notice anyone lower than a duke, his place in the dining-room being taken by his rather more approachable *maître d'hôtel*, the plump, smiling Henry, whom it was a positive joy to watch as he carefully and lovingly poured the sauce over a *Barbue au vin rouge*, and whose well-fed person could always be counted on to put

Paintings of the nineteenth-century kitchen scenes are rare. Théodule Ribot was probably the only artist of the time to take an interest in the life of the working cook.

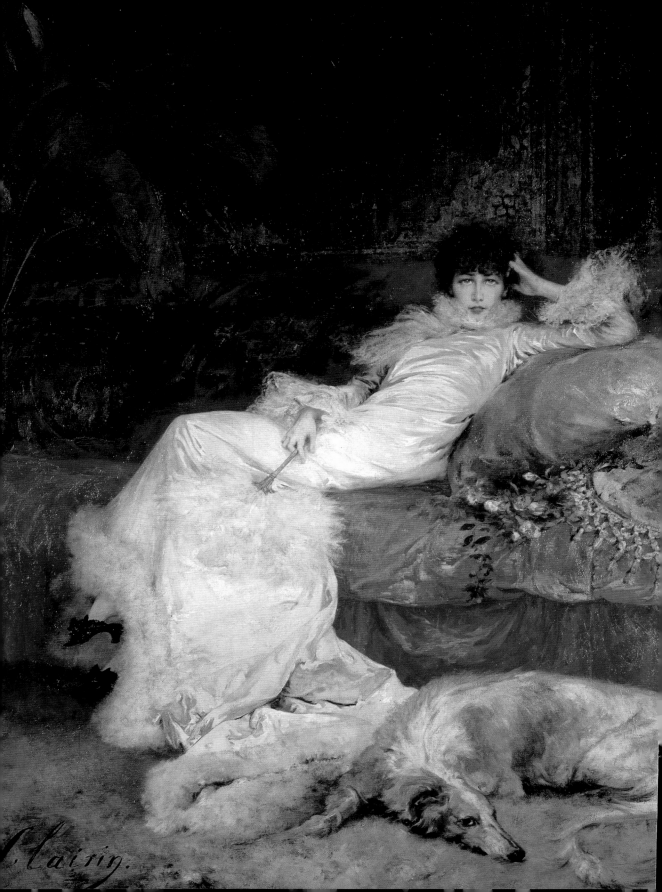

Clairin.

people into a hungry and festive mood. The owners of the Maison Dorée, the famous Verdier brothers, were another example of proprietorial arrogance. They only talked to clients whose political opinions were the same as their own.

Escoffier's success in liberating himself from the kitchen underworld was astonishing at the time. Even today it seems extraordinary, and not altogether easy to analyse. He not only bridged the gap between *cuisine* and *salle*; he also bridged the greater gap between management and the board of directors. In the beginning he had followed the first of the two courses already mentioned (his attempt to start his own restaurant did not last), that is to say, he stayed within the hotel system to become kitchen manager at Monte Carlo and the Savoy; but after this, personal factors peculiar to himself came into play: he had star quality. A brilliant cook, he possessed, in addition, subtle traits of character which set him quite apart from other cooks of his generation, even when they were as skilled as he was. As *chef de cuisine*, in his early days in Nice and Paris, there was something about him which people at once liked, which attracted clients and won their confidence and respect. The same feelings, later on, were to enter into Escoffier's friendships with people like Lord Northcliffe and Sarah Bernhardt; they were also shown him by members of his own profession, who, by the 1890s, had recognized him as a leader. Integrity combined with instinctive discretion and a deep sympathy for other human beings enabled the disciplinarian of the Savoy kitchens to make meaningful contacts on different social levels at a time when such differences were far more divisive than they are now. He was never intimidated or overawed by a superior, nor did he ever patronize an underling. His manner and personality remained unchanged, irrespective of whether he was talking to the Prince of Wales or Adelina Patti, or whether he was complimenting or dressing down one of his junior cooks.

Up to 1883 Escoffier's career had been similar to that of many others; but through his meeting with César Ritz, and through the collaboration and partnership which grew up between the two

In this portrait by Clairin, a dog lies peacefully at Sarah Bernhardt's feet. In Paris she lived habitually with two immense hounds, five pumas and a boa-constrictor which she was evtually obliged to shoot with her own revolver.

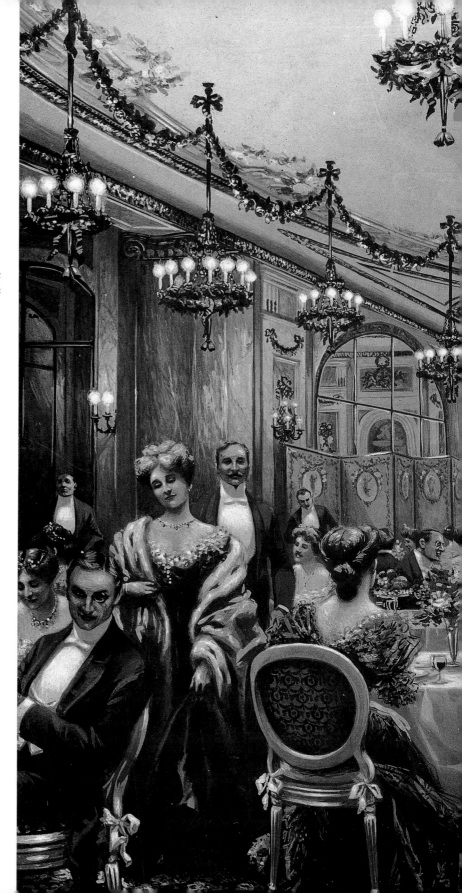

The restaurant at the Ritz

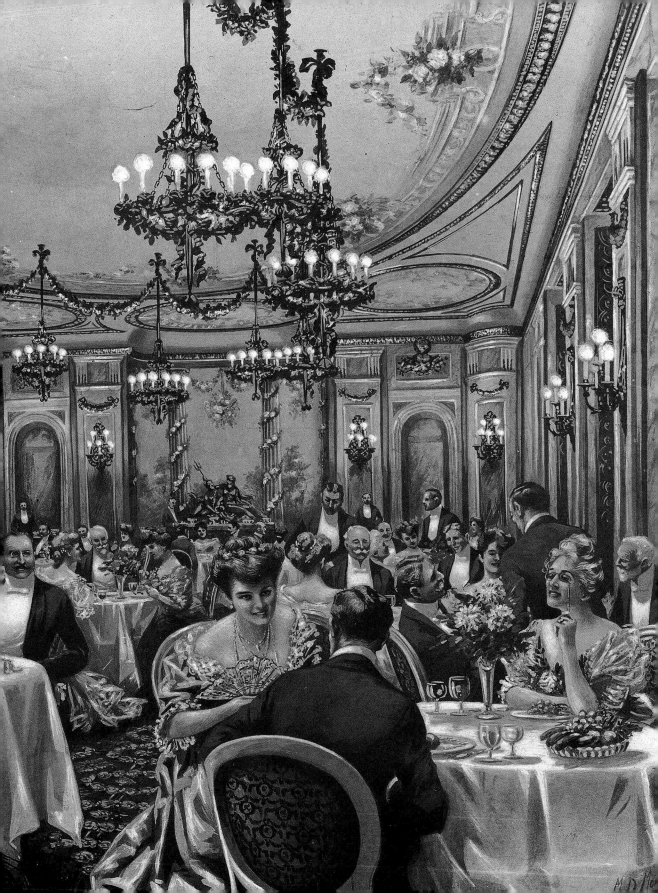

men, came a highly significant rise in professional and social status. From being a kitchen manager he became, in 1897, a member of the board of directors of Ritz's hotel company, and thus ultimately one of the proprietors of both the Paris Ritz and the London Carlton. Hotel proprietorship was normally out of reach for anyone from the cooking profession on account of the large amount of capital needed to enter it. The barrier was first broken by the energy and determination of Ritz (who married into a family of hotel owners) and by his amazing ability to raise capital. It was Ritz who transmuted Escoffier from chef into company director, and thus put him, officially at least, on the same level as the former's financial backers: people such as Calouste Gulbenkian, Jacques de Gunzbourg, Henry Higgins and Sir Alfred Beit. It is important to remember, however, that this would not have happened if Escoffier had not been Escoffier; and that a key element in his whole later career was the fact that he never completely abandoned his role as *chef de cuisine*. His directorship provided a permanent means of making fresh international contacts; but every Sunday, when he was at the Carlton, he put on his white coat and hat, and worked in the kitchen. Up in his first-floor office, he went on creating new dishes and new menus, writing down his ideas, and covering sheet after sheet of paper with his neat, meticulous handwriting.

The relationships which Escoffier built up with his clients were very varied, and often extended over many years and places. It was at Nice, as an apprentice and as a young chef, that he first met important customers, English, Russian and French. In 1867, the year of Napoleon III's Great Exhibition, many celebrities ate at the Petit Moulin Rouge, but Escoffier particularly remembered the colourful arrival one evening of the Emir Abd-el-Kadar, the Algerian leader who for years had fought so courageously against the French army. The bearded, dark-eyed Emir and his suite, all dressed in flowing Arab robes, arrived in two landaus, and strode into the restaurant garden where a table had been prepared for them, somewhat exotically, in the Chinese Pavilion. Naturally the promising young *chef garde-manger* recorded every detail of their

menu. After 1873, as *chef de cuisine*, Escoffier was in regular and frequent contact with dukes, statesmen and *demi-mondaines*, advising them over dinners, and suggesting dishes and recipes which could be specially created in their name. On one occasion he was asked to invent a soup to be dedicated to a winning racehorse.

Among the Petit Moulin Rouge's more awkward customers was Prince Galitzin (immortalized by *Faisan Galitzine*, a pheasant stuffed with truffles and minced snipe) who ate there frequently with the *demi-mondaine* Blanche d'Antigny. He was known for his puffy cheeks, and for the way he behaved towards his French servants, treating them like moujiks and even beating them if they allowed him to get away with it. At the restaurant he was a mean tipper and was odious to the waiters if he thought they were being too slow, though they took their revenge by spitting into his food on its way down the dark passage which led from the kitchen to the dining-room. When dining at the Carlton many years later he had a long, nostalgic talk with Escoffier, lamenting his vanished youth and his evenings at the Petit Moulin Rouge. 'I was young in those days and I led a joyful existence,' he mused, oblivious of the waiters' spittle. 'Now I am haunted by the pleasures I can never have again.' Usually, however, the Russians who came to the restaurant were generous and well liked; they spent money in Paris during the summer, when nobody else stayed there. Old Prince Anatole Demidov (inspiration for Escoffier's *Consommé Demidoff*), for example, a familiar figure during the Second Empire and once the impossible husband of Princess Mathilde, would go to the theatre in the middle of a heatwave, when it was half empty, and could be seen sitting in his box with the actress Duverger, resplendent with diamonds, all of which he had given her.

Gustave Doré lunched regularly at the artists' table. His studio was in the nearby rue Bayard; and Escoffier, the former would-be student at the Ecole des Beaux-Arts, had many conversations with him on the subject of painting and sculpture. They may also have talked about London and the English who were then still very fresh in Doré's creative imagination; his dramatic vision of con-

trasting wealth and poverty, and of a tiny worm of decay relent-
lessly gnawing at the heart of all the splendour, was subtly
prophetic of the Edwardian age which the *chef de cuisine* was to
know so well.

It was through Doré, in 1874, that Escoffier first met Sarah
Bernhardt. She was taking sculpture lessons at the rue Bayard
studio, and at the end of each day master and pupil were in the
habit of ordering one of Escoffier's suppers which was sent over
from the Petit Moulin Rouge. The meal often included a *timbale* of
sweetbreads and fresh pasta combined with a purée of foie gras and
decked out with truffles, which soon became one of the actress's
favourite dishes. 'It is to that *timbale*', wrote Escoffier subsequent-
ly, 'that I owe my long friendship with Sarah Bernhardt.' Over the
years they met frequently in London (which she visited almost
annually after 1895), Paris and New York; the last time they saw
each other was at Monte Carlo, shortly before her death in 1923.
The course of their two careers, and the status each had won in the
eyes of the world, were not altogether dissimilar, and their rela-
tionship was based on a deep, sincere affection and on the great
respect each felt for the other's achievements. The theatre and the
grand hotel are both, in their different ways, purveyors of illusion;
and old hands in either trade acquire the same shrewd knowledge
of what is true and what is pretence in human nature. Bernhardt
and Escoffier often had meals together at the Savoy or the Carlton;
occasions on which, it is tempting to imagine, the small, quiet man
with the grey moustache and the gold cuff-links was the only
person with whom the temperamental, flamboyant actress could
relax and, far from her attendant court, simply be herself. Escoffier
invented numerous dishes which he named after her; he was a
fervent admirer of her work in the theatre; he attended her first

*Sarah Bernhardt in her
Paris drawing-room*

nights whenever possible, and often celebrated them with a magnificent supper and a sumptuous menu of his own designing. One of the things he treasured most was the letter she wrote him from the Savoy on hearing that one of his sons had been killed at the front in 1914: '*Mon cher, cher ami . . . J'ai su ici votre douleur et mon coeur est plein de tristesse et mon amitié est plus grande encore. Sarah Bernhardt.*'

In 1910, when Escoffier was in New York, superintending the installation of the kitchens in the newly completed Ritz-Carlton Hotel, Bernhardt was there as well, staying, as befitted a great French actress, at the Hotel Marie Antoinette. She invited him to have lunch with her. During the meal, Escoffier asked her about the secret source of her amazing vitality. At first she was coy, but eventually she told him what it was. Every day, she explained, and with each meal, she never failed to drink half a bottle of Moët et Chandon champagne! Charmed, and sworn to total discretion, Escoffier felt honoured by the confidence, but he did not repay it by revealing a secret of his own, which had been puzzling Bernhardt for years. How, she always wanted to know, did he make such delicious scrambled eggs? No cook in the world could do them as well. The answer, which the actress never learned, was simple enough: before stirring the eggs, Escoffier always put a little bit of garlic on the end of his fork! It was a tiny detail, typical of the art of a great cook; but had Bernhardt known, she would have been horrified, for in those days even the slightest whiff of garlic was socially taboo. Escoffier's enigmatic little shrug, followed by a smile and complete silence, was typical of his customary discretion.

The Prince of Wales, later Edward VII, in 1878.

One July afternoon in 1874, Escoffier was handed a note specially addressed to him by Léon Gambetta. The republican politician wanted a room for three that evening at the Petit Moulin Rouge, and specified that the dinner should include a saddle of lamb and a chicken cooked with tarragon; items to which, in due course, Escoffier was to add melon; soup; fillets of sole garnished with roes *à la meunière*; a crayfish soufflé with layers of freshly cooked

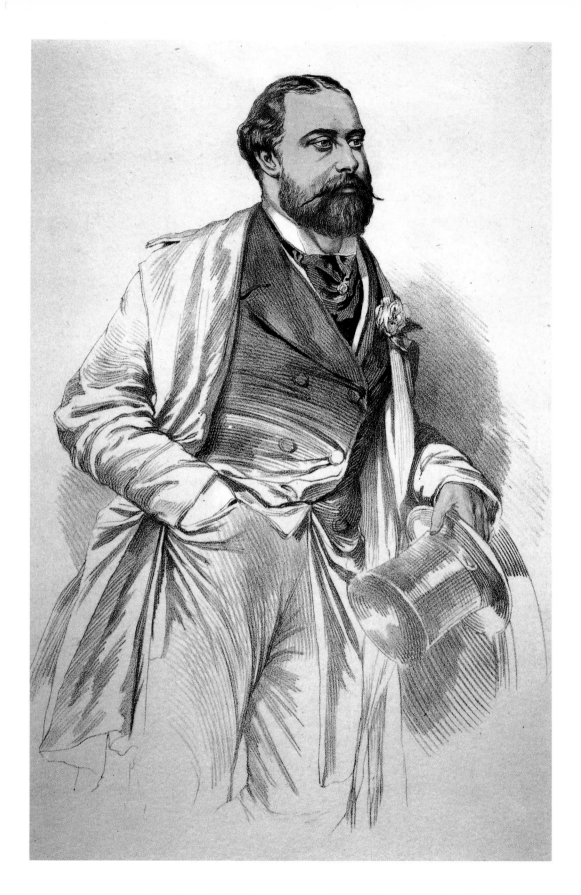

asparagus tips, crayfish tails and slices of truffle; a *biscuit glacé Tortoni*; and Montreuil peaches. The wines were Chablis and a Cos d'Estournel, Etampé 1864. Excellence was essential, not only because the occasion was the first of several, but also because one of Gambetta's guests was the republican Sir Charles Dilke and the other was the Prince of Wales, later Edward VII. It was characteristic of the latter, who was both an unofficial diplomatist and a distinguished royal gourmet (when he died in 1910, obituaries in the culinary trade press ignored the historical events of his life, and concentrated on the story of his magnificent appetite) to want to meet Gambetta face to face, for the fiery Frenchman was then the active leader of a strong anti-monarchist movement directed against the royalist President, the former Marshal de Mac-Mahon, and was therefore a potential opponent to the future king of England. As usual, however, the Prince's charm and intelligence triumphed over any hostility; and he certainly made a friend of Gambetta, even if he could not change his opinions. The Prince also noticed and appreciated Escoffier's cuisine; so much so, in fact, that from then until his accession in 1901 he was to prove one of the chef's most loyal and discerning clients. At the Savoy, he ate Escoffier's food at banquets and at many private dinners with Mrs Langtry and other friends from the Marlborough House set; and in 1900 he put his seal of approval on the new Carlton restaurant when he dined there on the day of the Derby. Escoffier felt greatly honoured by this appreciation, and kept a special notebook in which he recorded all the menus and dishes he prepared for the heir to the throne. The Prince, for his part, not only liked eating Escoffier's food; he also liked chatting to him, and getting him to tell the story of the famous occasion on which he managed to serve frogs' legs at a very smart and quite unsuspecting English supper party by christening the dish *Nymphes à l'Aurore*.

In February 1885, while staying at Cannes, the Prince of Wales heard that Escoffier was doing his first winter season at Monte Carlo, and immediately telegraphed the Grand Hôtel to book rooms for himself and his suite. He would be arriving the following afternoon. The news threw Ritz into a state of consternation, how-

ever; there was no room available with a private bathroom, without which a royal visit was unthinkable; a bathroom would therefore have to be created in less than twenty-four hours. The thing seemed impossible, but it was done nevertheless. All through the night Ritz urged on a bewildered team of painters, plumbers, decorators, upholsterers and carpet layers until at last, by lunchtime the next day, all was in perfect readiness, and an untroubled manager could welcome the Prince as he stepped out of his train, and proudly conduct him to the hotel. After spending some time at the casino, the distinguished visitor was accompanied back to the Grand Hôtel for dinner. A table for ten had been prepared, at which, according to *Le Figaro*, the guests included the Prince and Princess of Saxe-Meiningen, Mrs Fraser, Major Stevenson, Captain Percival and Mr Knopp. The Prince had asked Escoffier for 'something light but delicious'; and the chef duly obliged with a menu which featured *Poularde Derby*, a plump, stuffed chicken garnished with large truffles cooked in champagne and interspersed with slices of foie gras sautéed in butter and carefully arranged on *croûtons*, the accompanying sauce being based on the combined cooking juices of the chicken and the truffles. The Prince was full of praise for everything and said the meal had not only been 'fit for a prince', it had been 'truly royal'. After dinner, exhilarated by the good food, he took his friends to a concert given by the Belgian violin virtuoso, Martin Marsick, whom he applauded vigorously and loudly. In 1887 the Prince of Wales enjoyed another dinner at the Grand Hôtel; the menu this time included a saddle of lamb (one of his favourite dishes, as Gambetta knew); stuffed partridges with little game *quenelles*; and artichoke hearts cooked with marrow and Parmesan cheese.

Though visits below stairs were rare until the end of the century, and it is unlikely that the Prince descended into the cooks' underworld to inspect the stove and the *rôtissoire*, it is nevertheless at Monte Carlo in the 1880s that we first hear of a client making a special point of coming to see Escoffier in his kitchen. Katinka, one of the most attractive and successful *demi-mondaines* of the time, was spending a whole winter at the Grand Hôtel as mistress of the

fabulously rich Prince Kochubey (she travelled as part of his large suite of secretaries, couriers and valets). A keen amateur cook, and especially knowledgeable about the cuisine of her native Hungary, she enjoyed long talks with Escoffier during which she may have introduced him to some of the recipes *à la hongroise* which appeared later in *Le Guide Culinaire*. When she told him of her dream to eat prawns or crayfish, which she loved, without having to shell them messily with her fingers, he invented the *Rêve de Katinka*; and it was at her suggestion, and to please the Prince, that he one day added some frogs' legs to the fresh Mediterranean crayfish which garnished the whiting mousse. Once, when she was in bed with *la grippe*, Escoffier provided her with exquisite invalid food; but the occurrence was remembered less for his *consommés* and his *poulardes à la gelée* than for the fact that the elderly hotel doctor fell violently in love with his beautiful patient, ruined himself in buying her orchids, and finally, when she begged him to leave her alone, tried to poison himself.

In 1886, when the great soprano Adelina Patti was singing at Nice (Monaco could no longer afford her after her season there in 1881, when the combined costs of her salary, her villa and the various fêtes given in her honour had been colossal), she often came over to Monte Carlo just to eat at the Grand Hôtel. After enjoying several excellent restaurant lunches, she one day asked the proprietor how he could manage to eat so well and yet remain so active. In reply Xavier Jungbluth invited the singer to lunch the following day, and promised her that she would be able to share the simple food which his family ate every day. Escoffier was in charge of the cooking. The meal consisted first of a *pot-au-feu*, the *bouillon* being eaten as a soup, and the beef, surrounded by sausages and vegetables, following it as a separate course; and then came a chicken, spit-roasted, and accompanied by a chicory and beetroot salad. Here the meal should have stopped, except for a light dessert; but Escoffier could not resist going on with a *Parfait de Foie Gras Sainte Alliance* (a special creation, and, in the chef's own words, 'a jewel of French cooking'). Its name had nothing whatsoever to do with the Congress of Vienna, though Brillat-Savarin had used it to

Adelina Patti was the greatest coloratura soprano of the second half of the nineteenth century. She charged the then unheard-of fee of £1000 for a single performance, and used her fortune to build a fantastic castle in Wales complete with its own opera house and its own railway station. Escoffier knew her at Monte Carlo and at the Savoy and the Carlton in London. Before her retirement in 1906, Patti was threatened by the rising star of Melba. The two singers hated each other; and it was Ritz's job to make sure, if both were in the restaurant at the same time, that their tables were far apart.

describe a recipe for stuffed roast pheasant (admiringly repeated in *Le Guide Culinaire*), but referred instead to an 'indissoluble alliance' between the truffles of Périgord and the famous foie gras of the Jungbluths' own lost, native province of Alsace. The meal was brought to a close by an orange mousse encircled by strawberries

macerated in Curaçao. Verdi's favourite soprano must have appreciated this slight extension of her 'simple lunch', for she was still enjoying Escoffier's food at the Carlton in 1909, several years after her retirement. In the meantime there had been many *poulardes*, *suprêmes de volaille* and *coupes glacées*, which the *maître* named either 'Adelina Patti' or just simply 'Diva'. She may also have tasted the *Poularde Sainte Alliance*, invented at the Carlton in 1905, and memorable for the fact that no fewer than four waiters were needed to serve it.

During the summer seasons with Ritz at the Grand Hôtel National at Lucerne, Escoffier continued to receive many of his regular Monte Carlo clients, but also met new ones. With the Count of Fontalva, for example, the Portuguese minister at Berne, who arrived every year in a splendid carriage drawn by six mules, he planned dinners and suppers to form part of magnificent fêtes given on board illuminated yachts and pleasure boats as they sailed down the lake on hot August evenings. In 1887, the year of the Golden Jubilee, the Maharajah of Baroda stayed at Lucerne on his way to London. He insisted on eating Indian food wherever he was (though the Maharanee took a great liking to the local *petite friture*, the tiny, whitebait-like fish which abounded in the lake), and never travelled without his Indian cook. Escoffier tried hard to learn *la cuisine hindoue* but found it much more difficult than learning from the Russian cook at his uncle's restaurant at Nice. The concept of a standard recipe turned out to be quite foreign to the Indian way of thought; each cook worked in his own way, and quite differently on different occasions, even though the end result turned out more or less the same. Escoffier's classical French mind, and even his instincts as a chef, were completely baffled; either every single cook in the sub-continent was right or every cook was wrong; it seemed impossible to make logical distinctions. Curry recipes in *Le Guide Culinaire* are, in consequence, cautious, and usually amount to little more than the addition of a pinch or two of curry powder.

In London in the 1890s the best Indian food was said to be that of

the East India Club in St James's Square, and perhaps it was to meet this challenge that the Savoy employed an Indian-born cook, working quite independently from Escoffier, to provide authentic curries for those clients who wanted them. The Indian was known to everybody as Smiler, perhaps because he extended such a beaming welcome to any Indian Army officer, home on leave and calling in at the Savoy for lunch, who could greet him with a smattering of Urdu or a triumphant phrase or two in bad Hindi. Smiler's curry-chariot made an exotic counterpart to the 'oriental' trolley (inspired, no doubt, by the one at Monte Carlo) which made its way round the restaurant, dispensing coffee; the latter resembled a gondola on wheels, equipped with a sort of central kiosk and crowned by a star and crescent. It was manœuvred about by a robed Turk with a red fez, assisted by two lively and colourful little boys.

In September 1893 Emile Zola and his wife, in London as the official guests of the Institute of Journalists, stayed at the Savoy where they were sketched by a magazine artist, posing near one of the windows of their suite, with Big Ben and the Houses of Parliament in the background. The man of letters is writing at one of Marie Ritz's Maples–Louis Quinze tables, and Madame Zola is standing beside him with a book in her hand, possibly the final volume of *Les Rougon-Macquart*, which Emile had just completed. The novelist was a great eater, but not a very subtle gourmet; he loved the regional dishes of the Midi, especially those of the country round Aix-en-Provence where he had spent his childhood, and it was not long before he and Escoffier were deep in conversation on the subject of local food. Whenever the writer talked about his memories of a mutton *pot-au-feu* with stuffed cabbage, or of a *Blanquette d'Agneau à la Provençale*, he evoked precisely the same memories in Escoffier who had eaten identical dishes as a boy in Villeneuve-Loubet. Sometimes their shared nostalgia could become quite passionate. When Zola spoke of freshly caught sardines, for example, sprinkled with olive oil, grilled over the embers of a fire of vine shoots, and served in a dish which had been gently rubbed with garlic; or of polenta with white truffles; or of a good *cassoulet*, he became so wild and frenzied with enthusiasm, Escof-

The 'oriental' coffee trolley at the Savoy added an exotic touch to the gilded ceilings and the carved panelling of the restaurant.

fier recalled, that you would have thought he was already at table and that the hot, succulent dishes had just been placed in front of him!

Escoffier's repertory already included a *Consommé Nana*, but out of these conversations came the inspiration for the far more personal *Consommé Zola*, a chicken and celery soup flavoured with pepper and tomato, and garnished with the little gnocchi and the white Piedmont truffles the author so enjoyed. The custom of creating a dish for a particular person and naming it after him or her was comparatively rare in the eighteenth century, but grew more and more common as the nineteenth century wore on. Escoffier was one of its greatest exponents; far greater, in fact, than were such eminent predecessors as Jules Gouffé or even Carême. He was meticulously correct over the way in which he wrote recipe names, making a sharp distinction between *à la*, meaning in the mode or manner of a particular style, and the straightforward addition of a name which meant that the dish had been dedicated to that person. Looking through any index of Escoffier's recipes, one is confronted by a veritable Who's Who, not only of the royalty and nobility of the period (*Poularde Devonshire* and *Poularde Marguerite de Savoie*), but also of its actors, actresses and singers; its operas and plays; its hostesses and society figures; its writers, diplomats and Russian princes; its *demi-mondaines*; and even of a few favourite theatrical characters like Mariette or Dora or Madame Sans-Gêne. The aptly named *Chaud-froid Félix Faure* commemorates the French President who in 1899 died suddenly at the Elysée while making love with his mistress, Madame Steinheil.

Another figure who inspired a recipe, though probably unwittingly, was the Norwegian explorer, Fridtjof Nansen. He stayed at the Savoy in 1892, when he was in London to inform the Royal Geographical Society of his intention to reach the North Pole by allowing his ship, the *Fram*, to drift there after becoming locked in the ice. The *Fram* was specially constructed for the purpose; the expedition sailed in 1893 and returned to Oslo in 1896. Nansen had taken his idea from the fate of an earlier American expedition, led

by Washington de Long, which had ended tragically in 1881; its ship, the *Jeannette*, broke up in the ice, and of three groups of survivors, one was rescued while all members of the other two perished in the cold. It was the wreckage of the *Jeannette*, drifting for years in the ice, which caught the creative imagination not only of Nansen, but also of Escoffier, to whom it suggested *Suprêmes de Volaille Jeannette*; a cold dish in which poached escalopes of chicken breast, decorated with tarragon and laid on layers of foie gras mousse and chicken jelly, were placed in a dish which was closely imprisoned within a sculpted block of ice so as to represent the ship held fatally by the drifting floes. The item was first served in June 1896 to celebrate Nansen's meeting with a British expedition. It was a Sunday night, there were three hundred people in the Savoy restaurant, and the *suprêmes* were a great success. It is only to be hoped that the *maîtres d'hôtel*, explaining the story to attentive clients, did not upset them by dwelling too long on the sufferings and deaths of most of the *Jeanette*'s crew!

The *Bombe Néron* was another famous dish: an iced sweet which was served to Sir Herbert Tree, the actor-manager, after the first performance in 1906 of *Nero*, a verse drama by the fashionable Edwardian poet, Stephen Phillips. Tree played the title role, and put the play on at Her Majesty's Theatre which was, of course, the architectural twin of the Carlton Hotel. The *bombe* indicates Escoffier's love of the theatre, but in christening his recipes he had another special preference. One evening in 1910, while dining at Frascati's with Madame Duchêne, the wife of the manager of the London Ritz, he told her that all his best dishes had been inspired by and called after women; and this is confirmed by the number of women's names which appear in this connection. Among the princesses we find Louise, Isabelle, Alice, Alexandra and Hélène; among the actresses and singers, Judic, Réjane, Jeanne Granier, Yvette Guilbert, Duse, Melba, and, of course, Bernhardt; and of the *demi-mondaines*, Cora Pearl, Païva, Blanche d'Antigny, Otéro and Emilienne d'Alençon. But many of these once-famous beauties, professional or otherwise, are now forgotten. Who, for example, were Lili and Rosemonde? Who was Cynthia of the *poulet*

Sir Herbert Beerbohm Tree was an enthusiastic admirer of Stephen Phillips' overblown, hothouse verse.

He put on several of his poetic dramas at Her Majesty's Theatre, but Nero of 1906 was the last one to be successful.

Prominent at the opening of the Ritz in 1898, Boni de Castellane was a leading figure in fashionable Paris society.

He married the American railway heiress, Anna Gould, in 1895 and divorced her in 1906. She was small, energetic and immensely rich, with fine eyes and a bad complexion, perhaps the reason for the veil!

sauté? Who was Hilda? The mysterious Miss Hélyett on the other hand, the dedicatee of a raspberry jelly flavoured with kirsch and served with a thick border of whipped cream and fruit, was the famous heroine of a comic opera by Edmond Audran, a West End success in 1891.

Sometimes Escoffier named dishes after places. Many of his titles are connected in some way or another with Monte Carlo and Monaco and the Grimaldi family. *Filets de Sole Rhodésia* probably commemorated the further ambitions of one of the Savoy's diamond millionaires; and *Filets de Sole Walewska* were first served at a dinner given by the Duchess of Bauffremont at the magnificent Villa Walewska in Monte Carlo, very close to the Grand Hôtel. According to Escoffier, this dish owed a lot to the excellent taste of the lobsters caught off the Monaco coast in the 1880s, which was quite different to that of lobsters bought in Paris.

Such a remarkable bevy of associations shows how extensive Escoffier's connections had become by about 1900; in the course of his London years, he was to be even better known abroad through the prestigious kitchens he was commissioned to install and to equip with staff. The kitchens of the Grand Hotel in Rome began operating in 1893. In June 1898, amid considerable publicity, he launched those of the Paris Ritz. The hotel's opening dinner was one of the great social events of the Belle Epoque: the large, glittering crowd included the most fashionable members of the French aristocracy; dukes came from England and millionaires from America; Liane de Pougy and the Belle Otéro were there, and so also was Marcel Proust. Boni de Castellane, three years into his tempestuous marriage with the railway heiress, Anna Gould, stopped Ritz on the way out, complimented him on the dinner, and said he would be one of the restaurant's most regular customers. 'I am going home to sack my chef,' he added. 'It would be sheer folly for anyone to try to do better than you and Escoffier!' The follow-

Audran's operetta, Miss Hélyett, *was a London success in 1891 and inspired one of Escoffier's iced sweets.*

MISS HELYETT

OPÉRETTE EN 3 Actes DE MAXIME BOUCHERON

1 Cantique
2 Pour peindre une beauté
3 Duo de l'Album
4 Duo du portrait

MVSIQUE DE

E. AUDRAN

Paris, CHOUDENS Fils, Editeurs, 30 Boulᵈ des Capucines.

Tous droits d'exécution publique, de traduction & de reproduction réservés.

ing year, many of the same crowd would be enjoying yet more good food prepared by the *maître* in yet another new kitchen, that of the Carlton Hotel in London.

Escoffier's work for the Hamburg-American Line coincided with a difficult period in international relations. The Kaiser, William II, was starting to build up the German fleet as a direct threat to British naval supremacy, and, ultimately, to France; the Anglo-French Entente was signed in 1904; Emile Loubet, the President of France, had already paid a diplomatic visit to England in 1903, dining at the Carlton and having supper there after a gala performance at Covent Garden; and when the French fleet visited Portsmouth in August 1905, a naval luncheon was given in Westminster Hall, at which Escoffier's menu included dishes dedicated to Edward VII, the French President and Admiral Caillard. At a personal level Escoffier's reactions to these events was still marked by his experiences in 1870, though if he had any scruples about working for a German company, they were to some extent assuaged by the thought that the decision to do so was not his alone, but had been taken collectively by the Carlton's board of directors. In other respects, however, Escoffier found himself quite at home. The *Amerika* was a floating Grand Hôtel; much of the interior design was by Charles Mewès, who had worked at the Ritz and the Carlton; the suites and the cabins were the last word in comfort; and at the Ritz-Carlton Restaurant, first-class passengers could order *à la carte* meals at any hour of the day.

The planning of menus brought Escoffier more and more into direct personal contact with his clients; it was customary in well-to-do Edwardian circles to arrange lunches and dinners, especially the culinary details, well in advance if they were to take place at an important restaurant. There were two ways in which this might be done. You could pick up your telephone, ask the operator for the Carlton Hotel, for example, make an appointment to see the *maître* in his upstairs office, and settle everything that afternoon in the course of a private conversation; or you could do the whole thing by post, in which case the correspondence could sometimes

The Grand Hôtel de Marseille was a smart establishment in the rue de Nouilles. It boasted of electricity, hydraulic lifts and a private bar. It seems it may also have had menus specially designed for use in its cabinets particuliers!

become quite bulky. All of it, nevertheless, would be duly recorded by Escoffier in the thick, heavy, ledger-like volumes which he called his Menu Books. Letters, estimates, suggestions for new dishes, specimen menus, schemes for flower arrangements, and

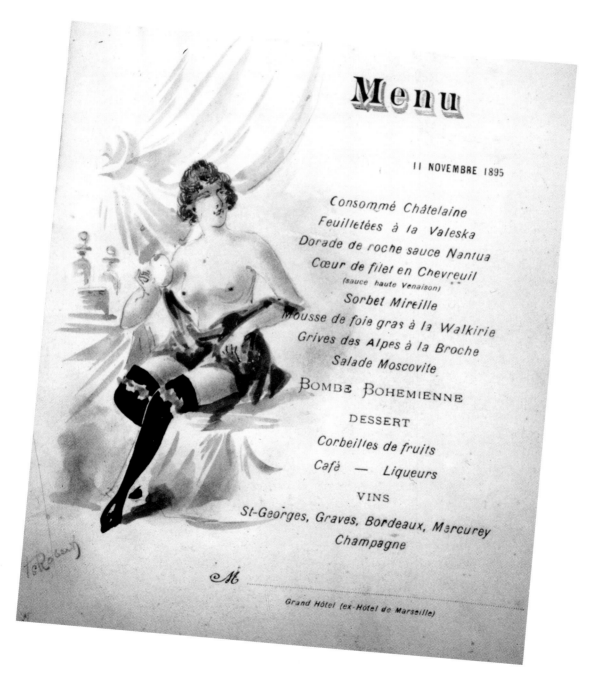

signed final agreements were all pasted into their pages and then carefully indexed. As a result, these albums are now a mine of information about the clients of the Carlton restaurant in the early years of the century; we learn who they were, what they ate, how often they came, and how much they paid. Once a menu had been agreed, Escoffier analysed it in detail; noted the position of the table, the number of diners, the date and the time; and then communicated the information to the kitchen by means of specially printed forms, one for the *chef garde-manger* and others for each *chef de partie*, indicating what dishes he had to have ready, at what time, and for how many people. All of these prearranged orders were prepared during the turmoil of the *coup de feu*, and were additional to the flood of casual orders received from the *maîtres d'hôtel* and relentlessly shouted out by the *aboyeur*.

The correct arranging of a meal was a matter of great importance to Escoffier. He saw it as a form of aesthetic creation, and often described it in terms borrowed from music or poetry. A written-out menu was like an orchestral score; the names of the dishes should read as euphoniously as a line of verse; in the manner of a medieval alchemist, Escoffier considered that the beauty of the food's verbal description should directly reflect the beauty and harmony of the real meal, and indeed of all the work and skill that had gone into its making. The observance of certain rules was essential if a correct balance was to be attained. If there were two soups, one must be thick and the other thin; brown and white meat must always alternate, and so should chicken and game; a sauce should always be different in colour and taste from the one preceding it; there was a special sequence to be followed by the various *entrées*; and two *garnitures* should never repeat the same ingredients, with the possible exception of truffles and foie gras. A meal should be tailor-made to fit the temperaments and personalities of the people who were to eat it; all embarrasing allusions should be foreseen and avoided. Escoffier once nearly died of professional shame at an important banquet, when he heard a *maître d'hôtel* zealously suggesting to a princess of royal blood that she should try an *entrée* named after a well-known and still very active *cocotte!*

The Hôtel du Quirinal was one of the principal Roman rivals to Ritz's Grand Hôtel. In 1893 the menu is still in French. After about 1900, the Quirinal tended more and more, in view of growing international rivalries, to write its menus in Italian and to serve only Italian dishes.

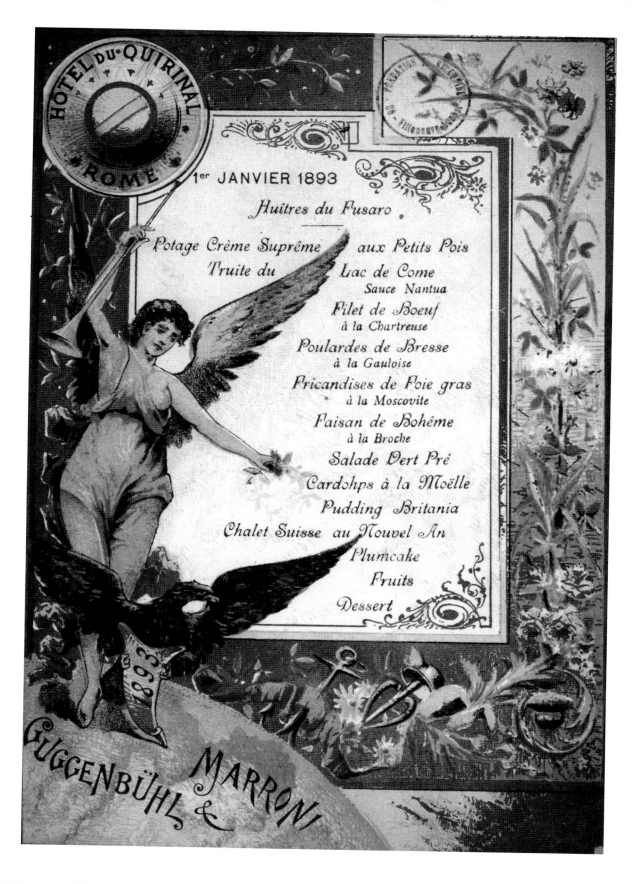

HÔTEL·DU·QUIRINAL
ROME

1er JANVIER 1893

Huitres du Fusaro

Potage Crème Suprême aux Petits Pois

Truite du Lac de Come
Sauce Nantua

Filet de Boeuf
à la Chartreuse

Poulardes de Bresse
à la Gauloise

Fricandises de Foie gras
à la Moscovite

Faisan de Bohême
à la Broche

Salade Vert Pré

Cardohps à la Moëlle

Pudding Britania

Chalet Suisse au Nouvel An

Plumcake

Fruits

Dessert

1893

GUGGENBÜHL & MARRONI

In 1900, very much as now, there were two types of menu, *à la carte* and *table d'hôte*, which Escoffier was just starting to refer to as 'fixed price'. The *à la carte* menu evolved from the earlier *service à la française*, the method by which dinners and banquets were served at European royal courts (notably at Versailles) and at the houses of the richer *bourgeoisie* during the eighteenth century. Meals were divided up into three main courses or *services*; and for each *service* the table, embellished with a centrepiece, was laid with a splendid array of covered dishes, usually in silver, of which the largest would be placed at the four cardinal points, the medium-sized ones in more central positions, and the smallest in circles round the larger like the satellites of a planet. The display was arranged on principles of architectural symmetry, while the food contained in each dish was different, and was offered simultan-eously to the diners, to be tasted or not as they felt inclined. The first thing to be eaten was the *potage* (our soup); the big tureens were then 'removed' or '*relevé*', as the French called it, and other dishes of fish or meat took their place. These were, in fact, called *relevés*; the smaller cooked dishes were known as *entrées* and the even smaller dishes surrounding them were called *hors d'œuvres*, a metaphor taken from the old language of fortification. The second course of the meal centred round the roasts, meat or game which had been cooked on a spit by the *rôtisseur* in front of an open fire; and these too were surrounded on the table by smaller dishes known as *entremets* which often consisted of vegetables. The third and final *service* was similar to our dessert course, and its subsid-iary dishes were known as *entremets sucrés* or sweet *entremets*.

Dinner at the Carlton. A typical example of one of the hotel's à la carte menus as shown in Escoffier's Le Livre des Menus *of 1912. There was certainly no lack of choice, and a meal for two with wine would probably have cost about £4.*

The essential characteristics of *service à la française* were that it presented a magnificent display, and that it offered many types and varieties of food simultaneously. Under certain circumstances the system lingered on into the nineteenth century (Escoffier would have known a minor version of it in the *cabinets particuliers* of his uncle's restaurant at Nice or at the Petit Moulin Rouge in Paris); but in the end its disadvantages, notably the difficulty of keeping the food hot, told against it, and it was replaced by another system, *service à la russe* (named after the Russian ambas-

Carte du Jour JANVIER

»»»> DINER ««««

HORS-D'ŒUVRE

Variétés Russes * Caviar de Sterlet * Sigui fumé * Saumon fumé de Hollande
Huîtres Royales * Crevettes roses * Melon d'hiver * Jambon de Westphalie
Artichauts à la Grecque * Tomates aux fines herbes

POTAGES

Petite Marmite * Croûte au Pot * Vermicelle * Orge à l'Ecossaise * Réjane
Quenelles de volaille et Laitue * Tortue Clair * Ox-Tail * Bisque d'Ecrevisses
Velouté de volaille au Currie * Crème de Tomate * Soupe aux Huîtres

POISSONS

Turbot Hollandaise * Turbotin Dugléré * Barbue Mornay * Merlan Richelieu
Eperlans diablés * Petite Friture * Petits Pâtés d'écrevisses
Sole : Meunière, Bonne-Femme, au Gratin
Filets de sole : Walewska, au Vin rouge, Américaine
Mousseline de Sole aux truffes
Saumon au vin blanc * Timbale de Homard Orientale * Brandade de Morue
Huîtres au gratin

RELEVÉS

Filet de Bœuf poêlé
(Tomates au gratin, Haricots verts à l'anglaise)
Chapon truffé aux nouilles
Jambon de Prague
(Petits pois Paysanne)
Cuissot de Venaison à l'Ecossaise

ENTRÉES

Poulet poché au gros sel * Poulet sauté à la crème * Poussin Polonaise
Côtelette de volaille aux pointes d'asperges * Mousseline de volaille au Currie
Caille pochée céleri et truffe * Riz Pilaw * Ris de Veau Toulousaine
Côtelette d'agneau jardinière * Côtelette de Chevreuil purée de marrons
Escalopes de Foie gras persillées * Filets de Perdreau Rossini
Noisettes d'Agneau Favorite

BUFFET FROID

Pâté de Foie gras * Caille à la Richelieu * Terrine de Perdreau
Galantine de Faisan * Mousse de Jambon au blanc de poulet
Fricassée de Poulet à l'ancienne * Poularde à la gelée * Jambon glacé
Langue écarlate * Bœuf à l'Anglaise

ROTIS

Poularde * Chapon fin * Poulet de grain * Faisan Casserole
Perdreau Périgourdine * Caille aux feuilles de vigne * Bécasse * Bécassine
Mauviettes * Canard sauvage * Sarcelle * Pluvier doré * Selle de Chevreuil
Selle d'agneau

SALADES

Simples : Laitue, Mâche, Endive, Escarole
Còmposées : Suzette, Rachel, Américaine

LÉGUMES

Asperges de serre vertes et blanches * Céleri au Parmesan * Cardon à la moelle
Endive belge * Petits Pois de Nice * Artichauts * Chou-Fleur
Choux de Bruxelles * Laitues braisées * Haricots verts

ENTREMETS

Chauds : Soufflé au Fenouillet * Pommes Impératrice * Poires Bourdaloue
Cerises Jubilé
Froids : Macédoine de fruits au Kirsch * Poires Bohémienne
Compotes de fruits * Bombe Havanaise
Glaces : Vanille, Fraise, Citron * Mandarines glacées * Parfait Moka
Coupe Adelina Patti

DESSERT

sador to the court of Napoleon), in which dishes were served separately and consecutively, more or less as they are now. This was the form of service which Escoffier's clients at the Savoy and the Carlton knew as *service à la carte*; curiously, though the way of serving the various dishes had changed radically, many of their old names remained intact. An Escoffier *à la carte* meal at the Carlton in 1910, taken in its fullest and most extensive form (though this does not of necessity represent what people actually ate), would have started with *hors d'œuvres*, a course about which the *maître* had strong feelings; he objected to soused herrings and pickled vegetables being eaten immediately before a subtly flavoured soup, and could only really approve of such items as oysters or caviar or smoked salmon, or the small, delicate, hot *hors d'œuvres* which are described in *Le Guide Culinaire* and were not unlike our present day *amuse gueules*. After soup and fish, the menu would have continued with two rather similar courses of cooked dishes which were called *relevés* and *entrées*; names taken from the old *service à la française*, though there the *relevé* was a far more substantial dish that it became at the time of Escoffier. In fact, many Edwardian menus dropped the *relevé* altogether and simply concentrated on the *entrée*. Then came a course of roast meat or game (the old *rôt*), hot or cold, accompanied by a salad, and followed by a separate vegetable dish (the former *entremet*); after which the meal was completed by a sweet course, the items of which, in memory of the old *entremets sucrés*, were still called *entremets*. Such were the basic elements of a traditional *à la carte* meal around the turn of the century; they could be adhered to or varied at will.

The fixed price menu, on the other hand, one of Escoffier's novelties, derived from the old *table d'hôte*, the long table in the main room of an inn at which all the guests sat and ate together, the innkeeper or his wife occupying the principal place, and where the food, cooked in the family kitchen, was reasonably cheap. At a town or city restaurant, the *table d'hôte* dinner was advertised for a precise time, usually about five or six in the evening, and the price stated; it was an inexpensive way of eating, but you had to be there in time for the soup! Photographs of hotel dining-rooms from the

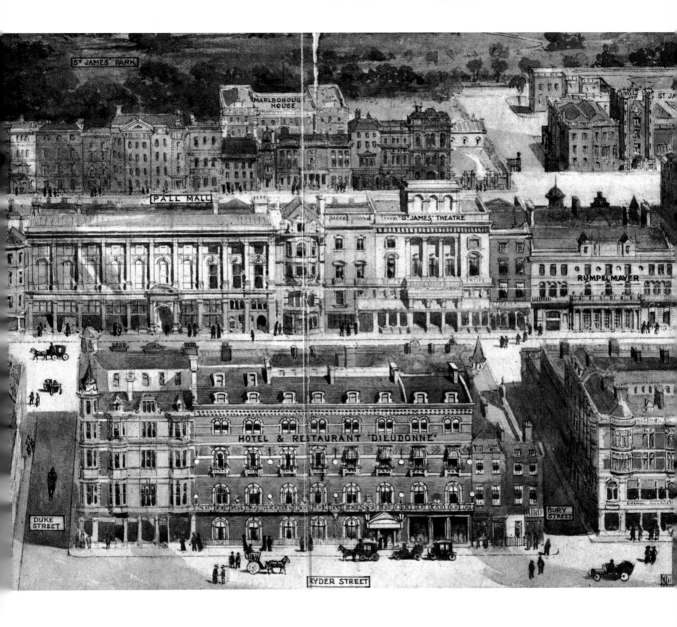

Dieudonné's Hotel in Ryder Street, shown here on a pictorial map, was famous for having had one of the last traditional tables d'hôte in Victorian London. Madame Dieudonné presided over an eccentric, Bohemian clientele of artists, writers and musicians, most of whom were French.

Belle Epoque sometimes show, amid a period atmosphere of potted plants, white tablecloths and bentwood chairs, the long central table at which *table d'hôte* meals were taken; all around it against the walls stand the smaller tables reserved for customers eating *à la carte*. The last genuine *table d'hôte* in London was probably that at Dieudonné's Hotel in Ryder Street, where it was presided over by Madame Dieudonné herself, sitting in matriarchal state at the head of the table; a famous London character, she was still remem-

Before dinner...

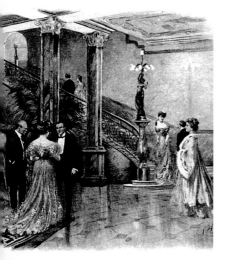

...and after.

bered by some of Escoffier's clients at the Savoy in the early 1890s. Others must also have known another institution, a survivor to this day of the *table d'hôte* system: the long table at the Garrick Club.

First at Monte Carlo, and later at the Savoy and the Carlton, Escoffier introduced a new and very chic version of the old inn-keeper's table which was an immediate success. To parties of four people or more he offered a variety of fixed price meals, each containing the basic seven courses of an *à la carte* dinner, but graded in cost according to the range of dishes chosen. Not only were the meals served at small, separate tables in a special room (that at the Savoy was known for its marble fireplace and the modish pattern of its 'oriental' wallpaper), but they could be eaten or ordered at any time during the main restaurant's normal opening hours. In 1901, when an *à la carte* dinner for four at the Carlton might cost about four or five guineas (without wine), one of the new, standard menus for the same number of people, with soup, trout, *Blanc de Poulet Toulousain, Noisette d'Agneau à la Moelle*, quails, asparagus and a strawberry mousse, was priced at 12/6d; while a menu for eight, which included Escoffier's *Timbale de Sole* and roast grouse, cost only 17/6d. The idea of a fixed price meal seems normal today, but in 1890 it was a complete innovation which was rapidly copied by others; by the end of the century nearly every London restaurant had its *table d'hôte* room. Originally, at the Grand Hôtel at Monte Carlo, or at Lucerne in the 1880s, Escoffier had introduced standardized menus because they appealed to English clients with poor French who were unable to understand the written *carte du jour*, and were therefore embarrassed when they had to choose between one complicatedly named dish and another without knowing what they were. The selection, under the aegis of a good *maître d'hôtel*, of one single, comprehensive menu seemed much easier, and took all the bother away. In London, during the early years at the Savoy, things were a little different. Here Escoffier found that the appeal of the new fixed price meals lay not only in their reasonable cost, but also in the comparative speed with which they could be served, an advantage particularly appreciated by

businessmen, millionaires and top financiers who were perpetually complaining about the stress and strain of modern life. Indeed a similar anxiety among clients at Monte Carlo had already induced Escoffier to think up *Poularde Grand Hôtel*, a fifteen-minute version of a grander recipe which normally took more than half an hour.

Speed was one of the great cults of the Edwardian age. Telephones, typewriters, and ever swifter trains and steamships had left their mark on the 1890s; the rushing images of the first film show had been seen in Paris; wireless telegraphy had pointed the way to quicker communication than ever before; and the latest American hotel technology, in the form of improved hydraulic lifts and running hot water, had delighted Mrs Langtry and horrified Oscar Wilde. The new reign, when it came, witnessed a rapid proliferation of motor cars. The Ford motor company was founded in 1903, and Austin followed in 1905; in 1904 the first motor taxi appeared in the streets of London, presaging the departure of the old horse-drawn hansoms and growlers; and in 1909 Louis Blériot crossed the Channel in an aeroplane. In the light of such momentous happenings, it could not be long before even the world of cooks and kitchens began to feel the winds of change.

Indeed the new passion for speed had already affected meals and eating habits in the great country houses. After the death of the Queen in 1901, hostesses and guests all began to remember how utterly dreary and interminable dinner parties had seemed in the time of their parents, and the new generation resolved to effect some important prandial changes. They initially took to breaking up the usual large groups of guests, and to lunching instead at small separate tables in a curious imitation of Escoffier's *table d'hôte* room at the Carlton; eating was now much more 'amusing', of course, but unfortunately the pace was still somewhat leisurely. Things were suddenly clarified when Edward VII announced that no lunch at which he was present would henceforth be allowed to last for more than an hour. The royal order to accelerate was welcomed by everyone, and speed at table became the principal pur-

Coffee at the end of dinner, and time to read the very last line of Escoffier's menu: Café Mode Orientale; Liqueurs de France; Fine Champagne 1865; Vieille Chartreuse du Couvent.

pose of every meal, even though some of the consequences proved uncomfortable. Sir Osbert Sitwell, for example, could remember boyhood dinners at which course after delicious course was rapidly placed in front of guests only to be removed a few minutes later by energetic footmen who seemed to be there just to prevent eaters from enjoying anything more than two or three mouthfuls before their half-consumed portions were triumphantly removed.

Sir Osbert was not the only critic of this anti-gastronomic conspiracy, however; it also aroused the indignation of Escoffier. Though the latter was in favour of smaller tables and, generally speaking, of quicker meals, he was nevertheless horrified by the idea of good food being bolted at breakneck speed; it was a sentiment he expresses unequivocally in *Le Livre des Menus*, thereby entering into a fascinating critical study of the great Edwardian meal. In the introductory pages, he sets out the overall principles on which he himself would plan a menu, and it is surprising how far-sighted these usually are. A meal should be no longer than circumstances demand. Diners should have reasonable time to eat each course, even if they are in a hurry; a long meal eaten too quickly is, as we have seen, a most unpleasant experience. At diplomatic or business lunches, the guests are too preoccupied with other things to worry about the quality of the food, which is best appreciated by a small group of friends, all gourmets, who can share a meal in relaxed, comfortable conditions; though even then the number of dishes must never be excessive. Escoffier concludes by returning to the theme of the maelstrom of modern life, and suggests that meals in the future will tend to get shorter, and a greater emphasis will be placed on food that is easy to digest.

Such precepts seem paradoxical (though Escoffier's culinary personality was often of a rather paradoxical nature) when one considers some of the great chef's more magnificently lavish menus, such as those of the three banquets he produced simultaneously at the Savoy on the night of 25 June 1895 (the transformation of a grim basement into a mirrored banqueting hall was another of Ritz's *tours de force* at short notice), and which he regarded as one

At the Savoy banquet given on 25 June 1895 to celebrate the marriage of the Duke of Aosta with Princess Hélène, the sister of Philippe d'Orléans, one of Escoffier's menu cards was signed by everyone present. The English royal family is represented by Princess Alexandra and her daughters and the Duke and Duchess of Connaught, and the royal families of Savoy and Orléans by signatures covering three generations.

of the highlights of his career. The first banquet for forty-two was given in celebration of the marriage of Hélène d'Orléans to the Duke of Aosta, a son of the royal house of Savoy and a nephew of the King of Italy. The bride was the sister of Philippe, Duke of Orléans, a regular customer of the hotel, and also an adventurous amateur explorer whose safe return from a voyage to Spitzbergen

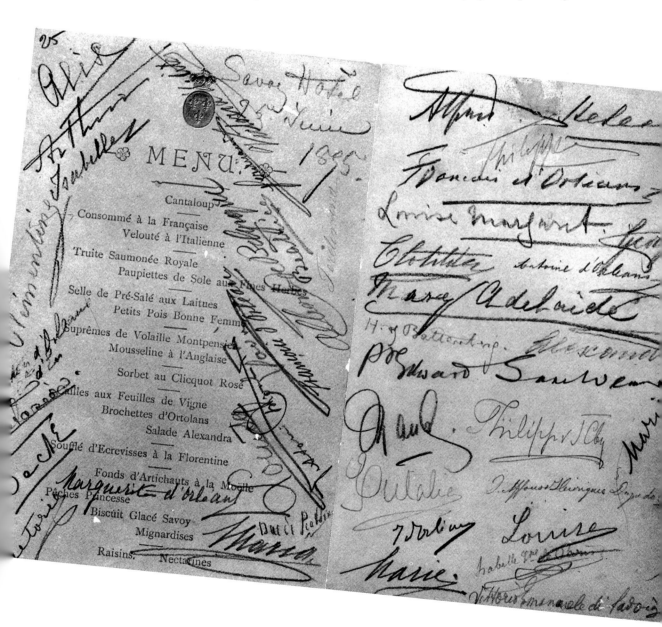

on board his private yacht was to be celebrated by another Escoffier dinner at the Carlton in 1905. The Duke had recently fractured his knee, and Princess Alexandra, who was guest of honour, opened the proceedings by pushing him gaily to the table in a wheelchair. The other guests included Princess Louise, the Duke of Connaught, two of Alexandra's daughters, Victoria and Maud, and most of the principal members of the Italian and Orléans royal families. The second banquet was for friends and attendants; and the third, quite unconnected with the first two, was for fifty members of the Cornish Club, presided over by the Prince of Wales.

At the first banquet nineteen different dishes were grouped into ten courses served *à la russe*; the salmon trout was poached in an Asti wine (one Savoy's compliment to another) and was accompanied by paupiettes of sole *à la Montpensier* (the last Duke of Montpensier, a brother of Philippe d'Orléans, was a guest at the dinner); quails roasted in vine leaves were garnished with ortolans, so tiny, tender and well cooked that each little bird could be eaten almost as a single mouthful, bones and all; and diners could refresh themselves, if they wished, with pink champagne sorbet or lobster mousse. The Cornish Club dinner with the Prince of Wales was of a similar calibre; but it included his favourite saddle of lamb and (a great concession on the part of Escoffier) an English savoury of soft roes on toast; the champagne was an 1884 Pommery, the claret an 1878 château-bottled Léoville Poyferré, and the port a vintage Croft's of 1858.

There are many such meals in the annals of Escoffier's career, but it is important to remember that though numerous dishes were inscribed on the stylishly artistic menu cards of the period, not every guest ate all of them. The usual assumption is that those people in the past who could afford it consumed enormous quantities of food; but it is more likely (even when one has allowed for more generous ideals of acceptable slimness or otherwise than reign in our own day) that in 1910, as at any other time, only those who were naturally voracious ate voraciously, while people with small appetites ate very little. Others were certainly mindful of Escof-

fier's advice to avoid overeating. It was possible, when faced with a
long menu, to order everthing but to eat only a very little of each
dish; or you could quite openly skip a course or two. You could
refuse the *relevé* and go on to the *entrée*; or you could refuse both
and move straight from *Potage Réjane* to a *Perdreau Périgourdine*.
In either case you avoided the ill effects of surfeit which, as the
maître rightly said, took all the pleasure away from eating.

If Escoffier insisted on gluttony being the arch-enemy of good
cooking, it was certainly because he was himself such an outstand-
ing cook. The elegance and the exquisite taste of his food lay at the
heart of his relationship with his public; but this is an aspect of him
which is now tantalizingly difficult to re-create. There is no other
artist whose finished work is as fleeting and ephemeral as that of a
maître cuisinier; no sculptor or musician expects to see the product
of hours of careful labour demolished in a matter of moments by a
ravenous client. We have no way of knowing what it was like to eat
a meal cooked by Escoffier, nor do we have any really detailed
account of how he worked in the kitchen. Antonin Carême once
listed the qualities he considered essential for the professional
cook: he must have a fine and delicate palate; an impeccable sense
of taste; a clear and inventive mind; and he must be a hard worker,
able to cope with the unexpected. It is a description which could be
applied perfectly to Escoffier. Even given his spectacular rise from
kitchen management to a directorship at the Carlton, it is his
genius as a cook, his power to reveal and to combine tastes, which
remains the essential part of his achievement; his hand-written
projects for new recipes and menus, scored through with crossings-
out and additions, are evidence of the amount of sustained creative
effort his work as a chef involved. 'Personally,' he wrote in 1907, 'I
have ceased counting the nights spent in the attempt to discover
new combinations, when, completely broken with the fatigue of a
heavy day, my body ought to have been at rest.' Novelty, and
novelty at speed was the continual demand; but Escoffier's
response never failed to be imaginative. His determination to
please his customers was paramount. Even when a basic recipe
(such as that for a stuffed *poularde* or for dishes prepared in the

style made famous by the Russian diplomat, Count von Nessel-
rode) was remade by the alteration of a sauce or a garnish, the
adaptation was always a genuine, well-conceived variation of
taste, never just a specious rearrangement for the sake of the word-
ing of a menu. It was as a working cook that Escoffier was respec-
ted in his lifetime by members of his own profession, and it is as a
cook that he is judged and studied by the equivalent people today.

The *maître* was that rare and valuable phenomenon, a born conser-
vative who is also very much a man of his own time, aware of its
new currents of opinion, and open to change. Much of his inner
strength sprang from his ability to assimilate old and new, to com-
bine the essence of one with the forms of the other, even though
this meant abandoning things he loved which were now out of date.
Escoffier the philosopher has often puzzled students of Escoffier
the cook, only too frequently classified as being either an icono-
clastic innovator and a herald of *la nouvelle cuisine*, or a hidebound
traditionalist who laid a dead hand on the subsequent develop-
ment of French cooking. Neither view is right, of course. *Le Livre
des Menus* and the introductions to the 1903 and 1907 editions of
Le Guide Culinaire express an almost Bergsonian sense of the crea-
tive flux of time, of social evolution and transformation, of the
changes taking place in the psychology of clients, and of the effect
of all these on the work of the cook and the *maître d'hôtel*. Not only
is the whole of culinary art perpetually on the move, but even *Le
Guide Culinaire* is destined to grow and to change in the course of
many editions, finally to be replaced by another work better
adapted to the differing needs of some future age.

Escoffier's maturity of mind came to him only gradually. It was at
Monte Carlo in the 1880s that he first began to be influenced by the
ideas of a brilliant group of younger cooks which included such
future stars as Prosper Montagné and Philéas Gilbert, and started
to be critical of moribund culinary attitudes and of the careless
application of hackneyed techniques, and to contribute regular
articles to *La Revue de l'Art Culinaire*, which rapidly became the
voice of the new school. As early as 1883, editorials were discussing

This photograph, probably taken sometime in the 1920s, shows Prosper Montagné's restaurant in the rue de l'Echelle in Paris. Montagné and Escoffier are sitting together on the right of the table in the foreground.

the social status of the cook, alcoholism in the kitchen, and conditions of apprenticeship. 'We neither eat nor cook now as we did in the past. For the new way of cooking, we need new men, and a new culinary grammar.' The hint was not lost on Escoffier; but it was only in 1897 that he began to write articles questioning the insensitive exploitation of Carême's system of principal and subsidiary sauces; or discussing the use and abuse of the *espagnole*; or advocating the serving of game-based sauces with game dishes, and fish-based sauces with fish.

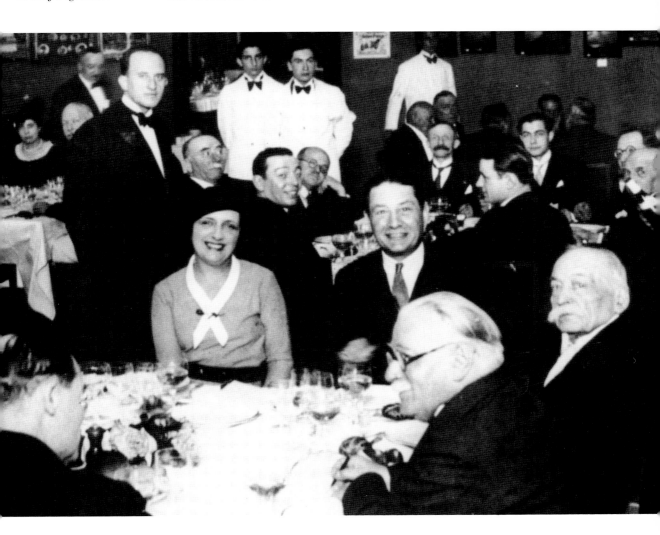

The conservative Escoffier was no supporter of revolution, however; neither in the streets of Paris in 1871 nor in the kitchen. It was the abuse of a system which he contested, never the system itself. He often described himself as an ambassador to the world on behalf of French cooking, and felt he was the custodian of a great tradition inherited from the very heart of his country's ancient past which it was his role to preserve in all its most essential aspects (tastes, techniques, *fonds de cuisine*) through a particularly difficult period of historical change. The old system he had known as a young chef could never return, but it was to haunt him to the end of his life, especially the elegant style of service, the spacious tables, and the pervading sense of stately, unhurried magnificence. Even in 1934, a year before his death, Escoffier was still referring wistfully in *Ma Cuisine* to the meticulous way in which eggs were scrambled in the old days, and which was no longer practicable in the hectic atmosphere of the modern kitchen.

Though it is not the aim of this book to discuss Escoffier's cooking in any detail, there are two strands in the texture of its culinary conservatism which are not without relevance: first, the patriotic holism which inspired the *maître*'s overall vision of French food and cuisine; and second, his nostalgic love of splendour. It was hardly surprising that the man who had suffered in the Franco-Prussian war, who never let a Sunday pass without hearing Mass, and who was to wear with such pride the ribbon and the rosette of the Legion of Honour should harbour a deep and passionate love for his native land. This, after all, was not only the age of Bergson; it was also the age of figures like Kipling, Péguy, Hilaire Belloc, Maurice Barrès, Lyautey and Cecil Rhodes; when many different varieties of patriotism quelled the hidden sense of anxiety and doom which haunted Europe in the decades before 1914. Uninterested in French party politics (he hated political conversations because he could never think of anything to say in them), Escoffier was nevertheless intensely and patriotically proud of his country's domination of the world in matters of *haute cuisine*; he saw France as a divinely ordained earthly paradise, where each region brought forth its own variety of natural produce, its own recipes, and its

own cooking skills. The French countryside was the ground on which the great edifice of *la cuisine française* was constructed in the form of a vast pyramid which had regional cooking at its base, *la cuisine bourgeoise* at its centre, and the infinitely skilled refinements of *haute cuisine* at the top. A happy symbiosis existed between country and provincial styles and that of the great restaurants. In thinking this way, Escoffier's generous, inclusive view was far removed from the ideas of some of the more bigoted *régionalistes* of the 1912 Club des Cent (fulminators against foreign produce, refrigerators and international hotels), with whose leader, the ebullient Curnonsky (Maurice Sailland), he never felt fully at ease. Escoffier travelled extensively in France whenever he was free to do so, and never failed to study, sample and record local recipes and meals; it was his way of renewing contact with his vital roots. In May 1878, for example, while doing thirteen days military service at Caen, he had Sunday lunch at a village inn, and noted the perfection of the *Sole normande*. Another year, in Haute Savoie, he had lunch with the local *curé* after Mass (a rabbit cooked with white wine, onions, garlic and cream), and later attended a hunting weekend at a castle in the mountains, where each meal was a feast. In 1912, near Pau, he ate *poule-au-pot*, a salmon trout freshly caught in the Adour, and quails prepared with truffles, Jurançon wine and Armagnac, which he described as '*un rêve*'! In 1913 he visited the 83-year-old Provençal poet Frédéric Mistral at Maillane (a *Poulet Sauté Mireille* had already celebrated that author's most famous work when it was turned into an opera by Gounod), and afterwards enjoyed a *blanquette d'agneau* and a dish of larks at the nearby inn. On the way back to London, in the Calais train, the *omelette fermière* and sirloin of beef were so good that Escoffier made a special note of the chef's name. Many of these country dishes turned up again at the Carlton; they were a sign of the *maître's* sense of the past and of the universality of his approach, just as was his inclusion in *Le Guide Culinaire* of Russian, Hungarian, Latvian, Portuguese and even English recipes. Among the latter (despite his determination not to learn English in case he should start to cook like the English) we find steak and kidney pie, roly-poly pudding, kedgeree, junket and even Scotch

woodcock; and from the annals of the Peninsular War he recorded a famous Spanish recipe for stuffed pheasant macerated in port. A French officer, sensing at once how delicious the dish would be, saved the manuscript from destruction when his men were pillaging the monastery library at Alcantara.

The second strand in Escoffier's culinary conservatism concerns the presentation of food. Brought up professionally under the gastronomic *ancien régime* of the Second Empire, he never really lost his admiration for the splendid, ornately decorated dishes which then regularly embellished tables in great restaurants and in the *hôtels particuliers* of the rich. As late as 1907, he remarked how hard it was not to regret the times when a meal was not only a *fête* but also a ceremony. Examples of the complicated creations this involved are illustrated in books by Jules Gouffé and Urbain Dubois, *chef de cuisine* with Emile Bernard to William I of Germany. Coloured plates in Gouffé's *Livre de Cuisine* of 1867 show salmon, beef, galantines, calves' heads, lobsters and chickens, surrounded by extravagant garnishes and pierced by *hâtelets* (ornamental skewers) exhibiting truffles, cocks' combs, shellfish, and other fantastic items. In was in the context of the laborious yet highly skilled construction of these astonishing, fairy tale castles of food, which had taken the place of the palaces and temples of Carême, that Escoffier, the would-be artist, published his first work in 1885: a pamphlet on the making of inedible wax flowers for their adornment. In the preface, he even looked back admiringly to the banquets of the First Empire, when 'the glory of French cuisine was brought to its height' by fireworks concealed in the *pièces montées* which exploded loudly and sent out showers of coloured sparks just as the guests were about to be served! In some ways the emptier tables produced by *service à la russe* encouraged the creation of even more massive structures of food than had been usual under *service à la française*. The solid wood *socles* (round, drum-like supports which sustained the displays from within) were already being grumbled at by Jules Gouffé in the 1860s, even though they were hidden beneath layers of sculpted stearine and paste; they were slightly reduced by Urbain Dubois, but still used; finally, at

The grande cuisine *of the Second Empire cultivated a magnificently sculptural presentation of food such as in the dishes shown here, from Dubois and Bernard's* La Cuisine Classique.

Escoffier retained a lifelong admiration for the culinary splendours he had known as an apprentice and a young cook, but this did not prevent him from adapting his style to the needs and manners of the new Edwardian age.

the Savoy and the Carlton, they were banished altogether. The change was forced upon Escoffier as restaurant tables got smaller and smaller, and the busier clients spent less and less time eating; the demolition of one of these great *pièces* by a *maître d'hôtel* took almost as long as its construction! Even the ostentatious Edwardian floral displays began to seem over-extravagant; the Carlton Menu Books show clients cancelling them on the grounds that they are an unnecessary expense. Escoffier, in the introduction to the 1903 *Guide Culinaire*, and even more rigorously in the second edition of 1907, discusses the growing exclusion everywhere of the *pièce montée*. Even the *garnitures*, which had been such a colourful part of Second Empire presentation, were considerably curtailed (though 130 of them still appeared in the final 1921 edition of the *Guide*) and were served from a side table as a separate dish.

Hot *pièces montées* eventually disappeared completely, to be replaced by elaborate desserts which were, in fact, cold *pièces montées* mounted on *socles* sculpted out of solid ice (the work of the dying Monsieur Eberlé), and frequently lit from within, not by Napoleonic fireworks but by that magic discovery of César Ritz, electric light. Escoffier was particularly pleased with his *Belle de Nuit* of 1895; a crescent moon, carved out of ice, rested on a larger block of ice which was illuminated internally by an electric bulb covered with spun sugar, and surrounded by a profusion of ice cream and crystallized fruit. Theatricality at the dinner table continued to astonish and amaze, but with a slight shift of emphasis. The original *Pêche Melba*, its poached peaches rising up in a cone of gold from a silver dish which lay between the wings of a noble Lohengrin swan finely carved out of ice and lightly veiled in spun sugar, was one of the most famous examples of the new style. The *Pêches Aiglon* of 1901, in celebration of Sarah Bernhardt's performance as the Duke of Reichstadt, included a whole mountain of ice topped by a frosty imperial eagle with extended wings, and below it, a cornucopia of peaches surrounded by a garland of pralined violets. At the Paris Salon Culinaire of 1910, an exhibit entitled *Langouste Blériot* culminated in a crayfish transformed into an aeroplane taking off from the edge of a cliff. Sometimes Escoffier

offered cold presentations of game or chicken which were almost as magnificent as some of the items devised by Urbain Dubois. *Aiguillettes de Caneton Saint Albin* even involved an inner support and a *hâtelet* with truffles; while the elaborate *Cailles à la Vendangeuse* called for a pyramid of quails, each in its own pastry basket, arranged around real vine branches and real grapes. Both recipes were still being reprinted in 1921. To see just how far Escoffier could go in the wildly theatrical production of a single meal, one has only to look at the details of the famous Red Dinner, given at the Savoy in 1895 to celebrate the winning of 350,000 francs (on the red) at Monte Carlo; everything, apart from the truffles which were black, was either red or gold in colour; the lights, all the food, the waiters' costumes, the wine, the menu, and even the chairs and the table and the women's dresses!

In his writings these two sides of Escoffier come together in the most natural fashion. Here the traditionalist blends with the up-to-date Edwardian, the practical hotelier who was always quick to give a client what he wanted in case he went to look for it elsewhere, the businessman of the kitchen who could calculate prices and profits and, from the Carlton, run his own company for the commercial production of the celebrated Escoffier bottled sauces. The books are a point of fusion. People were not so very far from the truth when they mistook the small, dignified figure with the grey moustache for an eminent man of letters. The fame and prestige, even today, of *Le Guide Culinaire* seems almost as extraordinary as that of its author. Consisting of groups of recipes linked together by sections of informative commentary, and written (especially after the 1912 revision) with a classical economy of phrase that is profoundly French, the work presents a comprehensive account of all the most essential processes and techniques which, in Escoffier's opinion, constituted French *grande cuisine* at the turn of the century, and were therefore worthy of being passed on to present and future generations of cooks. The book was to be a work of instruction, a practical tool, not a work of art. In its pages, the *fonds de cuisine* are, as always, seen as the heart and soul of French cooking; the 1912 edition catalogued twelve of them which,

Escoffier was involved in the commercial manufacture of tomato purée as early as 1892. When he was at the Carlton, he set up his own factory to produce the bottled sauces and pickles which made his name familiar to thousands. During the First World War financial difficulties obliged him to sell his shares in the company, but the sauces continued to be marketed under his name.

Ces Conserves sont fabriquées selon les formules et sous le contrôle de M. A. ESCOFFIER, du *Carlton Hôtel.*

traditionally, included not only the familiar *fonds bruns* and *fonds blancs*, but also the basic sauces of Carême; and then the *roux*, the *glaces*, the *essences*, the *consommés*, and so on. A traditionalist manifesto, perhaps, but also one of excellence if these important items were used with all the skill of the *maître*! As the bedrock of good cooking, the *fonds* are the starting-point for the creation of

Escoffier's original manuscript recipe for Pêche Melba.

sauces; and sauces, however much they might be simplified, were still, for Escoffier, the crowning glory of French cuisine and a main cause of its worldwide predominance. Despite the fact that out of the five thousand or so complex but infinitely varied and delicious recipes in *Le Guide Culinaire*, a number are creations by Escoffier himself, it is the definitive, comparatively impersonal and therefore classical character of the book (matched only, perhaps, by that of *La Grande Cuisine Illustrée* published by Prosper Montagné and Prosper Salles in 1900, three years before the appearance of *Le Guide Culinaire*) that has secured it its place of honour in the gastronomic library.

Escoffier first began to think about writing a book when he was at the Grand Hôtel at Monte Carlo with César Ritz, and had just brought out the first edition of *Les Fleurs en Cire*. He realized (as pointed out in *La Revue de l'Art Culinaire*) that there was at the time a serious lack of a simple primer, addressed specifically to young professionals, which would teach them basic techniques and definitions, and would ideally be small enough to fit into the pocket of the ordinary working cook or waiter. Urbain Dubois, the eminent chef revered by Escoffier as a master, had now retired from his post at the German court and was a frequent visitor to the Grand Hôtel; talks with him were a great source of encouragement, and the author also got a certain amount of practical and editorial help from Emile Fétu (later *chef de cuisine* at the Langham Hotel in London) and Philéas Gilbert – a cause, subsequently, of acrimonious dispute. The gestation of the book was protracted, however and it was not until some twenty years later, in 1903, the year after the coronation of Edward VII and Ritz's collapse, when Escoffier was well established at the Carlton, that *Le Guide Culinaire* was finally published by Flammarion in Paris. Revised editions appeared, together with a number of foreign translations, the English one being decorously cleansed of nearly all the references to famous *cocottes*! During his retirement, Escoffier wrote two short works on cheap and economical food for the poor, and produced many articles for the trade press, and for numerous magazines connected with food and travel. In 1934, the year before his

death, he published *Ma Cuisine*, a shortened version of *Le Guide Culinaire*, which was intended to be a manual of *cuisine bourgeoise*; that is to say, a cookery book for chefs working in large private houses, but without all the resources of a big hotel kitchen.

The author expressed the hope that some of its simpler recipes might also prove to be of use to the ordinary housewife; such a thought, coming at the close of his life and at the end of the longest and most influential career in the whole of culinary history, a career which had affected the lives of chefs in the kitchen as much as it had changed the outlook of diners in the restaurant, was typical of the generous spirit of the world's most famous and, without any doubt, most remarkable cook.

Recipes by Escoffier

Later editions of *Le Guide Culinaire* contained some five thousand recipes,
and Escoffier published others in journals and magazines.
Here it is possible to give only a very small selection from an extremely rich store.
The recipes chosen are not arranged in any systematic order,
though whenever feasible those mentioned in the book have been included.
The text is taken from the 1939 edition of *A Guide to Modern Cookery*, the English
translation of *Le Guide Culinaire* which was approved by Escoffier and first appeared in 1907.
The translation of *poularde* by 'pullet' is frequently found
in English cookery books of the period.

Frogs or Nymphes à l'Aurore

For various reasons, I thought it best, in the past, to substitute the
mythological name 'nymphs' for the more vulgar term 'frogs' on menus,
and the former has been universally adopted, more particularly
in reference to the following 'Chaud-froid à l'Aurore':

Poach the frogs' legs in an excellent white-wine *court-bouillon*.
When cooled, trim them properly, dry them thoroughly in a piece of fine linen,
and steep them, one after the other, in a chaud-froid sauce of fish
with paprika, the tint of which should be golden.
This done, arrange the treated legs on a layer of champagne jelly,
which should have set beforehand on
the bottom of a square, silver dish or crystal bowl.
Now lay some chervil *pluches* and tarragon leaves between the legs
in imitation of water-grasses, and cover the whole
with champagne jelly to counterfeit the effect of water.

Send the dish to the table, set in a block of ice,
fashioned as fancy may suggest.

Fried Eggs à la Verdi

Cut six hard-boiled eggs lengthwise. Remove the yolks, pound them with
two oz of butter, and add thereto two tablespoonfuls of thick, cold Béchamel,
two tablespoonfuls of cooked herbs, and one tablespoonful of
lean ham, cooked and chopped.
Garnish each half-white of egg with a good tablespoonful of this preparation,
and smooth it with the blade of a small knife, shaping it in such wise
as to represent the other half of the egg.
Dip each whole egg, thus formed, into an *anglaise*, and roll in fine, fresh breadcrumbs.
Plunge in hot fat six minutes before serving, and dish on a napkin,
with fried parsley in the centre.
Send, separately, to the table a garnish composed of asparagus-heads.

Potage Sarah Bernhardt

Sprinkle three tablespoonfuls of tapioca into one quart of boiling chicken consommé,
and leave to poach gently for fifteen or eighteen minutes.

Make twenty small quenelles from chicken forcemeat, finished by means of crayfish
butter, and mould them to the shape of small, grooved meringues.
Poach these quenelles.
Cut twelve roundels, the size of a penny, from a piece of beef-marrow,
and poach them in the consommé.

Put the drained quenelles and the poached roundels of marrow into the soup-tureen;
add one tablespoonful of a *julienne* of very black truffles,
and the same quantity of asparagus-heads.
Pour the boiling consommé, with tapioca, over this garnish.

Darne de Saumon Nesselrode

Remove the spine and all other internal bones.
Stuff the darne with raw lobster *mousse* stiffened by means of a little pike forcemeat.

Line a well-buttered, round and even raised-pie mould with
a thin layer of hot-water, raised-pie paste
(this is made from one lb of flour, four oz of lard, one egg, and a little lukewarm water),
which should be prepared in advance and made somewhat stiff.
Now garnish the inside of the pie with thin slices of bacon
and place the darne upright in it.
(To simplify the operation the darne may be stuffed at this stage.)
Cover the pie with a layer of the same paste, pinch its edges with those of
the original lining, make a slit in the top for the steam to escape,
and cook in a good oven.

When the pie is almost baked, prod it repeatedly with a larding-needle;
when the latter is withdrawn clear of all stuffing
the pie should be taken from the oven.
This done, turn it upside down in order to drain away the melted bacon
and other liquids inside it, but do not let it drop from the mould.
Then tilt it on to a dish and take off the mould.
Do not break the crust except at the dining-table.

Sauce Serve an American sauce with the pie, the former being prepared from
the remains of the lobsters used in making the *mousse*, finished with cream,
and garnished with very fine oysters (cleared of their beards),
poached when about to dish up.

Sole au Champagne

Poach the sole in a buttered dish with one-half pint of champagne,
Dish it; reduce its cooking-liquor to half; add thereto one-sixth pint of velouté,
and complete with one and one-half oz of best butter.

Cover the sole with this sauce; glaze, and garnish each side of the dish
with a little heap of a *julienne* of filleted sole, seasoned, dredged, and tossed in
clarified butter at the last moment in order to have it very crisp.

NB *By substituting a good white wine for the champagne,
a variety of dishes may be made, among which may be mentioned: Soles au Chablis,
Soles au Sauterne, Sole au Samos, Sole au Chateau Yquem, &c, &c.*

Sole Alice

This sole is prepared, or rather its preparation is completed, at the table.

Have an excellent fish *fumet*, short and very white.
Trim the sole; put it into a special, deep earthenware dish, the bottom of which
should be buttered; pour the *fumet* over it and poach gently.

Now send it to the table with a plate containing separate heaps of one
finely-chopped onion, a little powdered thyme and three finely-crushed *biscottes*.

In the dining-room the waiter places the dish on a chafer, and, taking off the sole,
he raises the fillets therefrom, and places them between two hot plates.
He then adds to the cooking-liquor of the sole the chopped onion,
which he leaves to cook for a few moments, the powdered thyme and
a sufficient quantity of the *biscotte* raspings to allow of thickening the whole.

At the last minute he adds six raw oysters and one oz of butter divided into small pieces.

As soon as the oysters are stiff, he returns the fillets of sole to the dish,
besprinkles them copiously with the sauce, and then serves them very hot.

NB *In order to promote the poaching of the soles, more particularly when they are large,
the fillets on the upper side of the fish should be slightly separated from the bones.
By this means the heat is able to reach the inside of the fish very quickly, and the operation is accelerated.*

The sole is always laid on the dish with its opened side undermost –
that is to say, on its back.

Timbale de Filets de Sole Grimaldi

Prepare: (1) A rather deep timbale crust, and decorate it with noodle paste.

(2) Cook, as for bisque, twenty-four small *langoustines*;
wrench off their tails; cut them into two length-wise, and keep them hot in butter.

(3) Finely pound the *langoustines'* carapaces, and add thereto one-third pint of fine Béchamel.
Rub through a fine sieve first, and then through tammy.
Put the resulting cullis into a saucepan, and heat without boiling it;
intensify the seasoning; add a few tablespoonfuls of cream, little by little;
put the prepared tails in the cullis, and keep the latter in the *bain-marie*.

(4) Cut four oz of *blanched* and somewhat stiff macaroni into pieces,
and add thereto one-sixth pint of cream and three oz of sliced truffle.
Heat until the macaroni has completely absorbed the cream;
thicken with one-sixth pint of Béchamel sauce finished with fish *fumet*;
add one and one-half oz of butter cut into small lumps and keep hot.

(5) Coat sixteen fillets of sole with truffled fish forcemeat;
roll the fillets into scroll-form, and, at the last minute, poach them in fish *fumet*.

To garnish the timbale, spread a layer of macaroni on the bottom thereof,
lay half of the rolled fillets upon the macaroni, and cover these with
half of the *langoustines'* tails in the cullis.

Repeat the procedure, in the same order, with what is left of the garnishes,
and finish the timbale with a layer of the *langoustines'* tails.

Set the timbale on a folded napkin lying on a dish, and serve immediately.

153

Filets de Sole Walewska

Poach the fillets in fish *fumet*, keeping them in their natural state.

Dish, and surround them with three *langoustines'* tails cut into two lengthwise,
and stewed in butter (with lid on) with six fine slices of raw truffle.

Coat with a delicate Mornay sauce, and set to glaze quickly.

NB *The Mornay sauce may, according to circumstances, be combined with
one and one-half oz of* langoustine *butter per pint.*

Mousse d'Ecrevisses

For ten people cook thirty crayfish as for Potage Bisque.
This done, remove the tails, and reserve a dozen fine carapaces.
Finely pound the remainder, together with the *mirepoix* in which the crayfish have cooked,
and add thereto one-half oz of butter, one oz of red butter,
one-quarter pint of cold fish velouté, and six tablespoonfuls of melted fish jelly.
Rub through tammy, and put the resulting purée in a saucepan;
stir it over ice for two or three minutes; add three-quarters pint of half-beaten cream,
and the crayfish tails cut into dice or finely sliced.

Before beginning to prepare the *mousse*,
line the bottom and side of a *charlotte-mould* with paper,
that the *mousse* may be moulded as soon as ready.

Pour the preparation into the mould, taking care to reserve enough for
the twelve carapaces already put aside,
and put the *mousse* on ice or in a refrigerator until dishing it.
Fill the twelve trimmed carapaces with the reserved *mousse*,
and decorate each with a round slice of truffle.
When about to serve, turn out the *mousse* on a small, round cushion
of semolina or rice, one-half inch thick, lying on a dish.
Remove all the paper, and decorate the top of the *mousse* with a crown of
fine slices of truffle dipped in melted jelly, that they may be glossy.

Surround the semolina or rice cushion with a border of chopped jelly,
and arrange the garnished carapaces upon this jelly,
setting them almost upright.

NB *(1) Instead of being served on a cushion, the crayfish mousse
may be sent to the table in a deep silver dish with a border of chopped jelly,
and surrounded by the garnished carapaces.
The utensil is then laid on a flat dish in a bed of broken ice,
or it is encrusted direct in a block of carved ice.*

*(2) For the moulding of crayfish mousse, the mould may be 'clothed' with fish jelly
and decorated with slices of truffle.*

A mousse *prepared in this way may be either dished on a semolina or rice cushion,
or in a deep silver entrée dish, as described above.*

Tournedos Favorite

Season the tournedos; fry them in clarified butter,
and dish them, in the form of a crown, on crusts stamped out with
an indented cutter and fried in butter.

On each tournedos place a round collop of foie gras,
a little smaller than the piece of meat; the collop should be seasoned,
dredged, and tossed in butter.
On each collop of foie gras put a fine, glazed slice of indented truffle.
Garnish the centre of the dish with a fine heap of asparagus-tops cohered with butter,
or merely set these in small heaps round the tournedos.

Serve separately a timbale of potatoes (of the size of hazel-nuts) cooked in butter,
rolled in pale meat-glaze, and slightly sprinkled with chopped parsley.

Tournedos Judic

Season the tournedos; fry them in butter, and dish them in the form of a crown
on crusts fried in butter.
On each tournedos set a crown of truffle slices, with a cock's kidney in the centre,
and surround with braised, trimmed, and quartered lettuces.

Timbales de Ris de Veau

Butter a timbale mould and decorate its sides with thin pieces of noodle paste,
in the shape of lozenges, crescents, indented rings, discs and imitation-leaves.
Excellent ornamental arrangements may be effected thus;
but the reader should bear in mind that the simplest are the best.

Prepare a skullcap of paste;
slightly moisten the ornamental work in the mould, that it may cling to the
paste of the timbale, and line the latter with paste which should be
well pressed in all directions, that it may take the shape of the mould.

Then pierce the paste on the bottom, to prevent its blistering during the baking process;
line the bottom and sides with buttered paper,
and fill the timbale, three-quarters full, with split peas or lentils.

Cover the latter with a round piece of paper, and close the timbale
by means of a round layer of paste, which should be sealed down round the edges.
Make and trim the crest of the timbale; pinch it inside and out,
and finish the cover, by means of applied imitation-leaves of paste,
superimposed to form a kind of dome.

Set in a moderate oven, and when the timbale is baked, remove its cover with the view of
withdrawing the lentils or peas and the paper, the sole object of which was
to provide a support for the cover.

Besmear the inside of the timbale with a brush dipped in the beaten white of an egg;
keep it for a minute or two in front of the oven with the view of drying it inside;
turn it out, and spread upon its bottom and sides a very thin coat of chicken
or ordinary forcemeat, the purpose of which is to shield the crust
from the softening effects of the juices of the garnish.

Put the timbale in the front of the oven for a moment or two,
that this coating of forcemeat may poach.

Garnish. Veal sweetbreads, braised without colouration and cut into collops;
small mushrooms; cocks' combs and kidneys;
small quenelles of chicken, *mousseline* forcemeat, or roundels of
chicken forcemeat rolls one-third inch thick, trimmed with the fancy-cutter;
and slices of truffles, half of which should be kept
for the purposes of decoration.

Cover this garnish with Allemande sauce, prepared with mushroom essence.
Pour it into the timbale, just before serving;
upon it set the reserved slices of truffle, in the form of a crown;
replace the cover; dish upon a folded napkin, and serve.

NB *(1) As already stated the garnish of the timbale may be cohered with
a half-glaze sauce, flavoured with Madeira or truffle essence.*

*(2) In this garnish, whether it be cohered by means of
a white or brown sauce, the slices of veal sweetbreads are always the principal ingredient;
but, subject to the circumstances, the other details may be altered or modified,*

Selle d'Agneau de Lait Edouard VII

Completely bone the saddle from underneath, in suchwise as to leave the skin intact;
season it inside, and place in the middle a fine foie gras, studded
with truffles and *marinaded* in Marsala.

Reconstruct the saddle, and wrap it tightly in a piece of muslin;
put it in a saucepan just large enough to hold it, on a litter of pieces of bacon rind,
cleared of all fat and *blanched*.
Moisten, enough to cover, with the braising-liquor of a cushion of veal;
add thereto the Marsala used in *marinading* the foie gras,
and poach for about forty-five minutes.

Before withdrawing the saddle, make sure that the foie gras is sufficiently cooked.
Remove the muslin, and put the saddle in an oval *terrine à pâté*
just large enough to hold it.
Strain the cooking-liquor over it, without clearing the former of grease,
and set it to cool.

When the saddle is quite cold, carefully clear away the grease that lies upon it,
first by means of a spoon and then by means of boiling water.
Serve it very cold, in the terrine as it stands.

Poularde Derby

Stuff the pullet with rice, and *poêle* it.
Dish, and surround it with collops of foie gras, tossed in butter (each set on
a small, fried *crouton*), and alternate these
with large, whole truffles, cooked in champagne.

As an adjunct, seve the pullet's cooking-liquor, cleared of all grease,
combined with the cooking-liquor of the truffles
and one-sixth pint of veal gravy.
Reduce the whole to one-sixth pint and thicken with arrow-root.

Poularde Devonshire

Bone the breast of a fine pullet; season it inside, and fill it with a chicken forcemeat, prepared
with cream and mixed with half its weight of very fine sausage-meat.

In the middle of the pullet set a nice salted and cooked calf's tongue,
trimmed and cleared of all cartilage; and place it so that its thin end
lies in the region of the bird's tail.

Sew up the pullet's belly with thin string, allowing the skin sufficient play
not to tear under the pressure of the forcemeat, which swells while cooking.
Truss, cover the pullet with a slice of larding bacon, poach, and drain it.

When about to serve, make an incision around the breast with the point of a knife;
detach the stuffing with the blade of a knife,
passed horizontally on a level with the spine, and cut off, at a stroke,
the piece consisting of the pullet's breast, the stuffing, and the calf's tongue.

Dish the carcass with the legs and wings still attached, on a low cushion.
Cut the breast, lengthwise, into two; and, if the fowl has been properly stuffed,
the tongue should then be found neatly bisected.
Slice each half, and return them to the carcass in suchwise as to reconstruct the bird
and give it an untouched appearance.

Coat lightly with Allemande sauce, combined with very red tongue, cut into dice;
and surround with a border of timbales made from a purée of fresh peas,
each set on an artichoke bottom.
Serve a sauceboat of the same sauce as that with which the pullet was coated.

Poularde aux Huîtres

Boil the pullet gently in light, white stock, until it is well cooked.
With the cooking-liquor prepare a suprême sauce, and add thereto the
almost entirely reduced poaching-liquor of twenty-four oysters, one-half pint of cream,
and the twenty-four oysters (cleared of their beards).
Dish the pullet, and pour this sauce over it.

Poularde Louise d'Orléans

Insert a whole foie gras into the pullet, the former having been
studded with truffles, poached for fifteen minutes in some succulent veal stock,
and one glassful of old Madeira, and afterwards cooled.

Stiffen and colour the pullet for twenty minutes in the oven,
sprinkling it with butter the while.

Cover it entirely with thick slices of truffles; cover these with slices of bacon,
and envelop the whole in a layer of plain dough, which should be well sealed up.
Set the pullet, prepared in this way, on a baking-tray;
make a slit in the top of the paste for the escape of steam during the cooking process,
and cook in a moderate oven for one and three-quarter hours.

This pullet is served as it stands, cold or hot.

Poularde Marguerite de Savoie

Fry quickly ten larks in butter, insert these into a fine pullet,
and braise the latter in veal stock and white Savoy wine, in equal quantities.
Prepare a milk polenta; spread it on a tray in layers one inch thick, and let it cool.
Now stamp it with a round cutter one and one-half inches in diameter,
and, a few minutes before serving, dredge these roundels of polenta,
and brown them in clarified butter.

Just before dishing up, sprinkle them with grated Parmesan,
and glaze them quickly at the salamander.

Dish the pullet on a very low cushion of fried bread; surround it with
the glazed roundels of polenta; pour a little of the fowl's cooking-liquor, thickened,
over the dish, and send what remains of it in a sauceboat.

Serve at the same time a vegetable-dish of white Piedmont truffles,
slightly heated in a little butter and some consommé.

Poularde Sainte Alliance

Heat in butter ten fine truffles seasoned with salt and pepper;
sprinkle them with a glassful of excellent Madeira, and leave them to cool thus
in a thoroughly sealed utensil.
Now put these truffles into a fine pullet, and *poêle* it just in time for it
to be sent to the table.

When the pullet is ready, quickly cook as many ortolans, and toss in butter
as many collops of foie gras as there are diners,
and send them to the table at the same time as the pullet, together with
the latter's *poêling*-liquor, strained and in a sauce-boat.

The waiter in charge should be ready for it with three assistants at hand,
and he should have a very hot chafer on the side-board.
The moment it arrives he quickly removes the *suprêmes*, cuts them into slices,
and sets each one of these upon a collop of foie gras,
which assistant No.1 has placed ready on a plate, together with
one of the truffles inserted into the pullet at the start.

Assistant No. 2, to whom the plate is handed forthwith, adds an ortolan
and a little juice, and then assistant No. 3 straightaway
places the plate before the diner.

NB *The name* 'Sainte Alliance' *which I give to this dish
(a name that Brillat-Savarin employs in his* 'Physiology of Taste' *in order to
identify a certain famous toast) struck me as an admirable title for
a preparation in which four such veritable gems of cookery are found united –
the* suprêmes *of a fine pullet, foie gras, truffles, and ortolans.*

This dish was originally served at the Carlton Hotel in 1905.

Poulet Sauté Mireille

Sauté the chicken in oil and add to it, when half-cooked,
one chopped onion, four *concassed* tomatoes, and one pimento cut into dice.
Ten minutes before serving, flavour with a small piece of crushed garlic.

Dish the chicken; pour the juice of the tomatoes into the sautépan;
reduce to half, and strain over the chicken.

Serve a timbale of rice, flavoured with saffron, separately.

Caneton Braisé à l'Orange

This braised duckling must not be confused with roast duckling, which is also served
à l'orange, for the two dishes are quite distinct.

As in the case of the roast, this duckling may be prepared with Seville oranges;
but, in this case, the sections of orange must not appear as garnish owing to their bitterness,
and only the juice is used for the sauce.

Braise the duckling in one-third pint of brown stock and
two-thirds pint of Espagnole sauce, and cook it sufficiently to allow of
its being cut with a spoon.

Clear the sauce of grease, reduce it to a stiff consistence; rub it through tammy,
and add the juice of the oranges and one half-lemon to it,
which should bring the sauce back to its original consistence.

Now add a *julienne* of the *blanched* yellow part only
of the rind of a half-orange and a half-lemon, but remember that
the addition of the juice and rind of the orange and the half-lemon
only takes place at the last moment, after which the sauce must not boil again.
Glaze the duckling, dish it, coat it slightly with sauce, and surround it
with sections of orange, skinned raw.

Serve what remains of the sauce separately.

Filets de Caille aux Pommes d'Or

Raise the quails' *suprêmes* after having poached and cooled them.
Set these *suprêmes* in the rinds of small oranges or tangerines, and fill up
the rinds with jelly prepared with Port.
When about to serve, deck each orange or tangerine, by means of the piping-bag,
with a small ornament of Granité, prepared with the
juice of the fruit used.

Cailles à la Vendangeuse

Roast the quails; let them cool, and set them, each in a little dosser of
dry paste, resting against a cushion lying on a round dish.
On top of the cushion plant a leafy vine-shoot bearing grapes.
Surround the quails with white and black grapes (peeled and pipped)
and cover with a slightly gelatinous aspic jelly,
prepared with liqueur brandy.

Faisan Galitzine

Bone two fine snipes; empty them of their intestines; fry these in butter,
and crush them on a plate.
Chop up the meat of the snipes, combining half its weight of cream with it,
and as much butter; season with salt and pepper, and add the crushed intestines
and four oz of truffles cut into large dice.

Stuff a fine pheasant with this preparation; roast it '*en casserole*', or rather in a *cocotte*.

At the last moment sprinkle with a little *fumet*, prepared from
the snipes' carcasses.

Roast Ortolans

Wrap each in a vine-leaf; set them on a tray, moistened with salted water, and cause them to set in a fierce oven for four or five minutes.

The small amount of water lying on the bottom of the utensil produces an evaporation which prevents the ortolans' fat from melting; consequently there is no need of slices of bacon, butter, or gravy.

Each ortolan may be served in a half-lemon, shaped like a basket.

NB *The ortolan is sufficient in itself, and ought only to be eaten roasted. The products sometimes served as adjuncts to it, such as truffles and foie gras, are deleterious, if anything, to its quality, for they modify the delicacy of its flavour, and this modification is more particularly noticeable the more highly flavoured the adjunctive products may be.*

With its accompaniments it becomes a sumptuous dish, for the simple reason that it is expensive; but it does not follow that the true connoisseur will like it; it must be plainly roasted to suit him.

Salade Trédern

Take twenty-four crayfishes' tails, cooked as for bisque, and cut lengthwise; twenty-four oysters (cleared of their beards), poached in lemon juice; and three tablespoonfuls of asparagus-heads. The three constituents should have barely cooled. Complete with fine shavings of raw truffles.

Season with condimented mayonnaise sauce, combined with a purée made from the crayfishes' carcasses, pounded with two tablespoonfuls of fresh cream.

Salade Monte-Cristo

Take equal quantities of lobster-meat, cooked truffles, and potatoes and
hard-boiled eggs in dice, and arrange them in distinct heaps.

In their midst place the very white heart of a lettuce.
Season with mayonnaise sauce with mustard, and add some chopped tarragon.

Coupes d'Antigny

Three-parts fill the bowls with Alpine-strawberry ice, or, failing this,
four-seasons strawberry ice, combined with very light and strongly flavoured raw cream.
The two most perfect examples of this cream are the 'Fleurette Normande',
and that which in the South of France is called 'Crême Niçoise',
and which comes from Alpine pastures.
Upon the ice of each bowl set a half-peach, poached in a vanilla-flavoured syrup;
and veil the whole thinly with spun sugar.

Bombe Néron

Take a dome-mould and *clothe* it with vanilla ice-cream with caramel;
fill it with vanilla *mousse*, combined with small, imitation truffles, the size of
small nuts, made from chocolate.

Turn out the Bombe on a thin cushion of Punch Biscuit,
of the same diameter as the Bombe.
Cover the whole with a thin layer of Italian *meringue*; and, on top,
set a small receptacle made of Italian *meringue* dried in an almost cold oven.
Decorate the sides by means of a piping-bag with *meringue*,
and set the whole in the oven to glaze quickly.

BIBLIOGRAPHY

Andrieu, Pierre. *Histoire du Restaurant en France*, Montpellier, 1955

L'Avenir de Nice for 1855–60

Bautte, André. *A Travers le Monde Culinaire et Gourmand. Critique de la Cuisine et de l'Administration des Grands Hôtels, et Restaurants Mondains, des familles Princières et Aristocratiques*, Paris, 1910

Delvau, Alfred. *Les Plaisirs de Paris*, Paris, 1867

Escoffier, Auguste. *Traité sur l'Art de Travailler les Fleurs en Cire*, Paris, n.d., (1885)
– *Le Guide Culinaire*, Paris, 1903
– *Projet d'Assistance Mutuelle pour l'Extinction du Paupérisme*, Paris, 1910
– *Le Livre des Menus*, Paris, 1912
– (editor) *Le Carnet d'Epicure*, London, 1911–14
– *Ma Cuisine*, Paris, 1934
– *Souvenirs Inédits*, Marseilles, 1985

Gouffé, Jules. *Le Livre de Cuisine*, Paris, 1867

Hamp, Pierre. *Mes Métiers*, Paris, 1930

Herbordeau, Eugène, et Thalamas, Paul. *Georges Auguste Escoffier*, London, 1955

Illustrated London News

Jollivet, Gaston. *Souvenirs de la Vie de Plaisir sous le Second Empire*, Paris, 1927

Le Journal de Monaco for 1881–90

Jullian, Philippe. *Edward and the Edwardians*, London, 1967

Laver, James. *Edwardian Promenade*, London, 1958

Levy, Paul. *Out to Lunch*, London, 1986

Librairie Larousse. *La Cuisine et la Table Modernes*, Paris, n.d., (c1905)

Luchet, Auguste. 'Les Grandes Cuisines et les Grandes Caves' in *Paris Guide*, 2 volumes, Paris, 1867

Maurois, André. *Edouard VII et Son Temps*, Paris, 1933

Mennell, Stephen. *All Manners of Food. Eating and Taste in England and France from the Middle Ages to the Present*, Oxford, 1985

Mény, Georges. *Nos Petits Marmitons*, L'Action Populaire 71, Rheims and Paris, n.d., (c1906)

Montagné, Prosper, et Salles, Prosper. *La Grande Cuisine Illustrée*, Paris, 1900

Newnham-Davis, Nathaniel. *Dinners and Diners*, London, 1899

Nouveau Guide de l'Etranger à Nice, Nice, 1857

La Revue de l'Art Culinaire, Paris, 1883–1939

Ritz, Marie-Louise. *César Ritz*, Paris, 1948

Sackville-West, Victoria. *The Edwardians*, London, 1930

Saint Germain, Philippe, and Rosset, Francis. *La Grande Dame de Monte Carlo*, Paris, 1981

Sitwell, Sir Osbert. *Left Hand, Right Hand*, London, 1945
– *The Scarlet Tree*, London, 1946

The Sphere

Urbain Dubois, Félix. *La Cuisine Artistique*, 2 volumes, Paris, 1872–4
– *La Cuisine d'Aujourd'hui*, Paris, 1889

NOTE First French editions only are given for books by Escoffier.

INDEX

Abd-el-Kadar, Emir, *108-9*
Albert, Prince, of Monaco, *40*
Alençon, Emilienne d', *121*
Alfonso XII, King of Spain, *80*
Alfonso XIII, King of Spain, *55*
Antigny, Blanche d', *23-4, 77, 109, 121*
Aosta, Emmanuel, Duke of, *135*
Asquith, Herbert, *95*
Audran, Edmond, *122*
Autheman, Monsieur, *75*

Balzac, Honoré de, *15, 32*
Bardoux, Monsieur, *21, 102*
Baroda, Maharajah of, *118*
Barrès, Maurice, *140*
Barry, Sir Charles, *69*
Battenberg, Alexander of, *40*
Bauffremont, Duchess of, *122*
Bazaine, Marshal Achille, *24, 26, 28*
Beit, Sir Alfred, *52, 108*
Belloc, Hilaire, *140*
Bergson, Henri, *138, 140*
Bernard, Emile, *147*
Bernhardt, Sarah, *11, 12, 47, 55, 59, 105, 110-12, 121, 143*
Bignon, Louis, *75, 102*
Blériot, Louis, *133*
Bologna, Sylvain, *94*
Bouniol, Jérémie, *24, 27, 28*
Bozzone, chef saucier, *91*
Brillat-Savarin, Jean-Anthelme, *77, 117*
Brunswick, Duke of, *22*

Caillard, Admiral, *124*
Carême, Antonin, *11, 102, 120, 139, 142, 145*
Caruso, Enrico, *52*
Castellane, Boni de, *11, 122*
Chamberlain, Joseph, *40*
Charles III of Monaco, Prince, *39*
Charles, chef de cuisine, *90-91*
Chevet, caterer, *29, 32*
Christophle, silversmith, *20*

Churchill, Sir Winston, *11, 55*
Colcutt, Thomas, *42*
Connaught, Arthur, Duke of, *136*
Curnonsky (Maurice Sailland), *141*

Daffis, Paul, *29*
Daudet, Léon, *55*
Davenport-Handley, Mr, *41*
Demidov, Prince Anatole, *109*
De Morgan, William, *49*
Derby, Lord, *11, 40*
Dieudonné, Madame, *131*
Dilke, Sir Charles, *114*
Doré, Gustave, *109–10*
D'Oyly Carte, Richard, *42, 44, 48, 71*
Duchêne, Madame, *121*
Dugléré, Adolphe, *100*
Duse, Eleonora, *99-100, 121*
Durverger, Mademoiselle, *109*

Eberlé, chef glacier, *89-90, 143*
Escoffier, Delphine (née Daffis), *29*
Escoffier, François, *19–20, 21*
Escoffier, Georges Auguste;
 childhood, *15-19*
 apprenticeship and years at Nice, *19-21, 74-6*
 in Paris, *21-4, 28-32, 49-50, 76-80*
 Franco-Prussian War, *24-8, 58-9*
 meeting with Ritz, *32, 38, 105-8*
 at Monte Carlo, *38-42, 95, 102*
 at Lucerne, *42, 118*
 in London, *45-8, 50-58, 62, 82, 89, 91, 95*
 Savoy dispute, *50-51*
 in America, *11, 59, 62-3, 110-12*
 in Germany, see under; William II, German emperor
 retirement and death, *9, 10, 62-3*
Escoffier, Pierre, *12*

Faure, Félix, *120*
Fétu, Emile, *146*

Florence, Henry, *51*
Fontalva, Count of, *118*
Fraser, Mrs, *115*

Galitzin, Prince, *29, 109*
Gambetta, Léon, *29, 112-14*
Garnier, Charles, *38*
Gilbert, Philéas, *94, 138*
Giroix, Jean, *37, 63*
Glyn, Elinor, *55*
Goncourt, Edmond and Jules, *21, 102*
Gouffé, Jules, *69, 120, 142*
Gould, Anna (Anna de Castellanc), *122*
Granier, Jeanne, *121*
Guilbert, Yvette, *121*
Gulbenkian, Calouste, *108*

Hamp, Pierre (Pierre Bourillon), *82-92*
Hardouin-Mansart, Jules, *68*
Henry, maître d'hôtel, *102*
Herriot, Edouard, *12*
Higgins, Henry, *108*
Ho Chi Minh, *55*
Houssaye, Arsène, *22*

Irving, Sir Henry, *47*
Isaacs, Lewis, *51*

Judic, *121*
Jungbluth, Xavier, *42, 102, 116-18*

Katinka, *40, 115-16*
Kipling, Rudyard, *140*
Knopp, Mr, *115*
Kochubey, Prince, *40, 116*
Kramer, Jacques, *91*

Labouchère, Henry, *47*
Langtry, Lily, *46, 114, 133*
Leopold II, King of the Belgians, *55*
Lloyd George, David, *55, 94*
Louis, aboyeur, *89, 92*

Long, Washington de, *121*
Loubet, Emile, *124*
Louise, Princess, *136*
Lourdin, Monsieur, *21, 22*
Lyautey, Marshal Louis Hubert, *140*

Macchia, commis rôtisseur, *89*
Mac-Mahon, Marshal Patrice de, *24, 26, 27-8, 114*
Marsick, Martin, *115*
Mathilde, Princess, *109*
Mecklenburg-Strelitz, Grand Duke of, *40*
Melba, Dame Nellie, *47, 75*
Mewès, Charles, *50, 52, 124*
Michel, chef entremettier, *89*
Mistral, Frédéric, *141*
Montagné, Prosper, *138, 146*
Montpensier, Ferdinand, Duke of, *136*
Morgan, Lady, *102*
Morin, Victor, *87, 89, 94*
Morris, William, *44*

Nansen, Fridtjof, *120-21*
Nash, John, *68*
Nesselrode, Count von, *138*
Newnham-Davis, Nathaniel, *44, 75*
Northcliffe, Lord, *12, 105*

Orléans, Princess Ilélène d', *135*
Orléans, Philippe, Duke of, *34, 46, 55, 135-6*

Orlov, Prince, *80*
Otéro, la Belle, *121, 122*
Ozanne, Achille, *94*

Paîva, Marquise de, *121*
Paris, Philippe, Comte de, *46*
Patti, Adelina, *11, 40, 116-18*
Pearl, Cora, *23, 121*
Péguy, Charles, *140*
Percival, Captain, *115*
Persia, Shah Nasir-ud-Din of, *24*
Pfyffer d'Altishofen, Colonel, *42*
Phillips, Stephen, *121*
Phipps, C. J., *51*
Poincaré, Raymond, *62*
Pougy, Liane de, *122*
Proust, Marcel, *122*

Réjane, *121*
Rhodes, Cecil, *140*
Ritz, César;
 early years, *32-37*
 meeting with Escoffier, *11, 13, 32, 38*
 at Monte Carlo, *37, 38-42, 101-2*
 in London, *44-5, 48, 50-52*
 in Paris, *50-51*
 collapse and death, *53, 146*
Ritz, Marie Louise, *48, 119*
Rochaud, Ulysse, *24, 89*
Rose, Mademoiselle, *24*
Rothschild, James de, *102*

Saki (H.H. Munro), *95*
Salles, Prosper, *146*

Saxe-Meiningen, Prince and Princess of, *115*
Scotto, Charles, *59*
Serres, Olivier de, *68*
Servi, Jules, *28*
Seymour, Mr, *41*
Sitwell, Sir Osbert, *134*
Smiler, *119*
Sormani, decorator and cabinet maker, *58*
Soyer, Alexis, *11, 69*
Steinheil, Madame, *120*
Stevenson, Major, *115*
Strauss, Johann, *48*

Terry, Dame Ellen, *47*
Tree, Sir Herbert Beerbohm, *121*

Urbain Dubois, Félix, *80, 142, 144, 146*

Verdier, Charles and Ernest, *105*
Victor, aide garde-manger, *90*

Waldner, Comte de, *28*
Wales, Prince of (later Edward VII), *11, 22, 29, 34, 40, 46, 52, 55, 105, 114-15, 136, 146*
Wales, Princess of, *136*
Wales, Princess Maud of, *136*
Wales, Princess Victoria of, *136*
Wilde, Oscar, *11, 47, 133*
William II, German emperor, *58, 61, 124*

Zola, Emile, *23, 119-20*